WATERCOLOR:
Let the Medium Do It

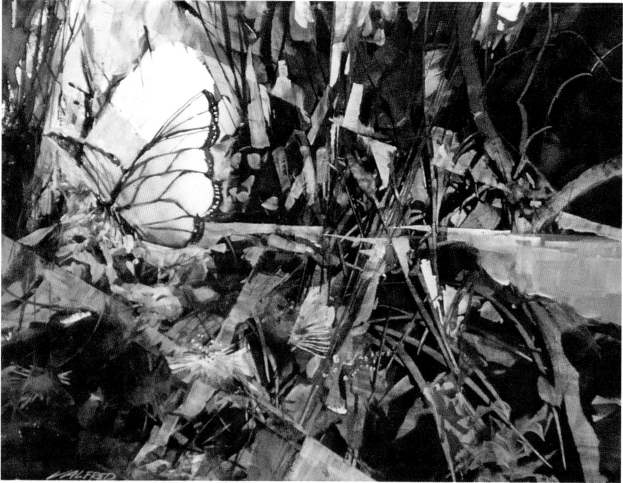

SIGN OF SPRING, 24″ × 30″ (61.0 cm × 76.2 cm), collection of Chivette Kerns

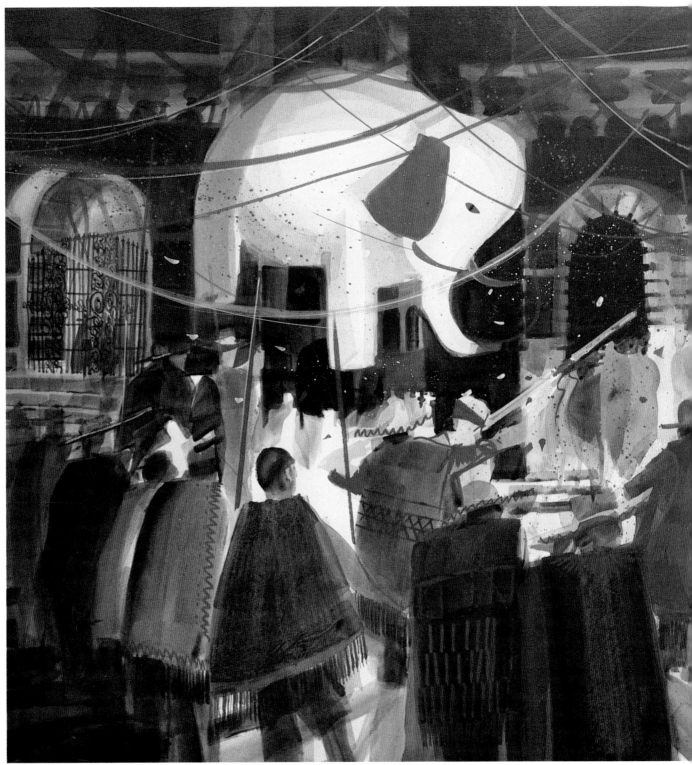

TAXCO PIÑATA, 24″ × 30″ (61.0 cm × 76.2 cm), collection of Eva Sawtelle

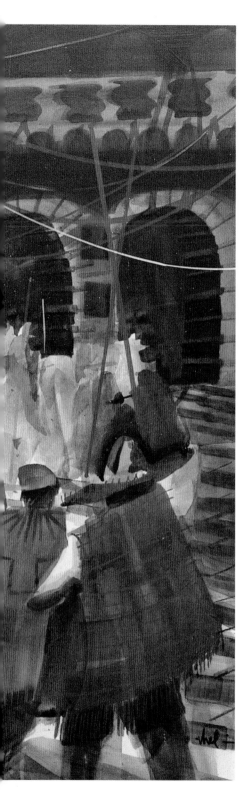

WATERCOLOR:
Let the Medium Do It

Valfred Thëlin with Patricia Burlin

WATSON-GUPTILL PUBLICATIONS / NEW YORK

I would like to dedicate this book to my grandfather, father, and mother, who gave me encouragement; to my late wife, Barbara, for her support; to Deidre, for friendship, as well as to doctors Bill, Michael, and Dick of the Maine Medical Center; and to Pat and Jack, for their persistence. Without all of them, this book would not have been possible.

Edited by Marian Appellof
Graphic production by Hector Campbell
Text set in 10-point Else

First published in 1988 in New York by Watson-Guptill Publications,
a division of Billboard Publications, Inc.,
1515 Broadway, New York, N.Y. 10036

Library of Congress Cataloging-in-Publication Data

Thëlin, Valfred.
 Watercolor : let the medium do it : projects for pleasure and
practice / Valfred Thëlin with Patricia Burlin.
 p. cm.
 Includes index.
 ISBN 0-8230-5667-8 : $27.50
 1. Watercolor painting—Technique. I. Burlin, Patricia.
II. Title.
ND2420.T47 1988
751.42′2—dc19 88-21061
 CIP

Distributed in the United Kingdom by Phaidon Press Ltd.,
Littlegate House, St. Ebbe's St., Oxford

Manufactured in Japan

First printing, 1988

1 2 3 4 5 6 7 8 9 10 / 93 92 91 90 89 88

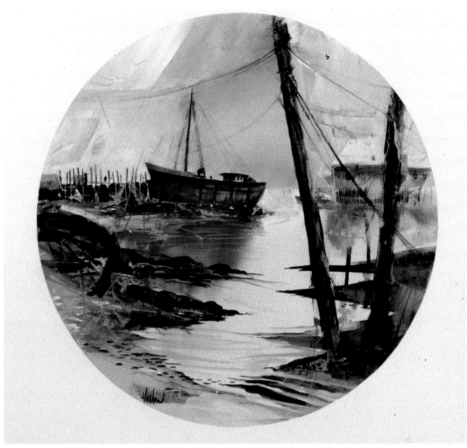

GLOUCESTER LOW TIDE, 30″ × 30″ (76.2 cm × 76.2 cm), private collection, Massachusetts

Painting may be abstract or realistic, depending on personal interpretation. I have no inhibitions about moving from what is called realistic to what is considered abstract, for I find relevance in both pertaining to the interpretation the individual may give a particular expression.

What is real in my paintings is the image itself, which fuses with my idea as I begin to paint. The painting seems to create itself during this process.

Forms tinged with personal feelings remembered or hidden in my unconscious spring into being, and the painting unfolds into a world of light and depth with its own consciousness.

CONTENTS

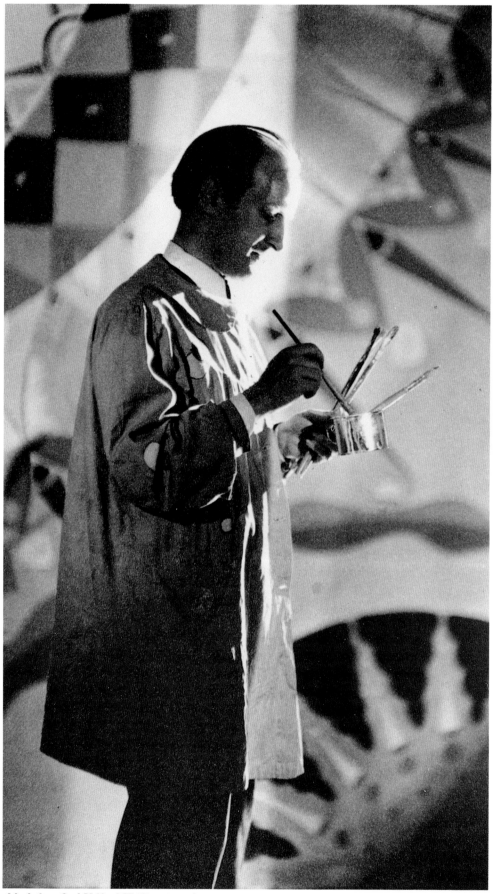

My father, Carl Valfred Thëlin, at work.

INTRODUCTION

My first teacher was my grandfather, Peter August Thëlin, a muralist who came to this country from Sweden in the mid-1800s. I was asthmatic as a child, and could not run and play with the rest, so I worked in a gazebo in the yard doing sketches of other children or still lifes in charcoal. Every day after supper my grandfather would critique my drawing, always emphasizing that "there are no mistakes, only corrections." Saturday afternoons we would walk along the Mississippi River and discuss how to look at and feel all the everyday things surrounding us as art forms. We sat on the worn stairs of abandoned houses and imagined stories about the lives of people who had once walked there. This awareness of people and things that he put into his work encouraged me to do likewise.

Another important teacher was my father, Carl Valfred Thëlin. A graduate of the Chicago Art Institute (the equivalent of today's School of the Art Institute of Chicago), he had been trained as a fine artist but worked in the commercial field. I spent a lot of time with him and his associates in the studio learning the tricks of his trade.

At age twelve I followed my father's footsteps and entered the Chicago Art Institute. The summer I was sixteen I worked in the studio of Hans Hofmann, who not only confirmed my desire to paint but also inspired me to teach. I was fascinated with the world of fine art as seen through his eyes.

Although I began as an oil painter, allergies forced me to switch mediums at midstream. First I tried commercial art, but with the help of my wife, Barbara Ann, I was able to turn to fine art and to pursue watercolor as a medium seriously. After studying with many different teachers here and abroad and analyzing the works of watercolorists I admired, I decided that what excited me about watercolor was the medium itself.

I love to watch the paint in its liquid state flowing freely within the water, expanding and twisting into many patterns. I let myself become completely immersed in the color, watching what it is doing for me. Slowly I feel a communication developing between me and the shapes and forms the medium itself creates. I find myself growing with it, looking and discovering references in my subconscious and slowly developing

realistic facts within the abstract forms. You might call me an "abstract realist."

It is this excitement with the medium itself that I try to communicate to my students. I believe every painting is a new experience, and I have tried to take a similar approach to this book. Each chapter should be a new and challenging experience for you, with step-by-step procedures to help you build on your knowledge and improve your skills. Chapters that focus on showing you how to depict specific subject matter such as trees, skies, and rocks complement others that introduce techniques you can apply to a broad range of subjects. This approach, I believe, will help you accumulate a more effective art vocabulary.

Anyone who really wants to paint can do so. Keep in mind that the only limitations are those you yourself set. Also be aware that I do not want to change your style; all I want is to expand your thinking. Every painting is a lesson; it's not how well it's done, it's how much you learn from it. By applying this to your own experiences and skills, you will discover a new "you" in watercolor.

1

THE CONTROLLED DRIP

The controlled drip is a fun exercise in patience and observation. This technique involves dripping paint onto a wet surface and manipulating it to get different effects. It is the best way to learn what pigments do in reaction and relation one to another and to discover what happens when they eventually dry. Observing what the pigments do alone and together gives you a valuable working knowledge of the medium. Although happy accidents are occasionally successful, knowing how they happen gives you a degree of control over the medium without inhibiting the action.

I particularly enjoy using the controlled drip technique when I am painting the misty illusions of the shoreline, the mountains of the West, and the abstract forms of the Southwestern landscape, with its leathery-textured rocks and cliffs.

To execute a controlled drip painting, I wet a brush in good clean water and dampen the surface of a sheet of paper exactly where I want the pigment to go, working my way up from the bottom of the sheet and forming the shapes of my subject—buildings, shipyards, or simply abstract patterns. Then I drip paint onto the wet area and tilt the paper to move the pigment into the appropriate places.

When using this technique, you must let the painted surface dry completely before adding another coat. I find that a terry towel laid under the wet paper absorbs the moisture and allows the paper to dry flat. To avoid runbacks, I drip excess pigment off onto a towel.

I call the controlled drip my "Florida technique" because it was there that I discovered that letting the sun dry the paper gave me more control over the pigment. When I am in areas with high humidity or chilly weather, the paint is more awkward to handle, and I usually need more glazes to obtain the color depth I desire.

You can use as many layers of color as you wish. I have done controlled drips with only one layer, using two or three colors in the same run, while in other drip paintings I have used as many as fifteen different layers. The beauty of this technique is that you don't have to get a painting done all in one day; you can leave it to come back to another time. Personally, I prefer to work on two or three paintings at a time so I can better capture the mood and feeling I am after.

Here I applied many layers of wash and allowed each of them to dry. I then added a pale wash of blue over the entire painting, making sure to use a very light touch. While it was still wet I covered the painting with plastic wrap to give texture to the sky and foreground. After it had dried I added two washes of green to the foreground, laying the plastic wrap back over the paper after each wash.

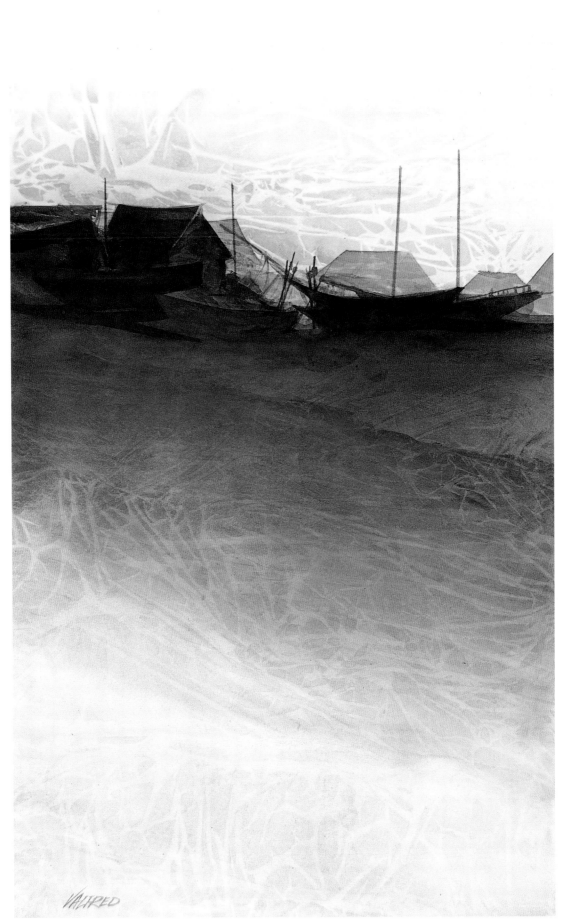

LOW TIDE, 28″ × 36″ (71.1 cm × 91.4 cm), collection of the artist

Overview of Materials

As you begin to pursue watercolor painting, you will need to consider some of your materials. Those mentioned here are basic, but other chapters will introduce you to experimental ones that will expand your art vocabulary.

Water Container. I personally prefer a deep water container with two sections. A large amount of water allows the pigment from the brush to settle to the bottom, keeping the top of the water fairly clean. In one side I keep water to use with pure watercolor; in the other is water for rinsing the brushes I use for gesso or polymer medium. Consequently, I avoid mixing the mediums and am assured that no acrylic medium will penetrate and damage my watercolor brushes.

Brushes. Good brushes are the most important part of your equipment because they are an extension of you. Even before you think of creating a painting, become familiar with your new-found friends and what they can do for you. Practice with them and learn their capabilities.

As a boy I was fascinated with the brushes in my father's sign-painting shop. One night while waiting for my dad, I tried using some of them. The next day the sign painters were outraged that I would even touch their brushes, let alone use them. One of the painters explained that each brush assumed the character of its owner, making it easy for him to stroke any letter he chose. It was then that I began to learn about the "care and feeding" of brushes.

I never just wash a brush and set it down. Each day when I finish painting, I wash my brushes, square up my flats and point my rounds, then place them on a towel to dry with the handles elevated by a dowel or a piece of wood. That way all the water is absorbed and can't run back into the ferrule, which damages the brush and loosens the hairs. In addition, I wash my brushes every two or three days with a mild soap. I have brushes that I've painted with for twenty years, ones that are slightly worn but still very useful.

Palette. I find that the color wheel seems to be the logical basis for all color placement, so I separate the cool side of my palette from the warm. My particular choice of colors has a lot to do with my experience, and because all of us see things differently, your palette will not be exactly like mine.

My basic palette is shown on the opposite page. When I travel from one part of the country to another, I often add colors characteristic of a specific region. For example, in the Southwest cadmium orange, cadmium red, cobalt violet, and new gamboge yellow seem to dominate, while in the tropical islands brilliant blues and greens take control. Seasonal changes also influence my palette. During spring and summer in Maine, sepia, greens, and umbers are prominent; in fall I change to warm oranges and reds; with winter, cobalt blue, sap green, and Indian red come into play.

I use mostly Liquitex and Winsor & Newton colors. I find that Liquitex is not only more reasonably priced than Winsor & Newton but also has more glycerin and thus lasts longer. I do, however, use Winsor & Newton cadmium red and cadmium orange exclusively, as they are particularly intense and interact differently with other colors. I also enjoy using some of Holbein's unusual colors, particularly opera, peacock blue, and cobalt violet. Whenever I purchase new paints, I always add a few colors I've never tried, so I am constantly experimenting.

I never clean my palette; the well-known watercolorist John Pike used to call me Mr. Mud, and I called him Mr. Clean. The heart of my palette is where colors overlap and bleed together, sometimes serendipitously. For example, when Winsor blue and alizarin crimson meet, they form a beautiful mauve; as these blend with warm sepia, I get varying shades of gray. Another color combination that appeals to me is Hooker's green dark and warm sienna. With various combinations from the "bottom of the pot"—the center of the palette—I come up with both warm and cool colors and all my gray tones.

Paper. I prefer Arches 140-lb. cold-pressed watercolor paper, because it is the most flexible and easiest to handle and absorbs watercolor beautifully. It offers a consistency in color reaction and explosion that I have not found with other papers. You can also use watercolor board or 300-lb. paper.

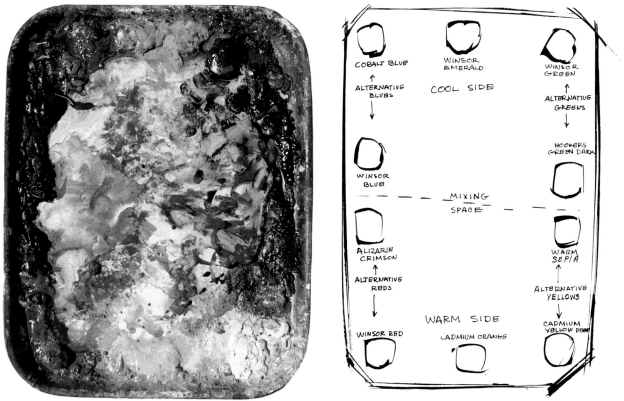

My basic palette. Note what happens in the center—the "bottom of the pot."

Colors attack or retreat from each other; this is particularly noticeable when you combine a coarse with a fine-ground pigment. Play with your paints to learn when reactions like these happen. In general, warm colors move forward and cool colors recede.

Cadmium yellow reacting
with Hooker's green dark.

Cadmium orange reacting
with warm sienna.

A Simple Controlled Drip

To learn about the controlled drip technique, start with a small painting like the one shown here. Choose a simple subject so you can concentrate on gaining control.

For this painting I used a divided water bucket, a large wash brush (1½″ flat), #5 and 10 round brushes, and a razor blade. A piece of terry toweling has been laid underneath the painting to allow for even, rapid absorption of water through the paper. I chose a limited palette: Winsor blue, Hooker's green dark, and cobalt blue.

With only the tip of my 1½″ flat brush completely saturated with water, I ran the brush over the dry paper in a diagonal line. This encouraged a diagonal wash to flow across the full width of the paper without damaging the surface.

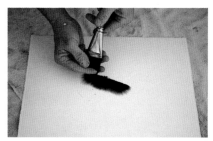

While the paper was still very wet I dissolved Winsor blue in a large puddle on my palette, making sure there were no heavy chunks of pigment in the mixture. Holding the brush in the center at the edge of the wet surface, I squeezed it between my fingers, forcing pigment to drip out in one continuous stream. Then I removed it quickly to prevent further dripping.

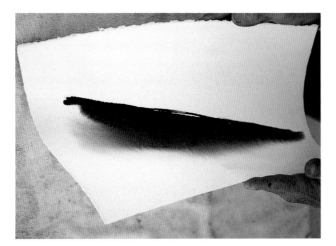

Now the medium really goes to work. As it begins to spread into the wet area, it follows the diagonal wash across the paper but will not pass over to the dry surface. By picking the paper up on one side or the other, you can make the color bleed more. Hold the paper by the edges between the palms of your hands to avoid getting fingerprints on it, since these can cause stains and create a pigment resist. Turn and twist the paper to encourage the paint to move over the wet area. You will find that it takes a bit of concentration to make the pigment run where you want it. To avoid backruns, drain off excess pigment on a towel.

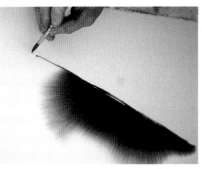

To encourage the color to move along the line a little further, I took a #5 round brush loaded with water only and moved the stroke along the edge.

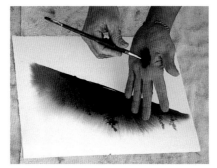

When the drying was half over but the paper was still damp, I took my #10 round brush and spread the bristles apart in the palm of my hand. I will refer to this throughout the book as a "mutilated brush."

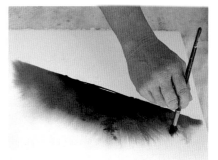

With my mutilated brush I stroked a series of vertical lines to indicate pine trees. I then crossed the vertical lines with horizontal ones to suggest branches.

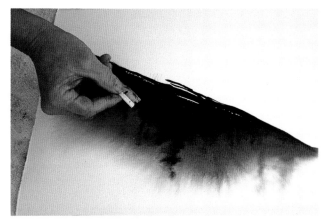

I scraped in tree trunks with a single-edge razor blade.

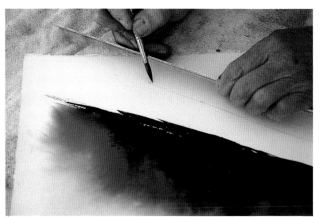

When the painting was dry I dipped my #5 brush into cobalt blue and, holding it against a ruler slanted at a forty-five-degree angle, drew a very thin straight line to suggest ski tracks.

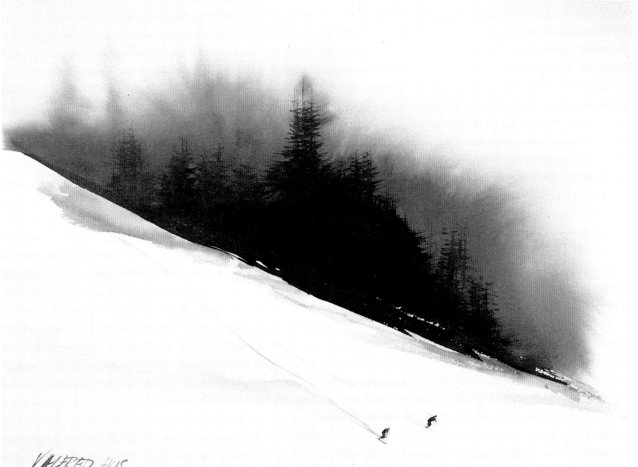

SNOW SKIERS, 11″ × 15″ (27.9 cm × 38.1 cm), collection of the artist

Then with a touch of red I painted the torsos of the skiers, and indicated their skis and legs with dark blue. The size of the figures helps define the expanse of the ski area, putting everything into perspective. I finished the painting by adding some shadow lines, some more trees, and my signature.

A More Complicated Drip

Once you've mastered the basics of the controlled drip, you're ready to experiment with more complex subject matter. When working on a complicated painting, I always start with a warm yellow, first light, then dark. The yellow on white paper seems to add a glow that reflects through the drips of additional colors and gives the painting a warm, even glaze. I am sure you will find, as I do, that a meditation process seems to occur when you're watching the pigments blend and explode as they slide from side to side across the paper.

As you continue experimenting, you'll find many different ways of using this technique. You can even combine it with plastic wrap, which you apply to the wet painted surface, as was done in *Low Tide*, page 11. Each weight of plastic wrap creates a different effect. Crinkled plastic gives you one kind of pattern, smooth another. In addition, you will find that the results you get vary according to the dampness of the paper and the length of time the plastic wrap stays on the painted surface.

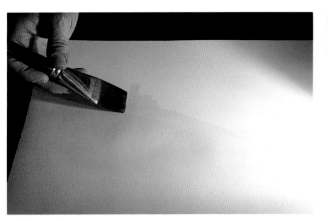

First I lay in a very wet wash of clear water, covering the area I want to flood with color and forming the initial silhouette at the top of the water line. Still using plain water, with a 1½″ flat brush I create the shapes of the lighthouse, building, and rocks; then I correct the lines with a #5 round brush to get a fine, straight edge. The paper is now very wet, with an even surface tension.

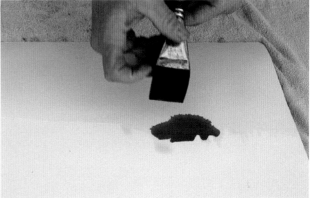

For the first color I mix up a large puddle of cadmium yellow and alizarin crimson, and fill my brush with it. With my index and middle fingers I slowly press the color out of the brush, letting it drop onto the surface at about the center of the picture area. Then I watch it spread and do its own thing.

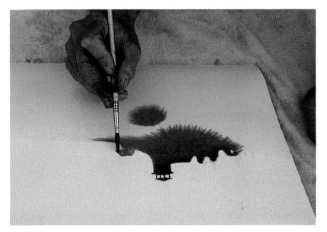

While the paint is still in motion, I sharpen some of the edges at the top of the paper with a #5 round brush.

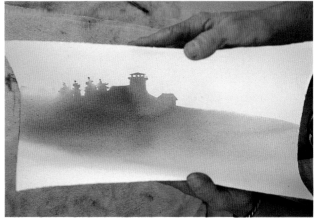

Now I pick up the paper and curve it to encourage the paint to flow away from the top, directing the color while allowing the pigment's granular quality to form a texture.

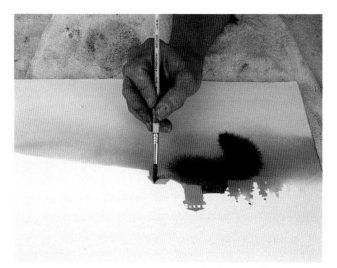

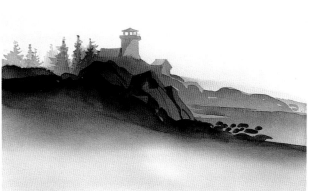

This is a repetition of the first step, only this time I am using alizarin crimson and Winsor red along the silhouette; I let the color run to the edge of the paper and drip the excess off.

You can continue this process as many times as you wish, each time getting the color in the foreground cooler and darker. Let part of every successive layer show.

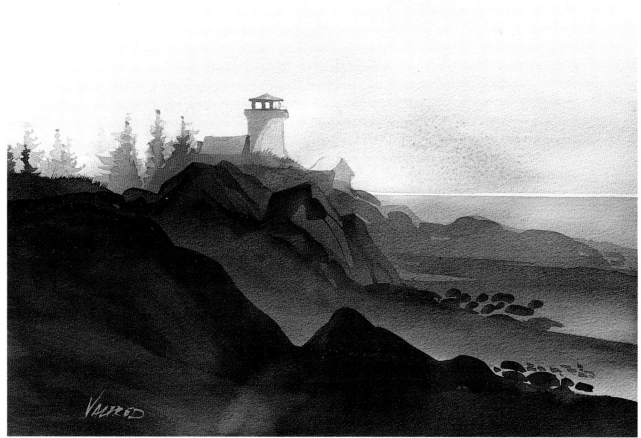

LIGHTHOUSE POINT, 11″ × 15″ (27.9 cm × 38.1 cm), collection of the artist

The last color I added was the cobalt blue of the sky and a wash of Winsor green to establish the horizon line in the background. In the finished painting you can see all the colors working with one another, the red glow of first light hitting the lighthouse and the stones reflecting in the tidewater area below.

Other Interpretations

"I always allow my subject matter to come to me; this painting," says the artist, "is the result of an extended visit to Alaska. To begin, I thoroughly wet a full sheet of paper and touched the brightest area with a brush loaded with Winsor red, sienna, and other reds. Then while it was very wet, I introduced into the dark area sap green mixed with bits of red, blue, and brown, which suggested trees behind the curved red forms. I then fine-tuned this area with smaller brushstrokes for textural and color variety. As the paper began to dry, I tipped it vertically so the paint would run as far as the drying edge. When I was satisfied with the hard-edged shapes, I laid it flat to dry completely. Next I popped out the light rocks at the top with midtone glazes, adding darker rocks behind them. The painting remained at this stage for several months; eventually I finished it by adding layers of red at the top to suggest mountains and sky."

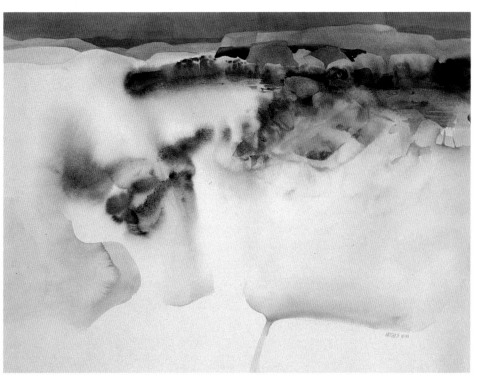

Barbara Nechis, **KENAI COAST**, 22″ × 30″ (55.9 cm × 76.2 cm), courtesy of the artist

Here is another example of a controlled drip painting, in which I achieved distance by putting down a series of horizontal bands of color of increasing width, building the darkest values in the foreground. I started with a Winsor red drip, allowing it to flow to the bottom of the paper, followed by alizarin crimson, Winsor blue, and more alizarin. Last I added yellow at the top to create the feeling of sunlight on mountains in the distance, and spattered in some pigment to suggest bushes.

SUNSET IN MONUMENT VALLEY, 15″ × 22″ (38.1 cm × 55.9 cm), collection of the artist

Dale Meyers, **WITH SILVER BELLS**, 26½″ × 34½″ (67.3 cm × 87.6 cm), courtesy of the artist

Dale's aim in this picture was to give the impression of fields of iris without making them look painted. She folded her paper accordion-style, sprayed it lightly with water, and dipped the edges into a soft gray-green paint. When the paper was dry she unfolded it and added blue, purple, and tan undertones, then mounted the painting on heavy museum board. When it had again dried, she dropped spots of color on the paper and added clear water to make them bleed and form petal-like edges. The flower centers and a few sharp spikes were added last. "The most difficult part," she said, "was getting the effect I wanted while using as little definition as possible, since I believed that too much delineation would negate the seeming spontaneity."

Practice Exercises

1. Lay out your palette.
2. Practice brushstrokes to become familiar with your brushes. The brush is an extension of yourself.
3. Play with several color combinations and watch how they work together. Colors are an extension of your feelings.
4. Do a simple controlled drip using a very limited palette, as seen in the demonstration on pages 14–15.
5. Attempt a completed drip painting, running pigment into selected areas to form buildings, flowers, boats, or other subjects.

2
SKIES

As you saw in the previous chapter, watercolor has a mind of its own, but will work for you if you meet it halfway. This interaction with the medium is important: No result in watercolor lacks a cause, and if you understand the cause, you no longer have an experiment but a skill you can apply to painting specific subjects that will express what you want them to.

The sky is one of nature's most dramatic continuing events. And because it is a major element of almost any landscape composition, the sky is a perfect place in a painting to let the medium do the work.

I am sure that like me, you have lain on a hillside on a summer afternoon picking out strange dragons, cats, polar bears, or little old men growing out of the thunderheads or noticed how many shapes and colors clouds come in—tall, bottom-heavy cumulonimbus forms shaded warm brown; high cirrus

clouds that are no more than wisps in the sky; or threatening storm clouds. You don't need to know their names to be familiar with the moods they can create.

The sky should be an integral part of a painting, not a unit unto itself. When a sky dominates a painting, it needs to have a beautiful, active surface that will occupy the space in an exciting way. If it is a minor part of the painting, it must direct your eye back into the picture and not compete with the other compositional elements.

Your ability to create depends on the level of your ideas, and these are connected to your observations of nature. That's why it's necessary to stretch out on the grass and study the patterns, colors, and values of the sky at different times of day and under different atmospheric conditions.

When rendering dramatic skies, I prefer rough-textured Strathmore watercolor paper mounted on #112

or 110 Crescent board, but for softer ones I use Arches 140-lb. paper. Before I begin a painting, I always put masking tape or painter's tape, available at any hardware or paint store, around all four edges of the board. I use the 2″ or #2 width because it masks off the paper into a format that fits a standard frame size. The tape gives me a surface on which to test my brush and supplies me with an instant mat when it is removed. Wait for the painting to become completely dry before you remove the tape; if you pull it too soon, you are likely to lift the paper. As a precaution, always pull the tape at a forty-five-degree angle. Additional tools you'll need to follow the demonstrations in this chapter are a single-edge razor blade (be sure to get the more flexible kind found in drugstores) and a 2″ sponge brush that you can find in hardware stores and can cut into any shape or size.

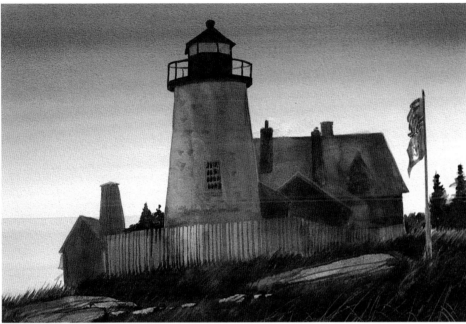

I made this painting using a series of glazes, allowing the pigment to move slowly from top to bottom. After the sky was completely dry, I laid in the foreground with Winsor blue, warm sepia, and cadmium orange. When this was dry, I put a light glaze over the entire picture to pull it together. The rocks and stones were scraped in with a razor blade.

PEMAQUID POINT, 16″ × 20″ (40.6 cm × 50.8 cm), collection of the artist

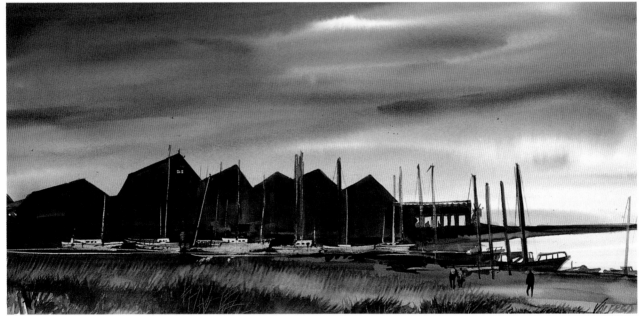

FISHERMAN'S VILLAGE, 45″ × 25″ (114.3 cm × 63.5 cm), Charlotte County Art Guild, Punta Gorda, Florida

Starting with a dry board, I painted Winsor blue in the sky area and blended in a little alizarin crimson, progressing into Winsor red and cadmium yellow. I had to keep the paint moving on the surface to avoid creating spots. I let the painting dry completely, then added the building shapes in Winsor blue, alizarin crimson, and warm sepia, scraping out details with a razor blade.

Overcast and Stormy Skies

The simplest sky is an overcast one that's just plain white; however, even when this is the case, I prefer to put in some gradation. Whenever you are working with a plain, bright blue or gray sky, it is important to have an interesting, strong foreground to offset it.

Start with a dark wash at the top of the paper and lighten it by adding more water as you move toward the bottom, blending the sky over the entire painting surface. This makes it possible for reflections of sky to show through later in other parts of the painting. If you want to accent the angle of light, you can add just a touch of color in the top corner of the paper.

Quite often I paint my skies only after I have an idea of what the foreground is going to look like.

However, if the sky is dramatic like the stormy one shown here and on the previous page, I paint it in first.

As you look at a stormy sky, study the changing colors and values in it as the clouds move along and block out the sun. Ask yourself what colors it is—a turmoil of violet and earth tones, perhaps, or a bottom-of-the-pot gray?

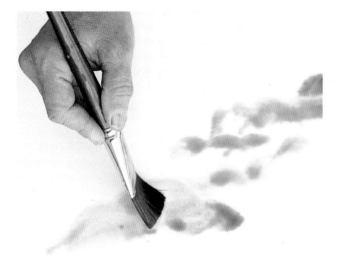

I began this painting by putting down a very wet wash with cobalt blue, being sure to leave a lot of the white paper surface showing through.

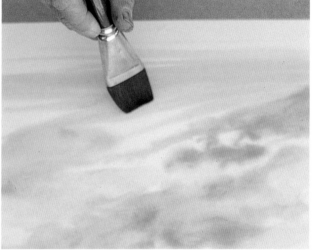

I came back into the wet wash with cadmium orange and warm sepia, and placed shadows on what would become the dominant cloud formation. I then added the foreground.

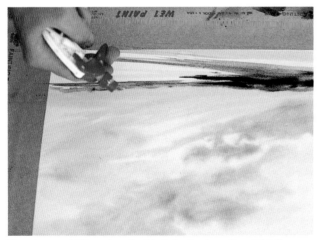

To set my middle value, I added the horizon line. Holding an atomizer 18″ (45.7 cm) from the surface, I sprayed my semidry painting lightly with water to create white spotting. You can use an empty atomizer left over from some household product as long as you wash it thoroughly first. To get larger white spots, I spatter water with my brush. This works best on a surface of Winsor blue or cobalt blue.

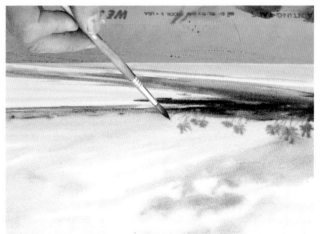

With a #5 round brush I added trees to the horizon.

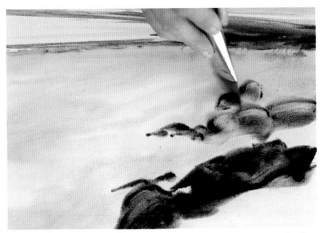

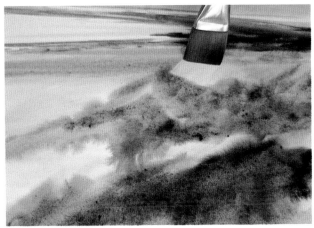

To turn the summer sky into a stormy one and make it look as if it was going to rain, I wet the painting surface one more time, working very evenly so as not to disturb the underpainting. I then added a mixture of Winsor blue, cadmium orange, and warm sepia to get a nice gray.

Aiming for the full dramatic look of an impending thunderstorm or tornado, I added a touch of Hooker's green dark and alizarin crimson. While the painting was still wet, I took a semidry 1½″ flat brush and pulled down through the stormy area to suggest streaks of rain in the distance.

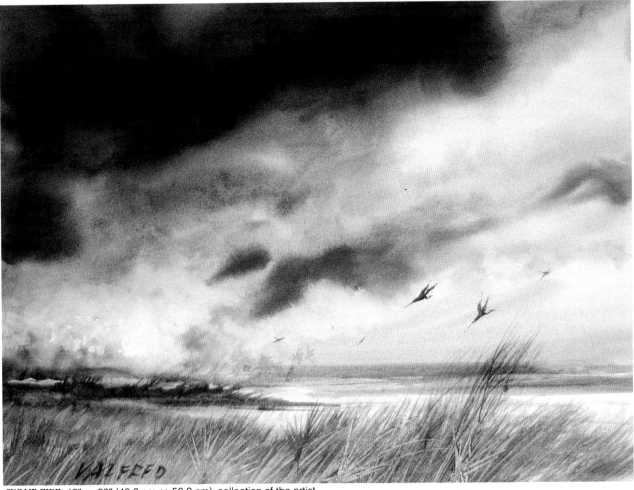

SWAMP FIRE, 16″ × 20″ (40.6 cm × 50.8 cm), collection of the artist

I finished the painting by adding some grasses in the foreground and a few seagulls flying overhead; their natural patterns among the clouds make a design that helps carry your eye through the composition.

Sunsets

The next time you see a setting sun, look at the foreground as well as at the sky itself; the silhouettes formed are made of not just black, but of many different colors, as seen in *Fisherman's Wharf*.

The secret of painting a successful sunset is to blend alizarin crimson with the blues, reds, oranges, and yellows you use. As the crimson blends into the blues, beautiful purples and mauves develop, and as it blends with yellows and oranges, beautiful reds develop.

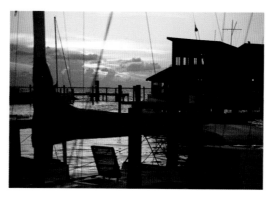

Here is a photo of the sun setting behind the fishing wharf that inspired the painting for this demonstration. When working with this type of very colorful sky, I like to use it as the background and paint a silhouette against it.

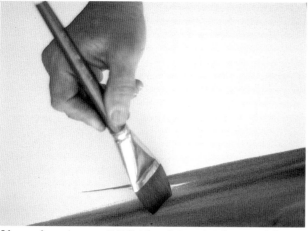

I began by using my 1½″ flat brush to paint the top of the paper with Winsor blue.

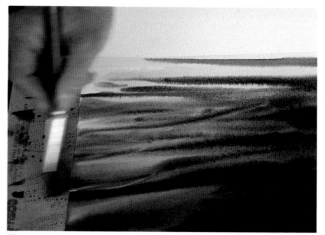

Then, working downward, I added alizarin crimson, blending to Winsor red and placing cadmium orange along the horizon line. Taking a damp brush, I encouraged the pigment to move in a specific direction, softening the cloud formations.

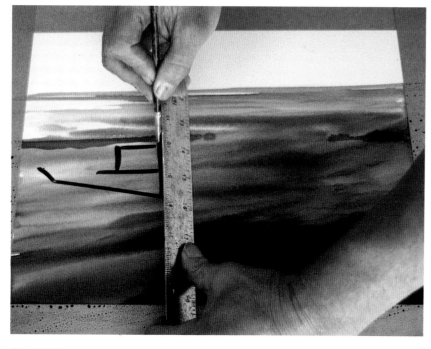

I suggested the main cloud shapes with a gray made of Winsor blue and warm sepia. Wherever I needed a straight line I used a ruler, holding it at an angle and placing the ferrule of my #5 round brush against it. You may prefer to draw lightly with pencil here instead of using just the gray watercolor.

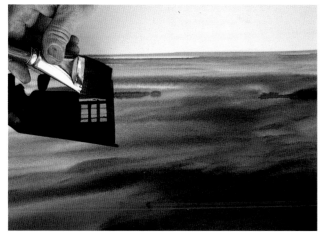

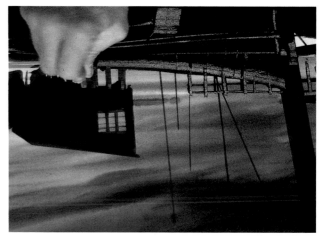

With my 1½″ flat brush I painted in the main wharf structures, using a mixture of Winsor blue, alizarin crimson, and warm sepia.

I then scraped out the highlights with a razor blade, using a squeegee motion, and I finished the details with my #5 round brush.

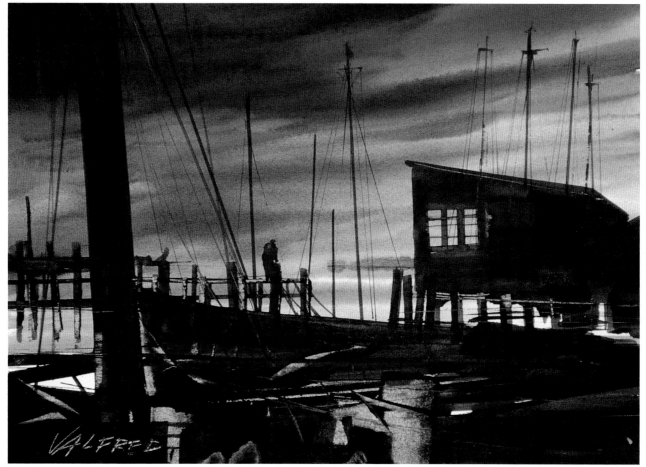

FISHERMAN'S WHARF, 16″ × 20″ (40.6 cm × 50.8 cm), collection of the artist

Ideas for Design

When a sky becomes the most important part of a painting, you have to become involved in the problems of designing some of the cloud formations and decide how you are going to solve them. For example, the sky must fit with the foreground composition so that it carries your eye into the picture and back to the foreground subject.

As a rule, foreground darks tend to come forward, overpowering and pushing out background color. Consequently, it is necessary to establish "signposts," compositional patterns or passages that will direct your attention to a specific area in a picture and give the overall work scale, as the strong diagonal furrows do in *Distant Thunder*, page 29.

When the sky is going to be an important part of a composition, you have to choose whether to use it as background or foreground. The painter Hans Hofmann had a simple exercise to help clarify how a subject can be changed from background to foreground. He would pour and splatter black ink onto a blank piece of paper, then would place a red dot in the empty space above the splatter (below left), where it looked as though it was in the background. When he turned the paper upside down, the red dot appeared to be in the foreground (below right). Try it!

Shapes push and pull against one another—some dominate in the picture plane, others retreat, just as colors do in the ways I mentioned in the previous chapter. Remember: Warm colors move forward, cool colors recede.

As you become involved in studying skies, paint a variety of small examples and set them aside for a day or two before you add the foregrounds. I always allow a painting to become completely dry before I add my foreground. I prefer not to use a hair dryer to speed the process along because it moves the pigment—unless, of course, I want this to happen, in which case it's an excellent device. When the painting is pretty close to being finished, I add my subject matter to the foreground—boats, harbors, buildings, trees, and so forth, giving the picture dimension and interest; details like birds, animals, and figures lying on a beach or sitting on a rock or pier further animate the scene.

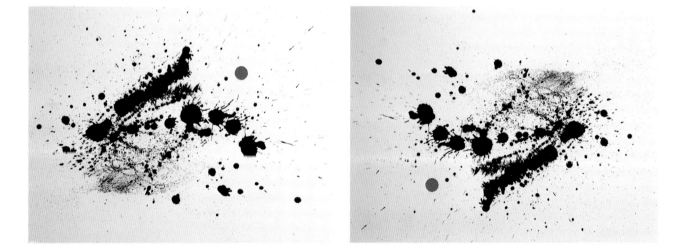

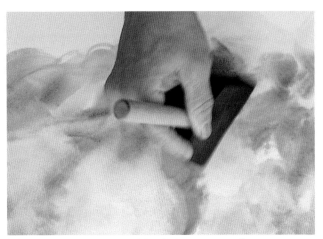

In this painting I wanted a soft sky, so I began with a damp board and brushed on some cobalt blue, letting the cloud forms take their own direction.

Then I considered some of the design aspects of my composition. With a sponge-rubber brush, I moved the pigment around until I felt the mood and atmosphere of a summer sky.

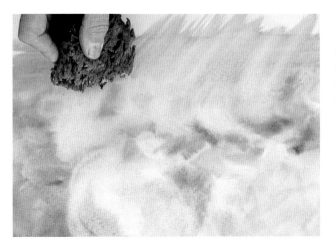

I wanted to develop some puffy clouds as part of the overall design. To do this you can simply leave areas of the paper's surface white, or blend and lift out color with a 1½″ flat brush. You can also use tissue to lift color, but it tends to leave a hard edge. Varying the lifting technique, in this painting I used an elephant-ear sponge to bring down rain patterns that would relate my sky to the foreground.

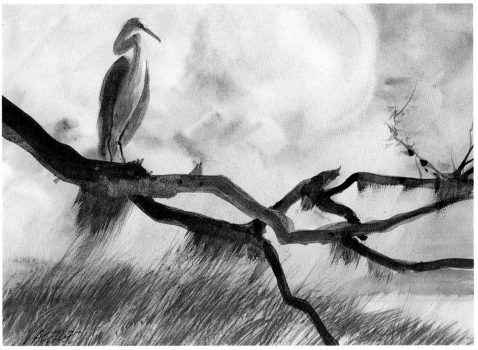

Adding the foreground, I established perspective, placing warm colors against cool colors, lights against darks, and soft edges against hard edges for compositional variety. The diagonal lines in the grass and Spanish moss not only provide a sense of movement but also lead the eye into the background, back along the tree branch, and toward the subject of the painting, the heron.

RESTING PLACE, 16″ × 20″ (40.6 cm × 50.8 cm), collection of the artist

Using Contrasts

An important rule to remember is to use a light foreground with a stormy sky, and a dark foreground with a bright, brilliant sky. Think about placing warm colors—the reds and yellows—against cool blues and greens to enhance an area. Use light colors against dark ones or dark against light, as well as soft against hard edges to create dramatic contrasts that will make your paintings visually exciting.

Don't let what you think of as typical sky colors limit your palette. There are the green skies of tornadoes, the mauve of an early morning haze, and the enveloping gray of a foggy sky that gives everything a dreamy feeling.

For this demonstration I began with a dry board and laid in Winsor blue. While the paint was still wet, I added alizarin crimson, which gave me a lovely mauve.

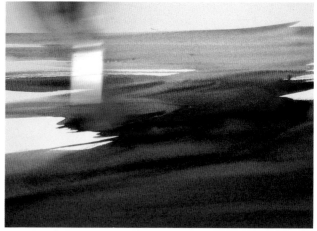

Next I added cadmium yellow and blended it into the alizarin to obtain an orange, then carried the yellow all the way down to the horizon line.

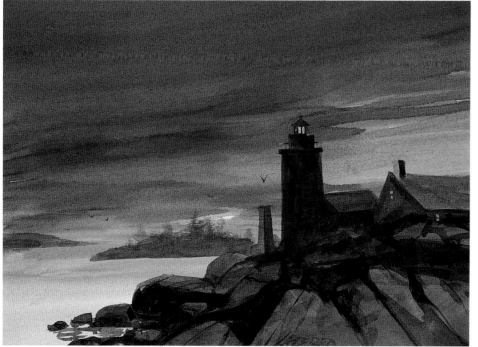

BASS LIGHTHOUSE, 16″ × 20″ (40.6 cm × 50.8 cm), private collection, Ohio

Finally, after the sky had dried, I added the silhouette of the lighthouse, using a mixture of Winsor blue, alizarin crimson, and warm sepia. With a razor blade I scraped out the rocks.

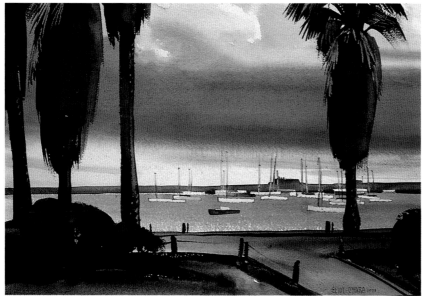

This painting is an excellent example of a stormy sky made striking by the use of strong contrasts. Note how the heavy, grayish-purple storm clouds are offset by areas of the paper left white to keep light in the picture, and how their soft forms stand out against the hard edges of the horizon line and the land in the foreground. Note, too, how strong vertical elements—the palm trees—contrast with and balance the dominant horizontals.

Eliot O'Hara, **SARASOTA HARBOR**, 22″ × 28″ (55.9 cm × 71.1 cm), collection of Valfred Thëlin

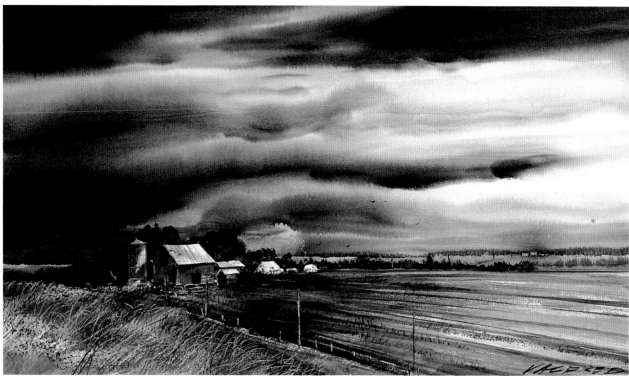

DISTANT THUNDER, 20″ × 30″ (50.8 cm × 76.2 cm), private collection, Indiana

This painting depicts a storm approaching an Indiana farm while the sunlight still shines on the fields. The sky, a combination of bright light and dark, ominous clouds, was painted in wet-on-wet two-thirds of the way down the surface; the bottom third was left very dry, since this would become the solid ground in contrast with the softer sky. While the top was drying, I put bright yellows and oranges across the foreground and created furrows in the fields with a comb. Just before the painting was completely dry, I used a razor blade to scratch in the lightning bolts behind the barn.

Haze and Fog

Painting a fog not only results in a lovely piece of work but also offers practice in achieving subtle value relations, an important aspect of the painter's craft. When I want to create a simple haze or fog effect, first I moisten my entire surface with a spray of water. While the surface is still damp, I paint objects in the distance in a light-value tone, working slowly toward the foreground as the paint dries. When the painting is completely dry, I add the foreground objects.

In addition to fog's inherent beauty, this common atmospheric condition is a means for reducing the complexity of a picture that has gotten a little bit out of hand; in muting all the details, a haze can unify disparate parts of a composition. The best way to capture a fog in this manner is to use staining colors like Winsor blue, alizarin crimson, cadmium orange, Winsor red, and warm sepia, and then rub off the pigment with a damp terry towel. Just enough color will remain to create the mistiness you're after. Other colors stain but not so intensely as the ones I've mentioned here; try painting swatches of color and wiping them off after they dry to discover which pigments will suit your purpose.

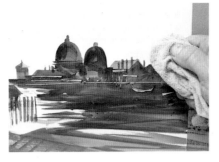

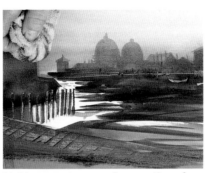

Making sure to use a clean section of damp towel for each area I worked on, I continued to wipe off paint, leaving a hazy silhouette behind. I moved from top to bottom, turning the towel over and around so as not to pull too much pigment down.

In this picture of Venice I used staining pigments—here, phthalo blue and alizarin crimson—and let them dry completely before attempting to create the atmospheric effects I wanted. Then with a terry cloth towel moistened in water, I began to wipe off the upper layers of colors, starting with the background.

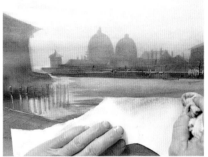

I used a paper stencil to protect the parts of the foreground I didn't want to lose.

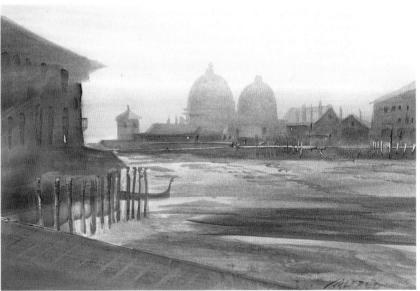

VENICE, 16″ × 20″ (40.6 cm × 50.8 cm), collection of the artist

Finally, I sharpened a few details and highlights in the middle ground, making clean, crisp strokes with a #5 round and a 1″ flat brush.

Another Interpretation

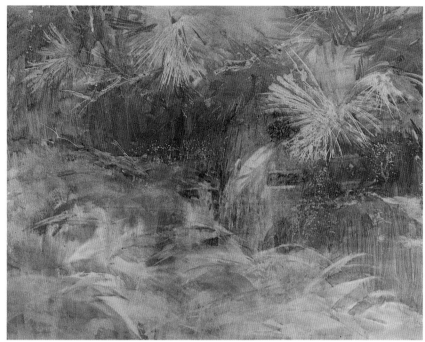

Ruth Wynn, MAINE'S MISTY MORNING, 28″ × 32″ (71.1 cm × 81.3 cm),
courtesy of the artist

Practice Exercises

1. Take time to look at the skies at different times of day and observe the various shapes and colors of the cloud formations. Make mental notes or sketches.

2. When a dramatic sky such as a sunset is overwhelming, pay attention to how the foreground looks. Make thumbnail sketches of the foreground elements, then simplify them in your paintings.

3. Experiment with pigments to see what they do. Set up several 8″ × 10″ (20.3 cm × 25.4 cm) pieces of watercolor board and apply different colors, some wet-in-wet, others on a dry surface, and watch how they move back and forth with one another.

4. Paint different skies and coordinate various foregrounds with them.

5. Try the wipe-out technique to create a fog in a painting that did not work out too well. See what areas you can make soft and what areas you can leave hard, what will remain part of the original painting and what you can create anew.

6. Try different paper stocks and boards to see what effects their various surfaces bring to your skies. Start with #110 and 112 Crescent board and Arches 140-lb. paper. It never hurts to experiment and look for things that will appeal to you.

The artist began the underpainting by laying raw sienna on the top third of the picture surface, washing it down to a mixture of cobalt blue and ultramarine blue. She then defined some pine branches against this ground. A second wash, thickened with burnt umber to the consistency of thin acrylic, was applied thinly at the top and more heavily under the tree branches. Next, Ruth sprayed the painting with an atomizer so the wash would run over and mix with the cool light blues of the pine needles. Under the tree she brushed the wash up and down until it had the appearance of a watercolor gone dry and dull. When the painting was completely dry, she sprayed it overall, then used a 3″ foam brush to pull the pines back to the underlying wash, scraping the needles out with the brush handle. Using a large watercolor brush, she wiped out the foreground. The first wash of ultramarine blue had stained the bristol board and left a blue haze that was thus revealed and provided the misty atmosphere the artist was after. Once the areas under the branches were dry, Ruth gave them a short spray of water and wiped downward with a ragged towel to create the feeling of falling dew. "My plan," says the artist, "was to reverse nature's coloration by using blues on the land and brown overhead. The picture reads from left to right, starting from the dark area under the branches and fading out to the highlighted boughs, the dew falling off them bringing the eye back to the ground and the mist rising from it."

3
FOUND MATERIALS

Finding forms your medium creates on the painting surface is one aspect of working freely; another is finding unusual tools to create texture and design within your painting. These tools and the way they can be used are as varied as your imagination will allow.

The most important thing to consider as you apply these tools to your painting is not to let any particular technique be obvious in your work. If someone comments on your "beautiful razor-blade painting," you blew it. You must always integrate technique with overall content.

Keep an eye out constantly for patterns and forms that you may be able to achieve with the tools you now use or with new tools. In hardware stores, junk shops, the kitchen, or in the field itself, I find many tools comparable to what can be purchased in art supply stores and am always seeking new products on the market to try. I enjoy discovering ways to use them in my work and the various effects they will create, and thus I encourage my students to experiment and improvise with both manufactured and natural materials.

When sketching in the field, I often begin with only a knife, sketch pad, and India ink, and when painting, I usually work on #112 Crescent board cut into 8″ × 10″ (20.3 cm × 25.4 cm) and 16″ × 20″ (40.6 cm × 50.8 cm) pieces that can easily be carried in my bag. Then I collect grasses, twigs, and other natural items to use as drawing and painting implements, sometimes chewing the ends of twigs as the Indians did to create brushes. I might even use pieces of shell or leaves to paint with instead of a brush. I constantly use my fingernails and hands to create tex-

tures or move paint around and have discovered that fingernails are particularly good for suggesting grass. The English painter Joseph Mallord William Turner used to cut his to a point for that purpose, although I find this isn't necessary.

You can have fun working with any of these tools if you don't fight them; let them work for you. Try to think of any item you collect in the field or at home with creative intuitiveness. How can it be applied to the watercolor medium and its surfaces? Ask yourself, "What if . . . ?"

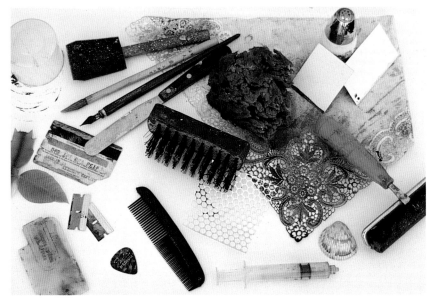

Here are some unconventional but useful found materials, a few of which I've used in the demonstrations in this chapter.

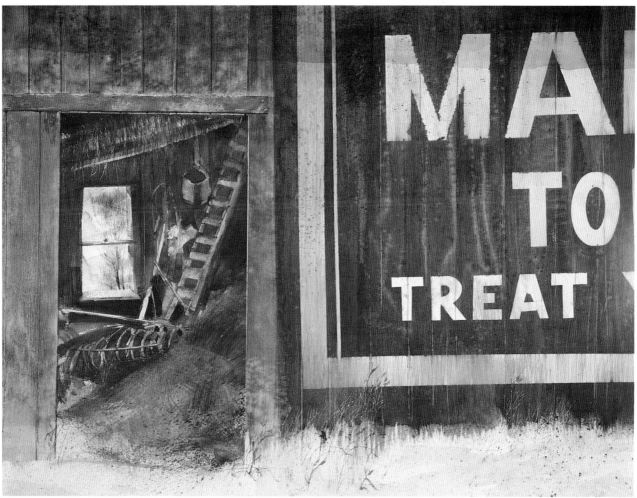

BARNSIDE, 38″ × 48″ (96.5 cm × 121.9 cm), private collection, New Jersey

In making this painting I used several different techniques based on found materials. These included paper tape and a rag to mask certain areas while I worked on others, notably the lettering on the side of the barn; a razor blade to scrape in the farm equipment, ladder, buckets, and other details; a wire brush to create the wood's texture; and my fingernails to scratch in the hay on the barn floor. To develop the texture of the barn walls, I handprinted the surface, spattered it with water, handprinted it a second time, and then when it was dry, pulled a wire brush over it. When the painting was completely dry, I added a light gray wash to accent the texture created by the wire brush. I formed the grass growing up against the barn and the snow blowing in the foreground by pulling the wire brush down from the painted surface into the part of the paper left white and adding a bit of white spatter.

Exploring Diverse Textures

Grasses swaying in the breeze and giving the impression of moving water excite me. There are various ways to suggest grass; the effects you want and the way you achieve them should work in relationship to the whole painting. The best, most direct approach is to be bold and attack the thought of the substance, creating it on the painting surface as if you are actually running your hands through it.

To depict grass I choose colors according to season. For spring and summer scenes I begin with an underpainting of bright green and paint a dark green over it; for fall and winter scenes I use cadmium yellow underneath warm sepia. Then while the painting is still damp but not wet, I scratch it with my fingernails, using both hands freely to suggest the grass blowing in the breeze.

Other readily available scratching tools that you can use to develop a variety of textures are wire brushes and scrub brushes. I particularly like to use them when I am painting the texture of tree bark, pine needles, or weathered old wood. Combs are similarly useful.

Another technique is to use the pressure of your hand to imitate such textures as tree bark, weed clusters, bushes, animal skins, and feathers. Using your hand to remove excess pigment and water, you can make a pattern with it; the results depend largely on how damp the paper is. When you employ this technique, be careful not to carry the color you pick up on your hand to a new surface.

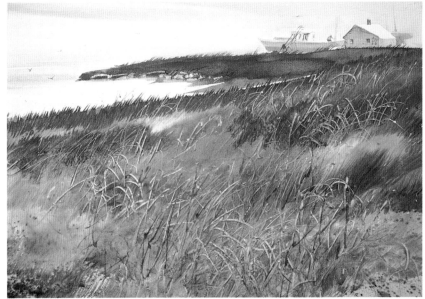

KERN'S POINT, 20″ × 30″ (50.8 cm × 76.2 cm), private collection, Wells, Maine

I have painted this scene many times in many different moods; here I've tried to capture the graceful sweep of the land and the gentle movement of the grasses in an S-shaped composition. The field, many subtle shades of brown and yellow, gains depth and a variety of textures when I scratch into the paint to create the impression of sunlight striking the blades of grass.

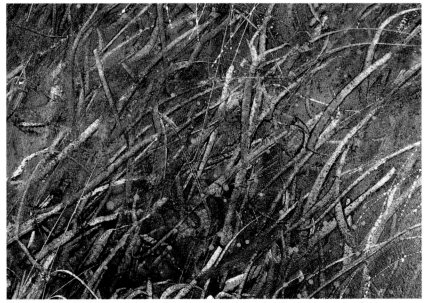

Close-up detail of *Kern's Point* showing the bold and delicate textures of grasses created by fingernail scratching.

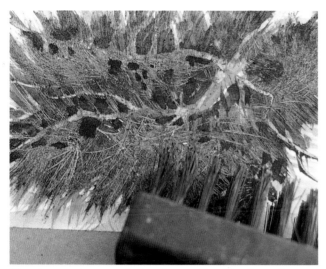

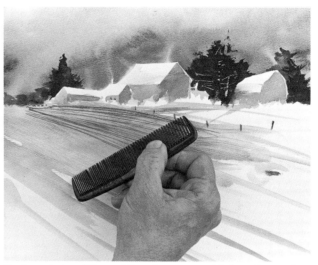

Here is a good way to depict pine needles. First I put down the design with brilliant green and scraped in the main branch and limbs with a razor blade. When it was dry, I laid on a coat of Hooker's green dark and cobalt blue, letting the original design show through. Then while the surface was still very wet, I took a wire brush and scraped through the painting to create the pine needles, all the time thinking about their texture.

In the painting *Distant Thunder* on page 29, I used a comb on the damp foreground to indicate furrowed fields, as shown here. You will find that a comb is uniquely suited to creating such striations anywhere you need them.

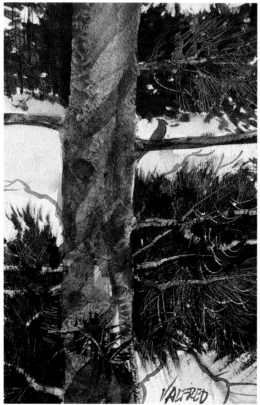

Next I added Hooker's green dark in the background, scraping it with a wire brush to imitate pine needles. I then placed shadows across the tree limbs and added a red spot for the cardinal.

Handprinting is an excellent way to bring texture into a painting. Here, in the first step, I washed in the tree, then used my hand against the damp surface to suggest bark.

RED BIRD, 8″ × 10″ (20.3 cm × 25.4 cm), private collection

Scratching In Grass

In the next step I picked up warm sepia and Hooker's green dark on different areas of a mutilated #12 red sable round brush and scattered the color throughout the tree area. With a razor blade I cut out the shapes of the trees, including limbs and branches.

For this painting I began with a light pencil drawing of the boat, then added the gray of the sky with a mixture of warm sepia and Winsor blue. While this was drying I painted in the foreground with cadmium yellow, allowing some of the white of the paper to show through for sparkle. I also used a light spatter at the bottom of the painting.

Painting negatively, I took a wash of alizarin and Indian red across the stern of the boat and around the letters of its name. Practice this technique with the alphabet, painting around the letters rather than the letters themselves. Negative spaces like these can be interesting and useful in a number of spots in your painting; in addition to making signs, you can outline figures, buildings, and other forms. I favor this technique in my own work for depicting fenceposts and lobster pots.

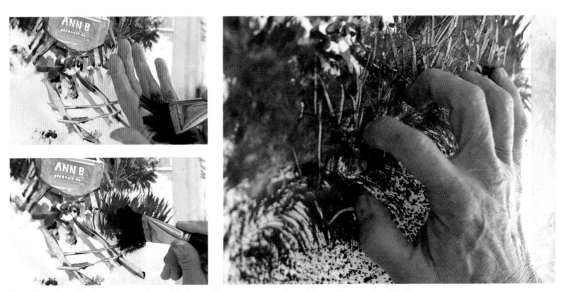

I made a handprint across the still-damp boat to suggest peeling paint and added the wooden rails below. Using a 1½″ mutilated flat brush, I painted in a foreground with warm sepia. Then I clawed it with my fingernails to create grass.

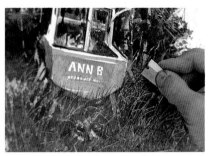

Next I added highlights with a razor blade.

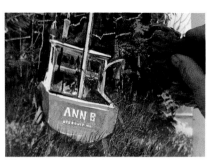

Using a sponge, I placed dark areas under the pines and then added some orange to the trees to suggest dead needles and autumn leaves.

Finally, with a #5 round brush I directed spatter across the foreground. Then, to pull the painting together, I washed a shadow of alizarin crimson, Winsor blue, and a touch of warm sepia over the entire surface.

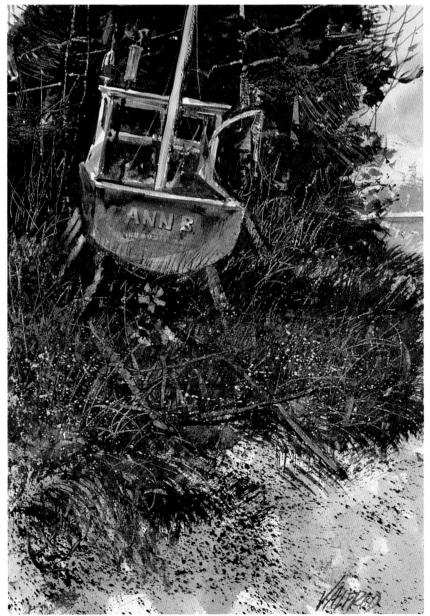

ANN B, 16″ × 20″ (40.6 cm × 50.8 cm), collection of the artist

Creating Wood Textures

Texture, color, grain, and age give wood its character, which you should aim to capture in your painting to provide interest. Handprints, wire brushes, razor blades, and palette knives are all useful tools for achieving such effects.

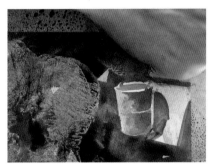

In the first step I established the details of the bucket and the light forms reflecting on the wall behind it. Then I painted a watery warm sepia over the entire area and added hand texture, being sure to dry my hand after each application.

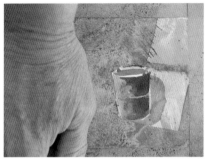

After this had dried, I added a little heavier wash of warm sepia and Winsor blue, allowing the light from the window to shine on the bucket. Once more I used a handprint to create texture.

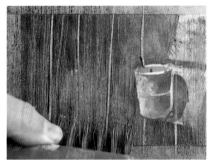

While the painting was still damp, I scraped straight down through the wall's surface with a wire brush to give the wood texture. You can bend and twist the wire brush to vary the texture as you wish. To suggest batten boards, I used a razor blade; a palette knife would also suit this purpose.

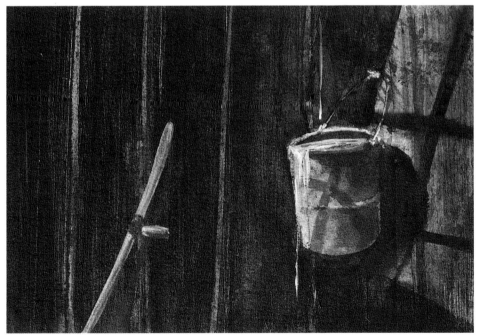

The scythe handle was added for design, while the water dripping into the bucket and down its side animates the painting. The cast shadows on the wall add depth.

Stenciling

Various materials can be used as stencils to add design and pattern to your work. These include perforated florist's ribbon and lace doilies. You can also cut paper stencils to mask areas you want to preserve in a painting or to surround areas where you want to lift color to bring back a lost white.

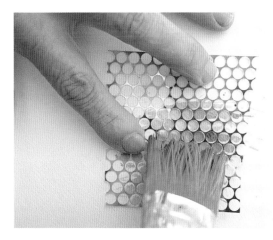

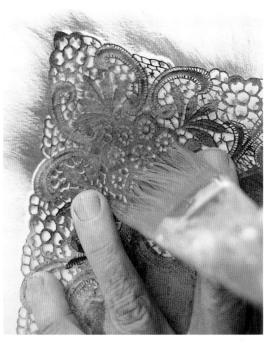

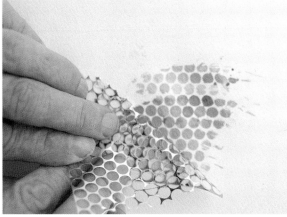

Here I simply laid a piece of perforated florist's ribbon on my painting surface and washed across it with color, then lifted it off to get a positive pattern. You can also lay it on an already painted surface and lift out color with a damp sponge to get the pattern in negative. This device is great for depicting industrial sites, boat marinas, and floral or abstract designs.

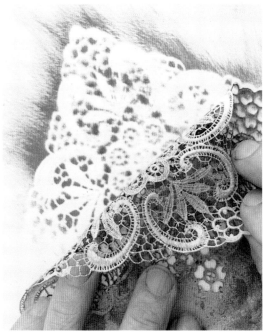

If you want to stencil with a doily, follow the same procedure. Doilies can be used to soften edges or to suggest lace curtains.

Masking Areas

Masking out areas with various materials is one way of maintaining the original white ground of your painting surface. Personally I prefer to paint around such spaces, treating them as negative areas rather than covering them up for protection, but when I find it necessary to use a masking technique, I choose between masking tape or a wax medium such as crayon, candles, paraffin, or wax paper.

Of all possible ways to cover an area I want to preserve in a painting, masking tape is my favorite. I use it to mask around rocks, trees, and overlapping white areas like boat bows and masts. I also use tape to create a specific design by applying it in patterns, putting it down and picking it up again and repeating the process to make a series of transparent lines and hard edges, as the demonstration shows.

Wax resists may be spread over wide areas of white paper or over a base color. In this demonstration I used wax to create the twigs. Wax paper provides a good resist; place it over your painting surface before you start to paint, then sketch trees, twigs, highlights, or whatever drawing you want to stay white on the paper throughout the painting. To remove the wax from an area, lay a paper towel over it and press with a warm iron.

I also find that Vaseline (petroleum jelly) works as a resist to create rock effects; it does not stain and evaporates afterward. The insect-repellent spray Off, another unusual material to try, creates a spattering effect that lends itself well to beach and rock textures. To get a specific result, apply it in a series of patterns.

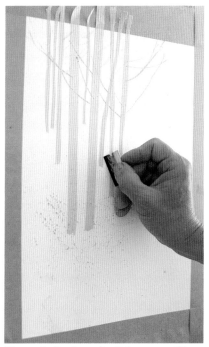

To create the trees for this composition, first I placed a strip of draftsman's tape on the surface of the board (it comes off more easily than masking tape). I then took a razor blade and cut through the tape, giving irregular edges to the tree trunks. The piece I removed was used for another tree.

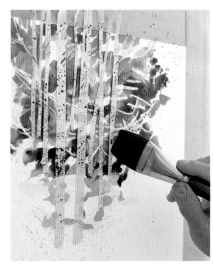

Next I washed on a series of fall colors, placing darks at the bottom and lights at the top.

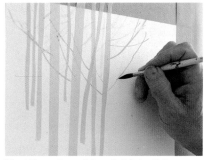

Next I used masking fluid, in this case Moon Mask, as a resist to maintain the whites.

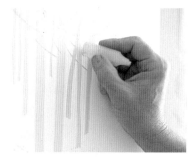

With a wax candle, I drew in the limbs of the trees. Sometimes when I want a very fine line I lay wax paper over the surface and draw on it. Wax may be added at any time to protect a color from additional washes.

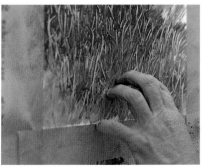

I used a razor blade to highlight the rocks and to suggest a stone wall behind the trees. In the foreground, which I had underpainted with new gamboge and Winsor green and covered with Hooker's green, I used my fingernails to scratch in grass, using larger strokes in front and smaller ones in the distance.

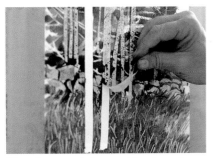 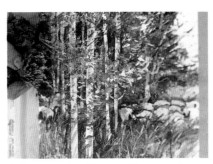 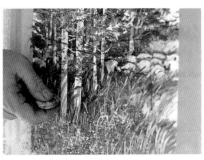

Next I removed the masking tape from the trees, working very slowly to avoid tearing the surface of the paper. If necessary, you can use a hobby knife to lift it.

After removing the masking tape, I added a bit of soap to my pigment so the paint would cover the wax surface. Then I dipped a sponge into the prepared colors and developed leaf patterns over the birch tree trunks.

To finish, I washed a soft mauve mixture of cobalt violet and Winsor blue over the background trees to push them back into the distance. Finally, I applied a rubber cement pickup to lift out the masking fluid I had used in an earlier stage.

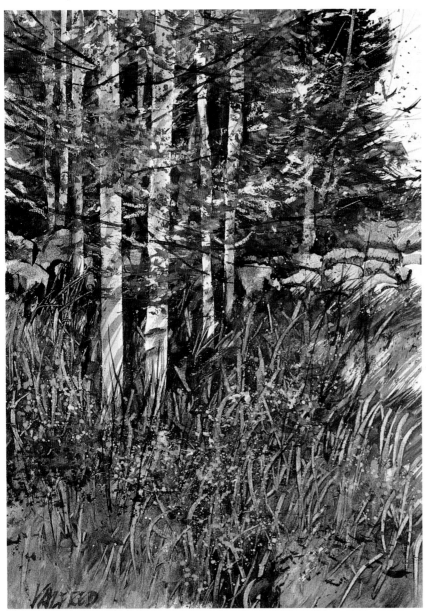

BIRCH TREES, 16″ × 20″ (40.6 cm × 50.8 cm), collection of the artist

Other Interpretations

In this painting the tree trunks in the forest were scraped out with a razor blade, the foreground was cut into with a palette knife to suggest movement, and the textured weeds and grass were created with plain table salt. You can also use kosher or coarse sea salt; dropped onto a semidry area of your painting, it will absorb the color and leave a beautiful white spattered pattern. The coarser the salt, the more dramatic the results. This technique can be very effective when you are painting flowers or rocks, and works best with cobalt blue and the earth tones. It's sometimes advisable when you can to use water spray instead of salt, as salt seems to cling to a surface for days, and over the years tends to yellow rag papers.

Maxine Masterfield is known for working with found materials. "I do not like to impose my will on the paper," the artist says of her work, "but prefer to let nature interact with my materials and leave its own mark." Here she has used sand. "Down at the water's edge," she explained, "I sprinkled sand over a dry piece of stretched watercolor paper. Then I watched as the water moved over the paper and sand, creating various forms. When I was pleased with the evolving pattern, I moved the paper away from the water's edge and laid it out in the sun to dry. When it was almost dry, I sprayed various hues of liquid watercolor over the surface and placed halves of nautilus shells on it, leaving them there until the paper was dry the next day. Then I removed them and brushed the sand off; impressions of the shells and the patterns created by the tide's movement remained."

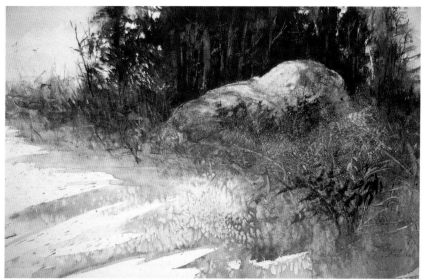

Patricia Burlin, **NEW ZEALAND GLADE**, 15″ × 25″ (38.1 cm × 63.5 cm), private collection

Maxine Masterfield, **LIGHT OF THE SEA**, 44″ × 44″ (111.8 cm × 111.8 cm), courtesy of the artist

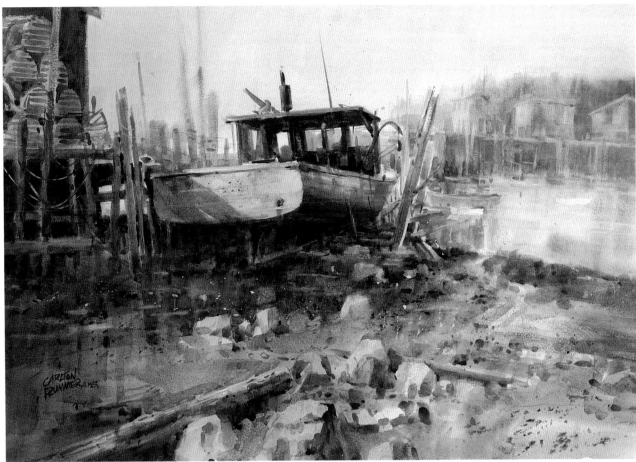

Carlton Plummer, **PORT CLYDE**, 30″ × 40″ (76.2 cm × 101.6 cm), courtesy of the artist

Another artist who uses a variety of found materials in his work is Carlton Plummer. "Based on a color thumbnail sketch I did on location," he says of his award-winning work, "this painting was created in the studio with very little pencil drawing. I mostly painted wet into wet to create the illusion of space, light, and atmosphere. Dark and light contrasts create diagonal movement that forces the eye to move around the composition in a zigzag manner. The strong contrast on the stern of the boat acts as a focal point that stands out against the muted tones of the misty background. To add textural effects, I used spatter and scraped and lifted paint while my surface was still damp. For the rock forms, I used a credit card and a razor blade, and for many of the fine lines I used a palette knife and the end of my brush handle."

Practice Exercises

1. Find different tools that you can use in your painting to create lines and forms: wire brushes, scrapers, razor blades, palette knives, and so forth.
2. Try depicting grass in a painting by scratching it in with your fingernails.
3. Experiment with your handprint to create textures.
4. Apply salt on samples of many different colors and let them dry completely. See what effects you get.
5. Experiment with a variety of resists: masking tape, rubber cement, petroleum jelly, candle wax, crayons, and wax paper. Some resist paint better than others; you need to be aware of each one's capability so you can get the results you desire.

4
TREES AND FOLIAGE

Every geographical region has its own identity, thanks to the landmarks nature provides. Trees are some of the most prominent of these, and in your painting they can easily bring to mind the mood of a specific place, as in *Woodlight*, which recalls the deep forest of upstate Maine.

To convey reality in a painting it is necessary for you to be familiar with the area you're depicting. My house in Maine, camouflaged by trees, sits high on a cliff overlooking the ocean and Narrow Cove, and when I'm at home in my studio, I need only look out the window to study the shape and color of the trees and rocks.

Evoking locations other than the one you live in depends on how closely you observe what characterizes them. When you travel, note how the colors and contours of the land differ from your usual surroundings and pay attention to the plant life. These details will be of use later when you want to re-create your impressions of a place in a painting. For example, you can use palm trees, banyan trees, palmetto bushes, Spanish moss, and Australian pines to create a Southern effect, while scrub pines and white pines connote the West. When depicting the Southwest, cacti and other desert plants against a backdrop of distant mountains painted in mauve tones set the right atmosphere. In the Midwest, white birches prevail in the northern part of the country, maples and oaks in the midsection, so use whichever are appropriate to your subject. In the North, pines and milkweed pods are typical, and along both the Northeast and Northwest coasts, rocks are especially dominant in the landscape and should be included as objects of regional identification. The advantage of these geographical landmarks is that you can use them to improve your composition, add interest, or cover up a mistake, even as they convey the local color.

I recommend that you first do several drawings of trees to become familiar with your subject; then when you're ready to paint, you'll be able to work directly and allow the medium freedom of movement. As you work through this chapter, you will find that it is an extension of the last one on found materials. Here I continue to put to use razor blades, combs, wire brushes, and stenciling, this time showing you how to create trees and bushes with them.

I began this painting with a yellow structure on a wet surface. When this was dry, I covered the entire surface with cadmium orange mixed with red, then laid plastic wrap over it. I first silhouetted the shapes of the major trees in the center, then painted in the floral patterns in the foreground. Finally I added the detail of weathered bark and further defined the roots of the tree along the eroded edge of the riverbank.

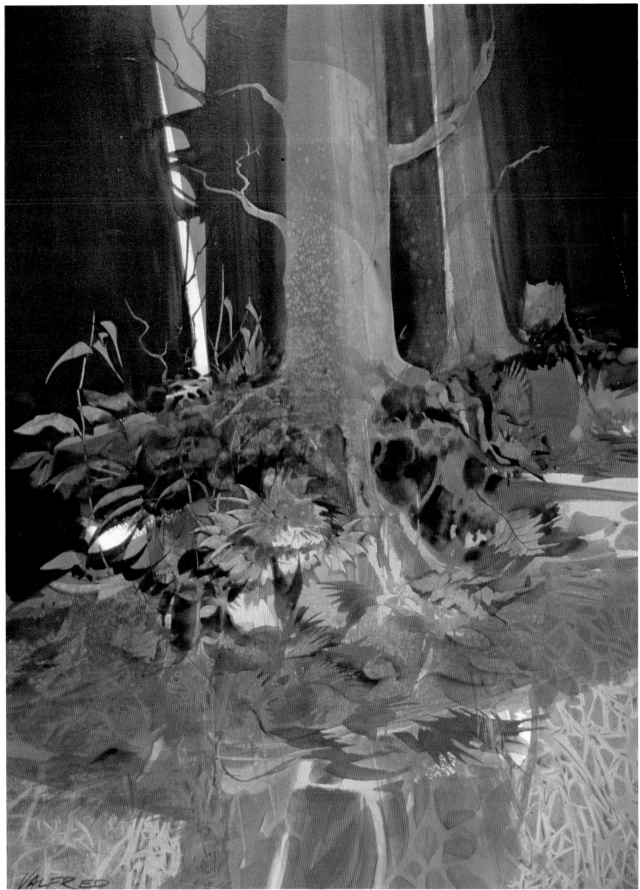

WOODLIGHT, 36″ × 48″ (91.4 cm × 121.9 cm), private collection, Indianapolis

Sponge Techniques

There is an infinite choice of sponges, and these can be cut to different shapes and sizes to use as painting tools. Commercial sponges have one texture, natural ones another; all can be used either to lift out or apply color.

My favorites are natural elephant-ear sponges because they reproduce the organic forms of the landscape best. They are excellent for creating bushes and large quantities of leaves on trees.

I prefer to use a sponge instead of tissue to lift color because it allows for soft edges. As I mentioned in the chapter on skies, tissue tends to leave a hard edge.

When painting with a sponge, you're using it as a brush, not scrubbing the floor with it; you need a very light touch.

Here is an array of sponges you can use for painting trees.

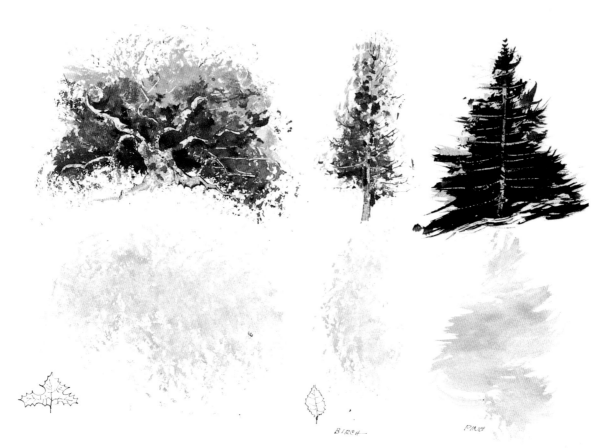

BIRCH

PINE

Using cadmium yellow deep for the underpainting, I laid in the forms of three different types of trees with my sponge. For the oak and the birch, I let this first color dry, then added Winsor red. The last color, alizarin crimson, was added while the trees were still wet. I kept the darker colors toward the bottom of each. Next I scraped out the trunks with a razor blade, allowing the colors to mix completely. After the surface was thoroughly dry, I took a #5 round brush and painted in the negative shapes: darks behind the light trunks and branches. I finished by touching a light color to the tops again, blending the branches into the leaves. For the pine tree,

I squeezed my sponge to a point and dipped it into Hooker's green dark, then flipped it from left to right, using large sweeps at the bottom and smaller ones at the top to suggest the branches, just as I had in the underpainting. While these areas were still very wet I scraped in the trunk, pulling the whole blade of the razor to one side and overlapping my strokes. I then scraped the branches out at equal spaces in clusters of five or six. To create summer trees instead of fall trees, use brilliant green with a touch of Hooker's for the underpainting in place of the cadmium yellow, and overpaint with cadmium yellow or new gamboge.

Stencil Effects

In the last chapter I touched on stenciling; here I will show you how to use this technique more extensively to develop trees. How much stenciling to use in a painting depends on the type of tree you're depicting and how it appears in nature. A word of advice: Don't let this or any other technique become obvious in your painting.

In addition to using paper stencils for trees, I like to use a piece of torn paper to form a hillside, as you will see. For this demonstration I used the same colors as in the sponge technique.

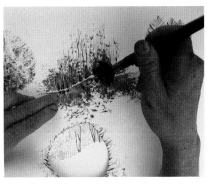

Here I tore a piece of paper into a shape that pleased me. I dipped a mutilated round brush into cadmium yellow and stippled the color on the surface as though stenciling with the tip of the brush. I moved it around until I obtained a satisfying texture, then added Winsor red (alizarin crimson would also work) to suggest the color of fall foliage. Finally, I added the dark shadows on the lower part of the trees with warm sepia and cut details into the trunks and limbs with a razor blade, creating a stand of birch trees.

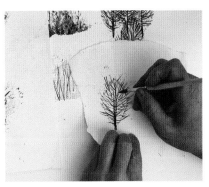

You will find that in outline most bare trees resemble the shape of their leaves. Keeping this in mind, I cut out a piece of paper in a leaf shape that would imitate the silhouette of the tree I wanted to create. Holding the stencil in position and using a #5 round brush, I drew in the trunk lines and limbs of one tree and did another when the first was dry. I continued to add more trees one after the next, allowing their bare branches to overlap and creating the feeling of winter.

For the tree on the left in this illustration, I used another paper stencil. Holding it in place, I applied cadmium yellow to my painting surface and let it dry, then added the trunk and branches with a #5 round brush. Next, I accented the bottom leaves with cadmium orange and alizarin crimson; to finish, I scraped out the trunk with a razor blade.

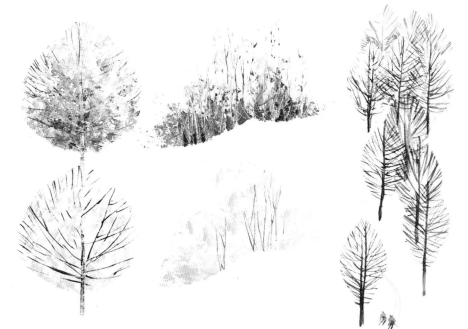

SPONGE AND PAPER MASK STENCILS

Adding Drama

When painting a scene in nature, choose to accent any one of the three picture elements of foreground, middle ground, or background for dramatic effect. In *Property Line*, for instance, the big white expanse of snow serves this purpose, heightening our focus on the tree stump, while in *Afterglow*, color is the dramatic element.

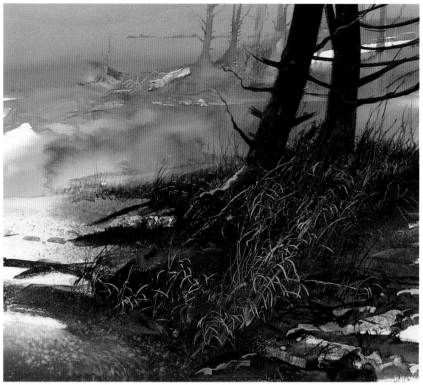

AFTERGLOW, 28″ × 32″ (71.1 cm × 81.3 cm), private collection, Bradenton, Florida

Pine trees in Yellowstone National Park inspired this painting. The glow of the sulfur flats' oranges and purples at dawn contributes to this area's unique atmosphere. I tried to capture it by painting a wet-in-wet background using cadmium orange and cobalt violet for full dramatic impact. I added the trees after the painting had dried.

I began with a cadmium orange underpainting, covered this with warm sepia and Winsor blue, then handprinted the stump, using a razor blade to scratch in details and snow patterns on it. When adding the background, I aimed to create both a positive and a negative area for the purpose of drama. Then to heighten that effect, I dipped my razor blade into color and created the wire of the fence, completing the dynamic Z shape of the composition. The grass swaying in the wind gives further animation to the painting.

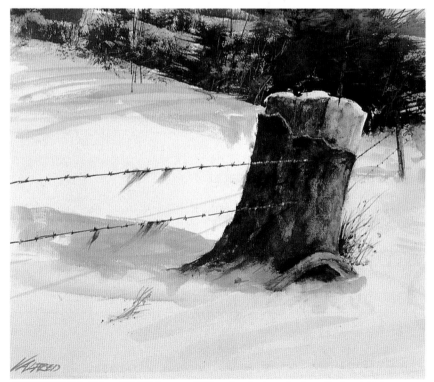

PROPERTY LINE, 24″ × 30″ (61.0 cm × 76.2 cm), private collection, Portland, Maine

Accounting for Distance

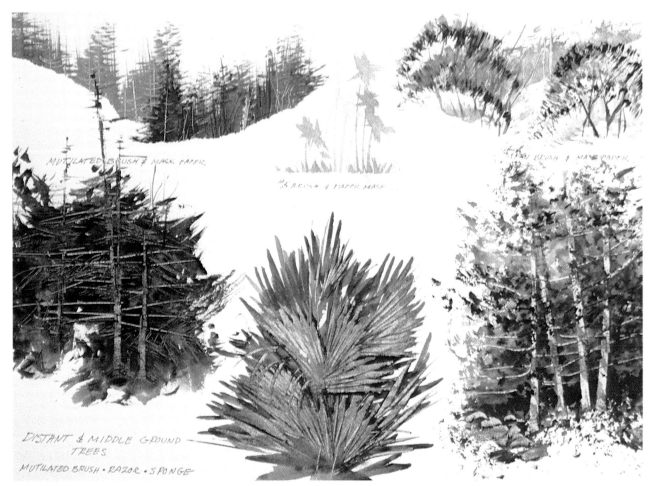

I used light values of cobalt blue and warm sepia for the soft green of the distant trees in the upper left-hand corner, and a paper stencil to create the snowy hillside. Moving a #10 round mutilated brush upward and across the painting surface, I created the pine branches; then I scratched in a few white highlights. After the pigment had dried, I moved the same paper stencil to the foreground and added a second, darker layer of trees with cobalt blue and Hooker's green dark. The pine trees in the immediate foreground are again Hooker's green, warm sepia, and a touch of cadmium orange, done with a mutilated brush, a razor blade, and a wire brush at the edges to soften the pine needles. As the painting dried, I added the fine branches at the top with a #5 round brush. I took warm sepia on a mutilated brush and applied it at the bottom of the trees to suggest the darkness of the forest floor. To depict the distant palm trees, I mixed alizarin crimson, Winsor blue, and a touch of cobalt violet to get a soft, pale mauve. Using just a few strokes, I put the first color down on a very wet surface. When my painting was completely dry, I repeated the same strokes in a slightly darker color over the original drawing. For the palmetto bushes in the center foreground, I used a 1½" flat brush loaded with Hooker's green dark at the bottom edge and a touch of cadmium orange at the top to make a series of strokes in cartwheel fashion, the results looking like spokes. I continued to put more down, letting them dry each time. To bring out the texture of the leaves, I used a razor blade, moving it back and forth on the damp surface. On the right, the distant deciduous trees were painted with light values of cobalt blue and warm sepia; for the row in front of them, the colors are darker and warmer, just as you would perceive them in nature. The trees in the lower right foreground could be birches, aspen, or similar species. Here I used a sponge, putting down cadmium orange first and topping it with brilliant green. When the surface was slightly dry, I finished the painting with Hooker's green dark and scraped the trunks and branches in with a razor blade.

Observing Differences

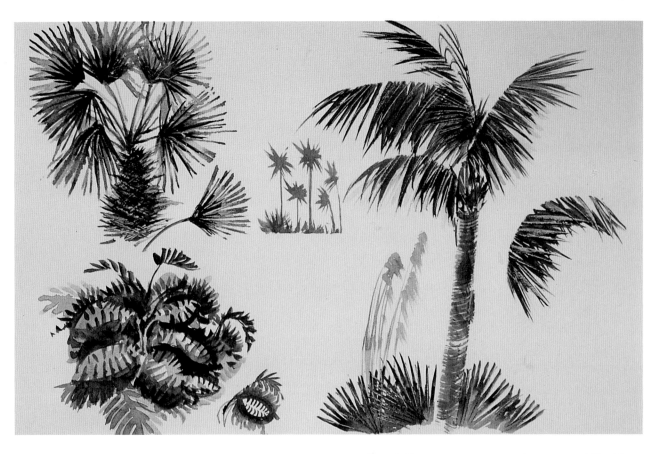

To create the palm tree with fan-type fronds in the background at left, I pulled a 1½″ flat brush loaded with Hooker's green dark on the inside and cadmium orange on the outside across my painting surface, working in a semicircle. I let my first strokes dry before going back to add more to each fan. The colors of the trunk are warm sepia and cadmium orange mixed on the brush, which I applied in a crosshatch manner to suggest the remains of dead fronds. While this was still wet, I crosshatched highlights on the palm leaves with a razor blade. In the left foreground is a philodendron; all species can be depicted either by painting in positive strokes that define the basic shapes of the leaves or by painting negatively around them. To create the featherlike palm fronds of the tree at right, I cut a curved mask from a piece of paper and pointed it outward from the top of the trunk. With my double-loaded brush, I stroked downward from the mask, varying the direction of the fronds. With the mask still in place, I used my razor blade to highlight the fronds. The trunk is painted with a rounded stroke using a mixture of warm sepia and Winsor blue and a damp, slightly mutilated brush. For the sea oats, I used a mixture of cadmium orange and warm sepia and my #5 round brush to draw the stems, pulling my thumb across them while the color was still wet to create their fuzzy panicles.

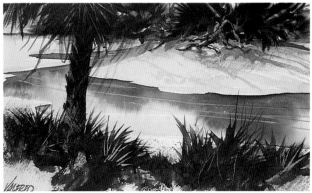

UP THE CREEK, 11″ × 18″ (27.9 cm × 45.7 cm),
private collection, Florida

I made this little painting in Florida when I was asked how to depict the native foliage. I began with cadmium orange where I wanted the foliage to appear. When it was dry, I overpainted the tree trunk with warm sepia and a touch of cadmium orange in crosshatch fashion, giving it a handprint, then scratching in the bark pattern. I then overpainted the other foliage areas with a mixture of Hooker's green dark and warm sepia, scratching back into it with a razor blade to create the palmetto bushes in the foreground and the mangrove roots in the background. To achieve the reflection, first I wet the area with water, then with a double-loaded brush of Hooker's green dark and warm sepia, I lightly glazed along the shore, letting the medium run. I finished by running a thirsty—slightly damp—brush through it to create ripples and adding mauve shadows on the sand.

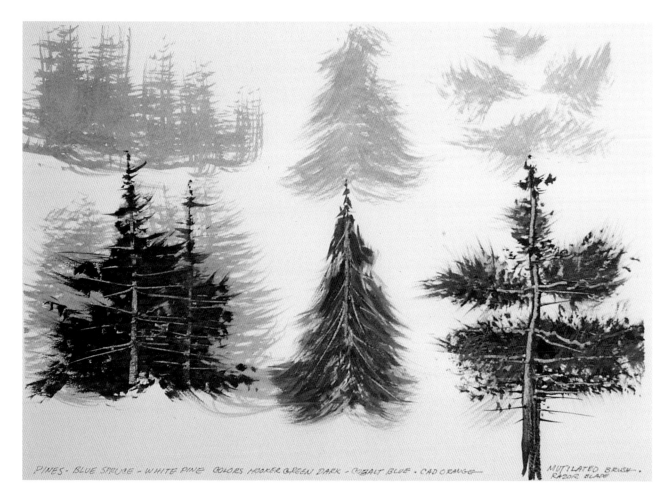

PINES - BLUE SPRUCE - WHITE PINE COLORS HOOKER GREEN DARK - COBALT BLUE - CAD ORANGE MUTILATED BRUSH. RAZOR BLADE

There are many varieties of pine trees; this demonstration offers a general approach for painting almost any kind. For the background trees I used cobalt blue with a light touch of warm sepia. In the illustration at left I held down a mask of torn paper to suggest the ground. With a mutilated #12 round brush, I picked up color and pulled the strokes straight upward, leaving fuzzy edges. I then crossed over them, making my strokes larger near the ground and smaller at the top to suggest the common balsam fir. Next, with the mutilated brush filled with Hooker's green dark and a touch of cadmium orange, I suggested pine needles. You can also use a wire brush for this purpose, scraping in the direction the needles grow in. I scraped out the trunk and branches with a razor blade, then lightly softened the tree trunk with a mutilated brush. The second tree represents a blue spruce. For this I laid in cobalt blue with a little warm sepia, then took my mutilated brush and pulled downward to define the limbs, being careful not to get the "Christmas tree" look. I used my razor blade up the middle for the trunk and brought the branches down to the outer edge with it. The third tree is the white, or yellow-leaf, pine, which has a bending and twisting character. Allow the first strokes of cobalt blue and warm sepia to suggest this feeling. Come back with a mixture of Hooker's green dark and cadmium orange on the boughs. Use warm sepia for the trunk, and while it is still wet, scrape in the texture lines and highlights.

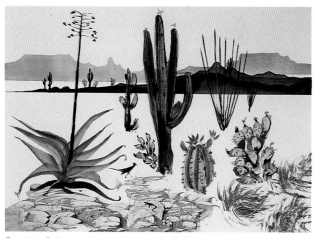

I painted the century plant in the left foreground with a double-loaded 1½″ flat brush, allowing the pigment to dry between the layering of the leaves. Then I used a #5 round brush for the main stalk and the seed pods. For this and the smaller cactus plants I used Winsor blue and Winsor green with a touch of Hooker's green dark. The striations were created with a comb, and the foreground rocks were scraped with a razor blade. For the prickly pear cactus at right, I used a flat brush to make each leaf and a #5 round brush for the flowers. I created the tumbleweeds with the swirl of a #12 brush filled with watered-down cadmium orange and Indian red, which I then scraped into for texture.

Other Interpretations

"I feel that to become more than a reportorial statement, a painting must be the gathering of idea and mood," says this artist. "It is my intention that *Loner* not only be seen but also *felt*. Not just witnessed, but *experienced*. The shapes and rhythms of nature provide the painter with a deep well from which to draw evocative responses. I began *Loner* with large, sweeping brushstrokes of very liquid color over the entire painting surface. While this was still fairly wet, I quickly modeled the patterns, adding darks to enlarge the sense of dimension. The colors I used up to this point were raw umber, olive green, Winsor blue, burnt sienna, burnt umber, yellow ochre, and cobalt blue. The wet surface allows the pigments a mingling and interplay that promises cohesion. As the surface dried, I sprayed water from an atomizer into the color, blotting areas with facial tissue at various stages of drying. This technique created a mottled effect that I'm fond of using to suggest outdoor and natural textures. The fairly smooth surface of the Crescent cold-pressed watercolor board I used allowed me to easily lift out the light tree with a damp brush. I felt that creating the light tree this way was more effective than painting around it or using masking fluid because I could obtain softer, obscure edges that would allow the tree to mingle with its setting. Finally, I painted the darkest darks, including the areas around the large and complicated tree to the left of the light tree."

I did the underpainting for this cross-shaped composition with cadmium orange and various yellows, then overpainted with Hooker's green dark. The dinghy, bottom up in the foreground, keeps the painting moving back into itself in a constant circular or oval motion. The white birch trees were carved out with a razor blade; the textures of the ground and the boat were achieved with handprints. I washed in the distant horizon line while the sky was just a little wet.

Irving Shapiro, **THE LONER**, 24″ × 32″ (61.0 cm × 81.3 cm), courtesy of the artist

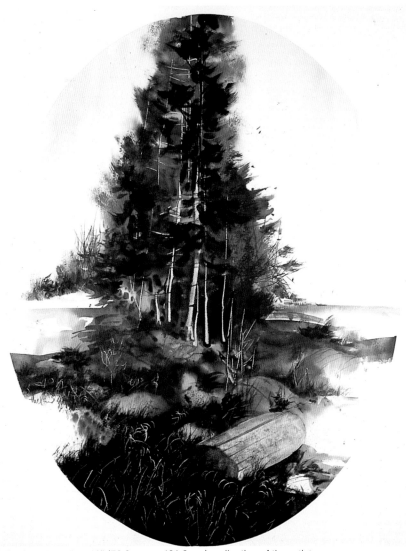

WINDBREAK, 30″ × 40″ (76.2 cm × 101.6 cm), collection of the artist

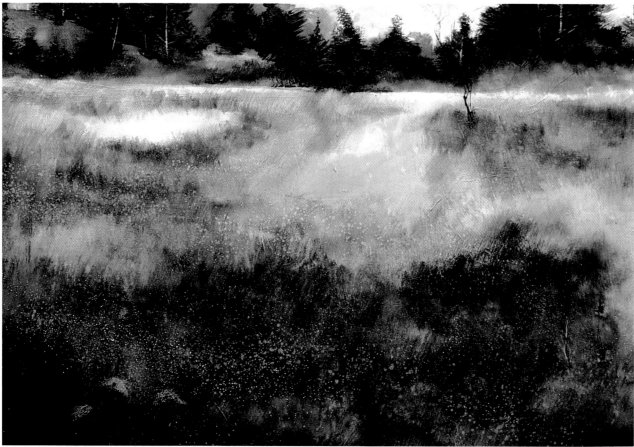

CARSON'S REFUGE, 22″ × 24″ (55.9 cm × 61.0 cm), collection of the artist

Carson's Refuge is a wildlife preserve in the tidewater area of Kennebunk, Maine. The area has a lot of undergrowth that, in the fall, holds the warmth of the day and responds to the night chill with a ground fog. In this particular painting, the entire surface was wet when I added cadmium yellow in various locations. While it began to dry I mutilated my 1½″ flat brush in order to pull up the pigment and suggest grass growing. At the same time, I added some sap green in the middle ground and Hooker's green dark in the foreground. While the surface was still wet, I added warm sepia across the background and let it bleed. When it was all dry, I held a piece of paper as a stencil across the background and came back with a mutilated brush to add the trees that poked up above the fog.

Practice Exercises

1. Take time to observe how trees grow, and study the differences among the various kinds. Do sketches to impress the shape and patterns of each type of tree on your mind. Wherever you live or travel, consider the natural forms that typify the local geography.
2. Take time to record the familiar landscape elements of your usual surroundings as well as those that characterize an area in which you are traveling, and compare them.
3. Attempt to define the natural forms of trees and bushes with the fewest number of strokes.
4. Experiment with a variety of natural and commercial sponges and liquid color to see what they can do for you.
5. Stencil some forms. Explore the potential of various found materials as stencils, such as florist's ribbon; create some trees using a stencil cut out of a piece of paper.

5

ROCK FORMS

Like trees, rocks describe the geographical locations where they're found, varying as they do in shape and color across the country. This means rocks can be used to represent the characteristics of specific areas, as can the shapes and colors of the shadows that fall across them. In northern areas, shadows tend to be dark and warm. A nice mauve made with a combination of Winsor blue, Hooker's green dark, and alizarin crimson works perfectly for this. Southern shadows tend to have a cool, reflective tone like what you see bouncing off white walls. For this I usually use Winsor blue with a touch of alizarin crimson, the same colors I use for northern shadows in summertime.

Rocks are landscape elements that lend themselves readily to painting with such found materials as sponges. Besides that, I basically use two methods. One is the razorblade or cardboard technique; the other is a spatter technique. When painting a rock, as with all objects I paint, I think about its placement, shape, size, and weight rather than about my overall subject matter.

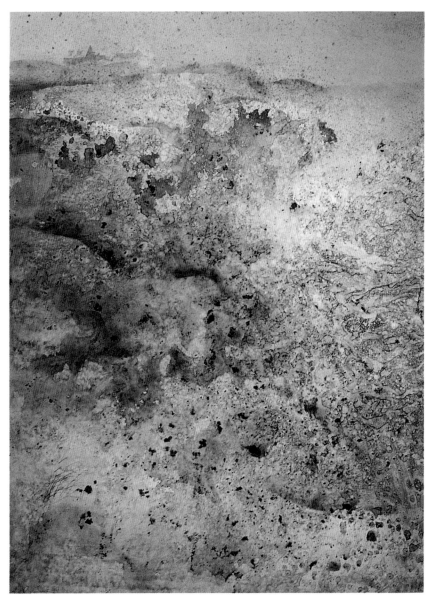

SPRING SURF, 30″ × 40″ (76.2 cm × 101.6 cm), Reading Public Museum and Art Gallery, Reading, Pennsylvania

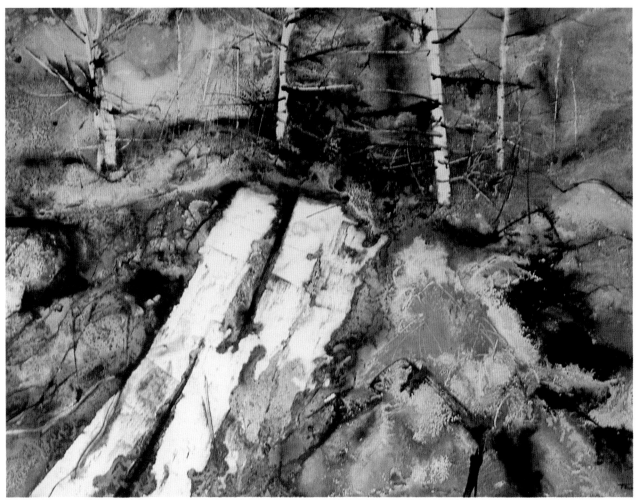

William Thon, **AUTUMN SHORE**, 20⅜″ × 27″ (51.8 cm × 68.6 cm), courtesy of Midtown Galleries, New York City

This painting of Maine rocks and shoreline has a yellow ochre underpainting that was overpainted with India ink; the artist scratched back into the washes with a razor blade, palette knife, and handle of a brush. He also used an atomizer spray on the ink, and a terry towel to wipe areas in the foreground.

This is an impression of the lighthearted feeling that comes with the warmth of spring. The first things I painted in were the rocks along the shoreline, using the drybrush technique—a slightly damp brush with just a touch of pigment to create very delicate, separated strokes that leave a softened texture. I then added buildings to the background. When they were completely dry, I wet the entire surface with water and spattered it with a variety of colors starting with cadmium yellow, red, and orange. While these warmer hues slowly dried, I added cobalt blue and Winsor blue over them. When the surface was completely dry, I went back with an atomizer spray several times, moving the color around to suggest texture and animation. I studied the painting once it was dry and was not satisfied with several areas, so I rewet the surface with an atomizer spray and painted into it to change some of the texture until it looked right.

Razor-Blade Technique

When using the razor-blade technique for my rock paintings, I begin by getting down the large shapes in the colors characteristic of the area's geological forms. For Maine rocks I use Winsor blue and sepia umber to create a gray tone. Moving down the coast, I add a bit more orange, overglazing with orange and sepia umber to bring up the underlying color. In the Southwest I lean more toward the reds and oranges.

For this painting of Northwestern rocks, I began with gray tones to develop the forms I needed. While the surface was still damp, I came back into the shapes with a razor blade (a credit card would also work), using it almost as if it were a snowplow to squeegee off color. The top edge of the blade left a distinct line as it pushed the pigment off, suggesting the rocks' edges.

I let the color move around, creating light and dark areas, pulling pigment downward to create shadows. Then I added dark trees behind the rocks. This technique is very rapid.

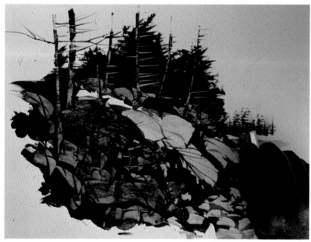

I finished by scratching out details of the trees with my razor blade.

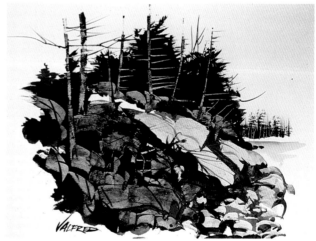

ACADIA sketch, 11″ × 14″ (27.9 cm × 35.6 cm), collection of the artist

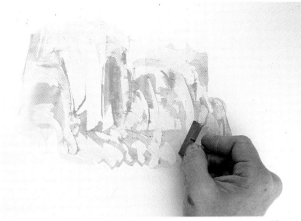

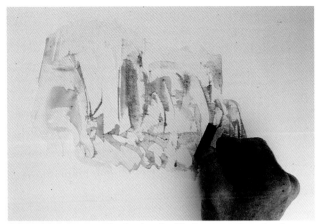

Western rocks glow with intense oranges and yellows. Using a thumbnail sketch as a reference, I first put down a wash of cadmium orange, then scraped it out with a razor blade.

After this was completely dry, I added a second wash of cadmium orange with a touch of sepia umber to darken various areas.

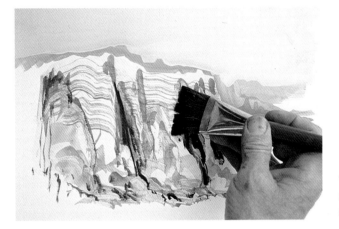

Then I dipped my split (not mutilated) 1½" flat brush into sepia umber and ran it horizontally across the surface to suggest the striations characteristic of this rock formation.

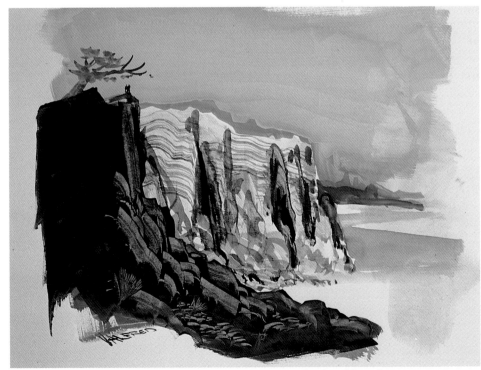

Last, I washed alizarin crimson and Winsor blue over the foreground, then scraped lights out of the dark, shaded areas with a razor blade. I completed the sketch by adding the sky and the tree atop the darker rocks.

CAREFREE, ARIZONA sketch, 11″ × 14″ (27.9 cm × 35.6 cm), collection of the artist

Spattering

I find the spatter technique effective in a wide range of situations and have been known to say, "When in doubt, spatter."

Some artists prefer to spatter by running a knife over a toothbrush loaded with paint or tapping the brush against a ruler. I find these methods do not give me as much control as hitting the brush on my hand, but you should experiment to find what works best for you. You can spatter with clear water to create an interesting effect with colors such as Winsor blue, cobalt blue, and warm sepia that are already on your painting surface, or you can spatter with paint to create texture. You can also spatter India ink while your surface is still wet with clear water or watercolor to get some very explosive effects.

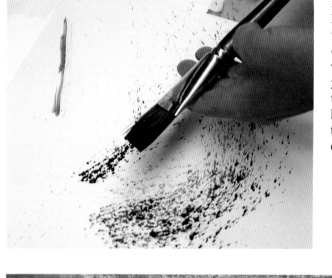

A damp brush will give you a very heavy spatter, while a dry brush creates a light spatter. The results you get depend on the amount of water and pigment you use, as well as on the dampness of your painting surface. To control the amount of water needed for a light spatter, pick up some pigment on your brush, then wipe the tip over a damp sponge. For this technique I use my regular flat brush and crack it against my hand. I find that wrapping my hand with a terry towel softens the blow. Don't strike the brush against a hard object; it may damage the ferrule.

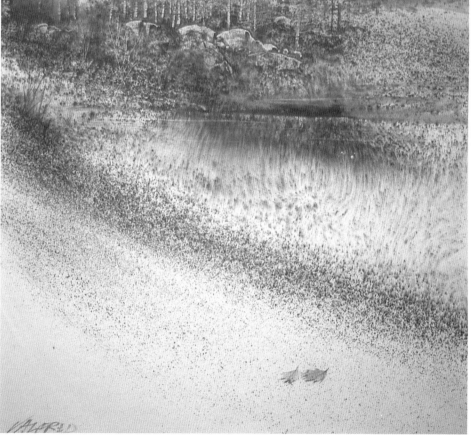

For this painting I laid in a yellow wash and spattered it with ink. I wanted the ink to explode and run in the pond area, so I rewet it with plenty of water, then spattered it with ink again. The spatter effects I achieved elsewhere varied according to the amount of dampness on the board. Last, I defined the rocks and trees with a razor blade.

STAPLES POND, 30″ × 30″ (76.2 cm × 76.2 cm), private collection, Florida

Sponge Techniques

Sponges are as versatile as there are different types. Commercially made sponges create fairly even textures that you can use to depict gravel, pebbles, or the weathered look of an old stone wall. Natural sponges are good for softening edges of forms; tear off a piece of one and, while it's still dry, dip it in moist color, then apply it to paper. Because sponges leave an identifiable impression in a painting, you should be careful not to overuse them. Understanding how best to take advantage of unusual painting tools takes time and training. Good taste and instinct will eventually guide you.

To depict rock textures with this technique, first cut a commercially made sponge into the sizes and shapes of the stones you wish to portray, then put a light wash over the area where you want them to appear. Dip the sponge pieces into the warm side of your palette, picking up ochre, cadmium yellow, and cadmium orange and blending them all together. Place the sponge pieces on your painting surface to leave an imprint that creates the brick pattern of a wall, as shown here. Then come back with a light stroke to add the shadow at the edge of each brick.

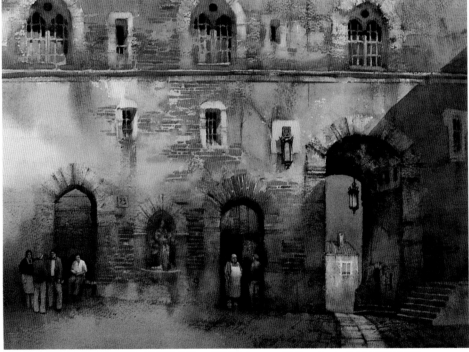

Tom Nicholas, ANCIENT WALL, ASSISI, 28″ × 32″ (71.1 cm × 81.3 cm), courtesy of the artist

"My prime concern when painting this beautiful wall in Italy," says Nicholas, "was capturing its pattern and patina. I tried to create interest with textural variety, an essential ingredient of good design, using wet-into-wet and drybrush painting as well as color changes and different kinds of edges. The delicate balance between variation and continuity was my major objective. You will notice that I subordinated the many figures in this painting to give the wall priority."

Combining Techniques

Another way I paint rocks involves both the razor-blade and spattering techniques. I begin by designing a rock that pleases me, then I mask out the surrounding area and spatter it. I also use handprinting to create texture. You might try using a piece of cardboard instead of a razor blade to move the paint around.

The approaches to rock painting I've introduced here will work with most rock forms that you come across; if you pay attention to their different textures, you'll get a feeling for which technique will work best for capturing them. For instance, if you want to depict the coquina rock you find in Florida, use a sponge dipped in ochre, sepia umber, and Indian red, touching the paper with it and beginning at the top of the rock.

Here is a more detailed approach to depicting rocks. Lay painter's tape on your watercolor board, then cut out of it the desired rock shape with a razor blade. Secure the tape so no paint can run under its edges.

I lightly washed the area with a mixture of warm sepia and Winsor blue, keeping the top of the rock lighter than the bottom. Then I used a handprint again and again to create texture, drying my hand between each stamping.

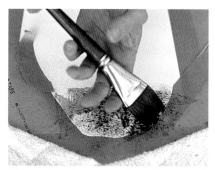

Next, using the same color mixture and a circular motion, I created a very fine spatter over the rock, working from the top to the bottom. The circular motion lets you direct the pattern the spatter forms so that you can create dimension with it.

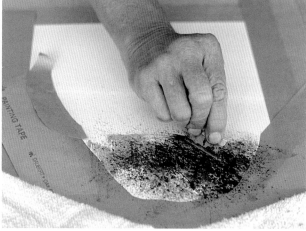

After this stage had dried, I came back with a mixture of green and cadmium orange, spattering again a little more heavily to suggest lichen growing on the rock. I forced darker tones toward one side of the rock to give the illusion of shade. When the spatter was completely dry, I overpainted the area with a gray tone, then squeegeed the damp color with a razor blade to create cleavages and small stones.

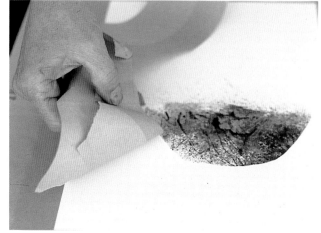

When the painting was completely dry, I added some of the final shades using a #5 round brush. I then peeled off the tape mask at a forty-five-degree angle to avoid tearing the surface of the board.

Close-up of rock with tape removed.

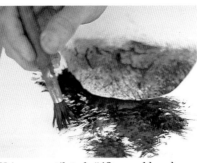

Using a mutilated #12 round brush dipped in water and dried almost completely on a terry towel, I picked up some Hooker's green dark and painted a few pine trees behind the rock to make it stand out.

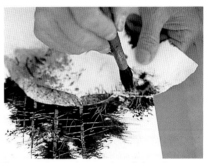

I scraped out the trunks of the pine trees with a razor blade. Then, holding a piece of paper as a mask, I continued using the mutilated brushstroke to add birch trees in the distance, suggesting a horizon line.

Still using the mutilated brush, this time with yellow ochre, I brought out the grass growing through the snow and scratched it with my fingernails to add more texture. Last, I added a pheasant in the foreground to complete the S-shaped composition.

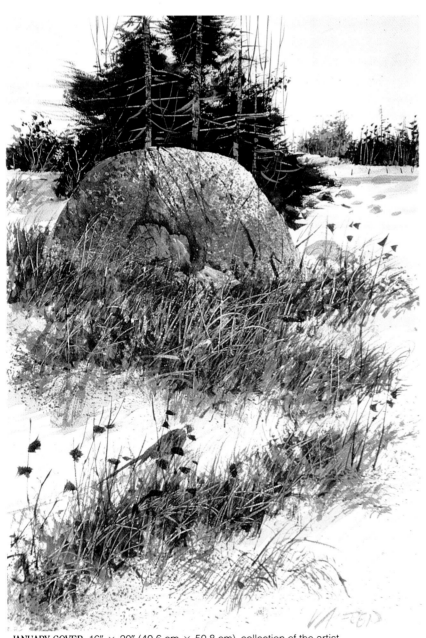

JANUARY COVER, 16″ × 20″ (40.6 cm × 50.8 cm), collection of the artist

Other Interpretations

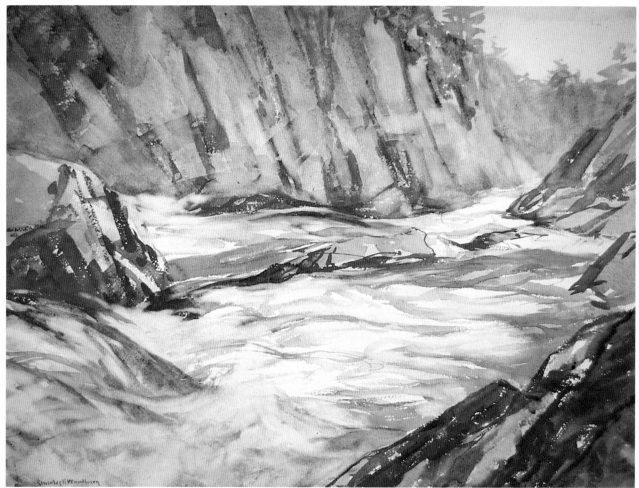

Charles Woodbury, **HIGH WATER**, 21″ × 31″ (53.3 cm × 78.7 cm), courtesy of the David O. Woodbury Estate

This painting offers a quite elegant approach to handling rocks. Here a square-edged brush loaded with many colors gives the same effect a razor blade can create.

This artist says of his painting, "Since the watercolor medium does not offer the tactile textural possibilities oil paint allows, I feel a need to emphasize edges in my work and display them in wide variety, from soft, diffused ones to others that are knife-sharp. After sitting at the rim of this quarry with the stone cutting into the back of my legs for an hour or two, I was well aware of what a hard edge it was and used it in the painting to lead the viewer's eye into the center of the composition. All other edges by comparison are much softer."

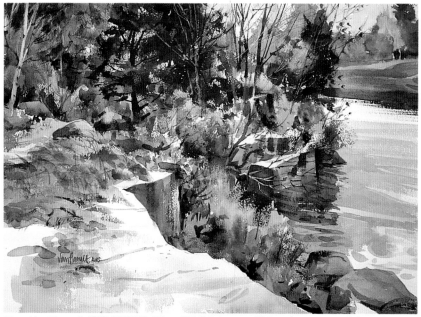

Tony Van Hasselt, **THE QUARRY**, 15″ × 22″ (38.1 cm × 55.9 cm), courtesy of the artist

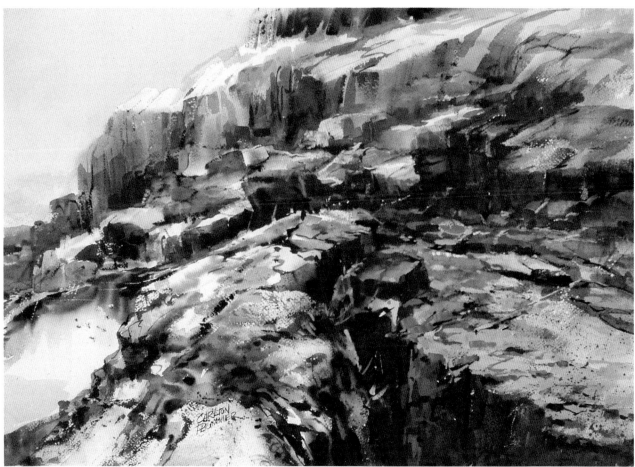

Carlton Plummer, **LEDGE MAZE**, 21″ × 28″ (53.3 cm × 71.1 cm), courtesy of the artist

The artist based this painting of rocks along the Maine coast on a sketch made on location. His intent was to create the illusion of a three-dimensional ledge thrusting upward toward the high, snowy cliffs above. Although the painting was done primarily with transparent watercolor, some revisions were made with gouache to strengthen and dramatize the dark areas that form the diagonals. The middle foreground was painted wet-into-wet with spatter to create spontaneous textural effects; the ledges, a series of overlapping tones, were painted freely with a 2″ flat wash brush.

Practice Exercises

1. Paint rocks with a razor blade and then with a credit card or a piece of cardboard to see which you prefer.
2. Practice spattering, first with a dry brush, then with a wet brush; try it on damp paper and on dry paper. Try hitting the brush against your hand in the direction you want the spatter to go rather than shaking it or rubbing a knife over a toothbrush. Notice the difference.
3. Try spattering with clear water, and see what reactions you obtain. Try it on plain colors and on blended colors, and note how it reacts in each case.
4. Try spattering India ink with water, then spatter a wash of color with India ink.
5. Use different sponges to see what rock effects you can get with them.

6
GLAZING COLORS

Glazing with watercolor is similar to glazing with oil color. It is simply the process of overlapping planes, using a flat brush and transparent washes. Glazing either highlights compositional focal points or places colors close together to push back or grade down another stroke.

The glazing technique works well with staining colors such as Winsor blue, alizarin crimson, Winsor green, Winsor red, new gamboge, and cadmium orange. The more water you use with the color, the more transparent the glaze. If you use any of the opaque colors such as yellow ochre, burnt umber, or other earth tones, be sure to apply them first and the transparent colors over them.

You can use glazing to darken or coat areas to create a variety of tones or shadow effects. The technique works particularly well when you want to pull passages together while letting bits of color show through.

Every stroke you take relates to the whole; the fewer the strokes, the crisper and cleaner the statement. Careful observation and a gentle touch will keep the pigments from joining too much; in a blend, each color should retain its own character yet add to the whole.

I usually call glazing my "housewife technique." I don't mean to disparage housewives; it's just that the time it takes to go for groceries, do the laundry, make the beds, get a meal, or visit with a friend benefits the process by giving a painting the chance to dry. Glazing is an excellent technique to use in the field, especially in a warm climate, where fast drying allows you to quickly glaze on the next layer of color. You can test the dryness of a painted surface by its temperature; if it is cool when touched lightly with the back of your hand, it is still wet.

Like all watercolor painting, glazing must always go from light to dark. As you work, ask yourself if you are looking for heavy or light development. That is, do you want dark, powerful painting, as in Doris White's *New Harbor* (page 71), or light and airy painting, as in *First Nighter* (page 74)? Basically the technique involves five steps, although I often use more than five glazes.

1. Create an abstract pattern using a warm wash of red, yellow, or orange. To obtain multiple shades of this color, add glazes of the same hue, allowing your strokes to slightly overlap the previous glaze.
2. Add a light neutral pattern with a grayed color, allowing a little of the first color to show through in some areas.
3. Put in a very transparent dark, allowing two or three shades to come up through the glaze.
4. Apply another dark, then add as many darks as necessary to create the pattern you desire.
5. Brush in the large details before adding the final realistic touches.

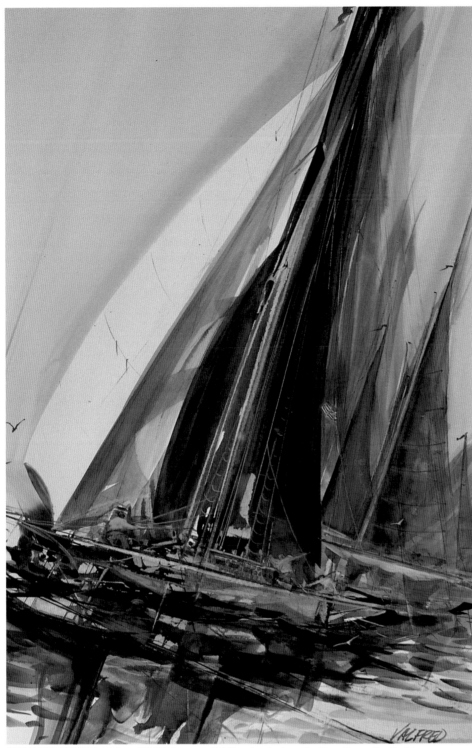

I began this painting with lemon yellow and cadmium orange, which formed an abstract cross that suggested a billowing sail and established my subject matter. When the first wash was semidry I added Winsor blue directly from the tube, then cut straight down through the pigment with my palette knife. As everything surged to the left, I moved rapidly, making patterns with my palette knife in the same direction, until this very abstract composition began to look like an exciting sailboat race. Coming back with a mauve and Winsor green, I overglazed the original orange and yellow to develop the suggestion of boats moving in the background; then, to increase the animation, I added seagulls and put some forward-leaning figures in the boat. When the painting was dry, I used pastels to accent the rigging and the American flag, then completed the scene by extending the prow of the ship in Winsor red and adding the small flags on the masts as accents.

STARS AND STRIPES, 30″ × 40″ (76.2 cm × 101.6 cm), private collection, Sarasota, Florida

A Basic Glazing Demonstration

When you're ready to use glazes, you should know that you won't lose any of the detail in your underpainting as long as you make certain that it is completely dry and that the patterns you apply as glazes are painted in one bold, appropriate stroke over another. If you use more than a single stroke for this, you will probably lift the underlying pigment or move it around. By working quickly and crisply, letting each glaze dry completely before going on to the next one, you will avoid wet spots and be less likely to create mud.

For this demonstration I used painter's tape to seal the edges around my painting surface. Sometimes I use 2″ or 3″ masking tape, depending on the size of border I desire. The tape allows me freedom of movement when laying in color and design lines and provides a useful spot for trying out a color or squaring up a brush. Easily removed when the painting is done, it gives an automatic mat that serves as an aid when you're evaluating your work.

Here I am using five different brushes—a 1½″ and a #1 flat, and #12, #10, and #5 rounds—along with a palette knife, a ruler, and five brilliant colors—cadmium yellow, cadmium red, Hooker's green dark, Winsor blue, and alizarin crimson.

First I put down washes of cadmium yellow and cadmium red to create an orange, then I used alizarin crimson, Winsor blue, and Hooker's green dark. Be careful when doing this; don't put red next to green unless you want mud. You may, however, use alizarin crimson next to green and blend into the blue.

While the surface was still damp, I cut in design lines with a palette knife, using complete arm movement. This is more effective on watercolor board, but will work on watercolor paper as well.

When it was dry, I added multiple glazes to accent the colors and the random forms made by my palette knife, making sure to let the surface dry between each glaze. With transparent glazes of alizarin crimson I added some dark shapes, then scraped out details with a razor blade.

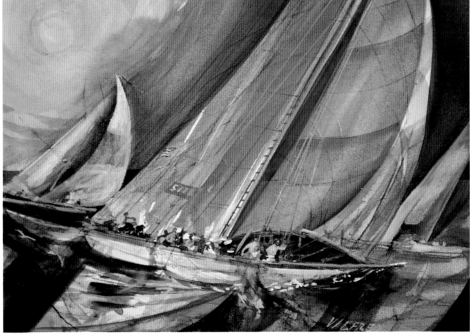

Finally I added waves of greens, still following the shape of the original design lines. I also added a few necessary darks to balance warm with cool and light with dark.

NIGHT SAIL, 16″ × 20″ (40.6 cm × 50.8 cm), collection of the artist

Glazing Flowers

I often use the glazing technique when I'm painting flowers and always keep some fresh blossoms in front of me for information about details, whether I am working abstractly or more realistically.

Sometimes when painting flowers I use rubber cement or another type of masking fluid, such as Moon Mask, to keep certain areas white. I do not lift this resist until the colors are thoroughly dry. To remove rubber cement I use a pickup designed especially for that purpose; heavy deposits can be trimmed off it with a pair of scissors. You can also remove rubber cement from a painting with the sticky side of masking tape or Scotch tape.

Once the resist is lifted, it is time to add details. Indian red backs up yellows very nicely, and Hooker's green dark and Winsor green deepen the yellow-greens. For deep darks, I combine alizarin crimson, cadmium orange, sepia umber, and Hooker's green dark. I often use a palette knife or spatula, depending on the size of the painting, to cut in random strokes over the entire picture plane. These are what I refer to as design lines.

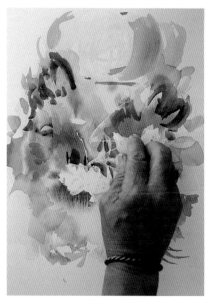

I began by wetting the area where I wanted the flowers to develop, working in a circle to lay in basic overlapping shapes. I added cadmium yellow, then Winsor red, letting the medium run into the wet surface and making sure to leave enough of the paper white for sparkle.

Next I alternated applications of different resists, including frisket and candle wax, with more colors—Winsor emerald, Hooker's green dark, and some alizarin crimson.

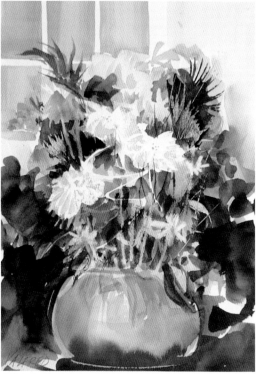

VI'S ARRANGEMENT, 16″ × 20″ (40.6 cm × 50.8 cm), collection of Vi Thëlin

After this stage was completely dry, I used a rubber cement pickup on the resist, then finished the painting with a glaze of Winsor blue and Hooker's green dark, scratching the surface with my fingernails for texture. I then added light squares in the background to suggest windows.

Other Flower Painting Ideas

One of the brushstrokes I particularly like to use in flower painting is the "bucket stroke," a term introduced by one of my students because it can be used to quickly render the form of a bucket. However, it can be used in many different ways for many subjects. Sometimes using this stroke is called Oriental painting, or loading the brush with multiple colors. It is similar to the double-loaded brush I briefly referred to in Chapter 4. In flower painting the bucket stroke is ideal for rendering petals in their natural dark to light gradations.

Of course, there are many ways to approach flowers. You can touch them up with an opaque watercolor, such as cadmium orange, to add some bright spots, or you can try gouache, watercolor crayon, or pastel.

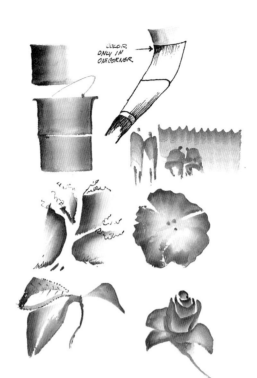

To paint a bucket stroke, take a completely clean flat brush that is moist but not wet and dip one corner of it into pigment. With the brush loaded, make a stroke. The dark will blend to light as the paint spreads into the wet area left by the side of the brush that has only water on it. This stroke can be used to outline trees, flower petals, leaves, figures, and various abstract forms. Loading your brush with two or three colors works particularly well in floral paintings.

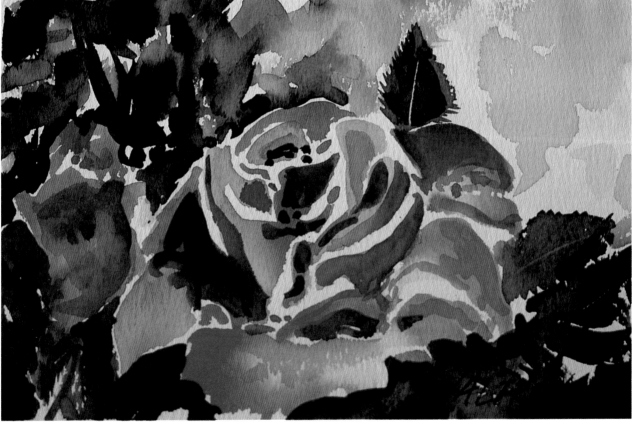

ROSE, 8″ × 10″ (20.3 cm × 25.4 cm), collection of Vi Thëlin

Here is a good example of a flower painted with overlapping bucket strokes.

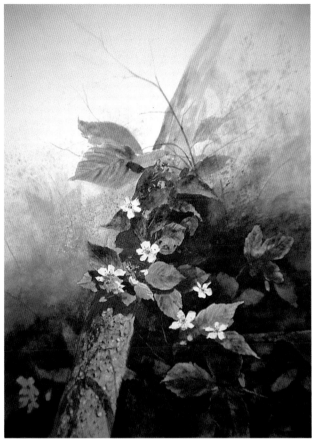

Mitch Billis, **NEAR BURNTHEAD,** 20″ × 15″ (50.8 cm × 38.1 cm), courtesy of the artist

As a first step the artist masked out the lower part of the branch, the flowers, and a few leaves with frisket where he wanted to suggest the sun shining. Then he wet the entire surface and squeezed some sap green, raw sienna, new gamboge, yellow ochre, and burnt sienna directly onto it, moving the paint around with his fingers and a 1″ flat sable brush to create patterns and shapes. While the surface was still moist, Billis splattered clear water and paint into some areas to establish middle and light values and create an abstract pattern. When this stage was completely dry, he removed the frisket and proceeded to paint the negative areas around the leaves to create shadows. He then painted the areas that had been masked out, placing some of the flowers in shadow. The texture of the bark was obtained by scraping the surface with a razor blade, the effects varying according to whether the surface was wet or dry. When the painting was basically finished, Billis spattered the branches with a light mixture of sap green and raw sienna to complete the composition.

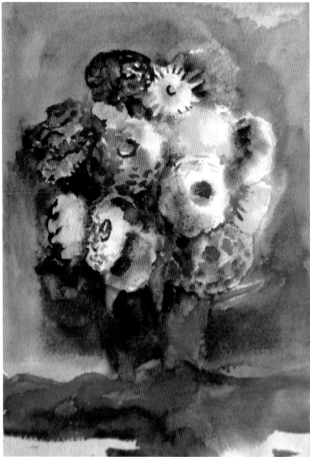

Walt Kuhn, **STUDY FOR ZINNIAS IN BLACK CROCK,** 14″ × 20″ (35.6 cm × 50.8 cm), Walt Kuhn Gallery, Cape Neddick, Maine

This masterful painting captures the feeling of a floral arrangement with simple glazes and quick brushstrokes in a semiabstract fashion.

Pastel Glazing

Pastels can be used for a form of glazing, although they are not often thought of as a watercolor medium. I sometimes sketch on board or paper with pastels; then, using a featherlike stroke, I wash over the sketch with water. The binders in the pastels turn the colors into a nice liquid surface from which you can lift out patterns and highlights with a dry brush. Since pastels are grainy and the particles tend to become embedded in the painting surface, each brushstroke you apply on top of them becomes evident, enabling you to bring out movement and pattern.

Because pastel stops on the surface, one of the beauties of painting with it is that you can continually go back in and move the color around. You can scratch into it and create streaks of light to develop dramatic effects; when it's dry, you can remove the color with a regular eraser or pull it out with a damp brush to bring light back into your paintings.

Another advantage of pastels is that they can be worked from dark to light—the opposite of watercolor painting—and can thus be used to add some very bright accents to an otherwise finished watercolor painting; that's how I depicted the rigging in *Stars and Stripes*, page 65. When painting haze or soft light, I've found success in blending the pastels almost entirely out and blurring them well.

Personal experimentation and careful observation are the best ways to appreciate the many combinations possible with watercolor and pastel. When working with this technique, I find Nupastel to be the most satisfactory. Pastels are easy to use on location, and when traveling, I've discovered that hairspray works well as a fixative.

For this demonstration I used a razor blade, a #5 round brush and a 1″ flat, and pastels. I put the color down in bold shapes, balancing them in an abstract pattern.

With a brush and water I dissolved the pastel, using it like watercolor to create a wash pattern around the area. Then I accented the yellow with light blue.

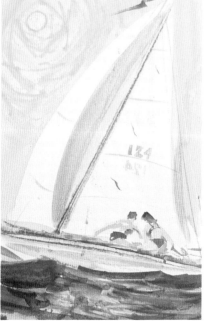

I then rubbed some pastel on the unused margin of the board and dipped my #5 brush into it, picking up color with which to add the figures and the flag. Finally, I put down some darker blues and scraped areas with a razor blade the same way I do with a regular watercolor, finishing by adding a few highlights to the water.

MORNING SAIL, 8″ × 10″ (20.3 cm × 25.4 cm), collection of the artist

Using Watercolor Crayons

I also enjoy using watercolor crayons for sketching, as they can be handled much like pastels. Many good brands exist; my preference is Caran d'Ache. They are excellent for short trips when your supplies are limited, and they can be used to accent light pen and India ink drawings. You may even find that some of the regular children's watercolor crayons are satisfactory in this capacity.

Alex Yaworski, TREES FROM AROUND THE WORLD, 24″ × 30″ (61.0 cm × 76.2 cm), courtesy of the artist

An exhibit of Christmas trees at Chicago's Museum of Science and Industry inspired this work, in which watercolor and wax crayons were used in combination with transparent watercolor underpainting and acrylics. Before the final darker tones were put down, the artist applied Crayola crayons to a couple of the trees to give texture to the trimmings, as is perhaps most evident in the second tree from the right.

Doris White, NEW HARBOR, 30″ × 40″ (76.2 cm × 101.6 cm), collection of Valfred Thëlin

The dark relationships in this cross-shaped composition were established with a series of underglazes; giving context to the various patterns and shapes are delicate lacy lines the artist drew with a watercolor crayon.

Making Monoprints

Another fun experiment with watercolor is monoprinting, which is a form of glazing. To make a monoprint, set out pigment at random on a smooth surface of glass, plastic, or tile, and create a pattern with it. Then place a piece of bristol board or hot-pressed paper over the painted surface, and apply pressure with your hand, a ruler, or a brayer to transfer the pigment onto this new surface. Then lift the board or paper from the painted surface, and turn and twist it until something emerges from the patterns that form. You may wish to add some detail to this or keep it an abstract design; the preference is yours.

In a monoprint, the interaction of colors and their drying times are important factors in developing the effects you're after. One of the reasons I prefer bristol board over paper for this technique is that it dries faster; the water does not have as far to go to penetrate the surface. If you want, you can slow down the drying time and keep the surface damp by spraying it with water from an atomizer. When necessary, you can go back into the surface with a wet brush, but work quickly, because slow or repeated strokes will cause a blossom to develop.

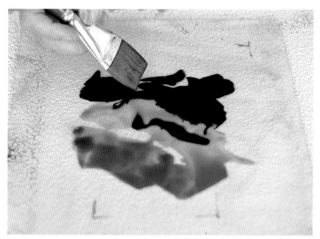

I laid glass over a piece of hot-pressed paper and marked the paper's corners on it so I would know the perimeters of my painting surface. Then I removed the paper and turned the glass over to preserve my perimeter marks. I mixed up pigment and placed it directly on the glass.

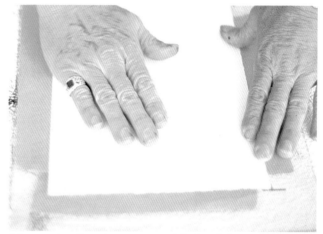

After moving the pigment around, I placed the paper face down on top of the glass and used both hands to press against the surface.

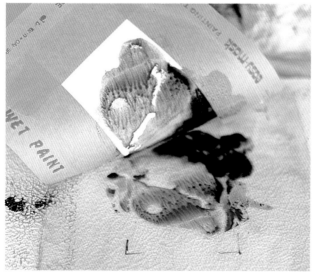

Removing the paper rapidly gives one type of pattern, removing it slowly another. You might want to try making two or three prints using the same amount of color, but pulling the paper off at different speeds to discover the various effects.

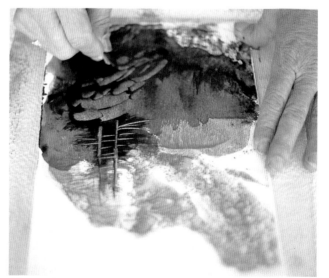

After making several prints onto the paper, allowing it to dry between printings, I used a razor blade to create the rock formations. The mountain form was caused by the monoprint itself.

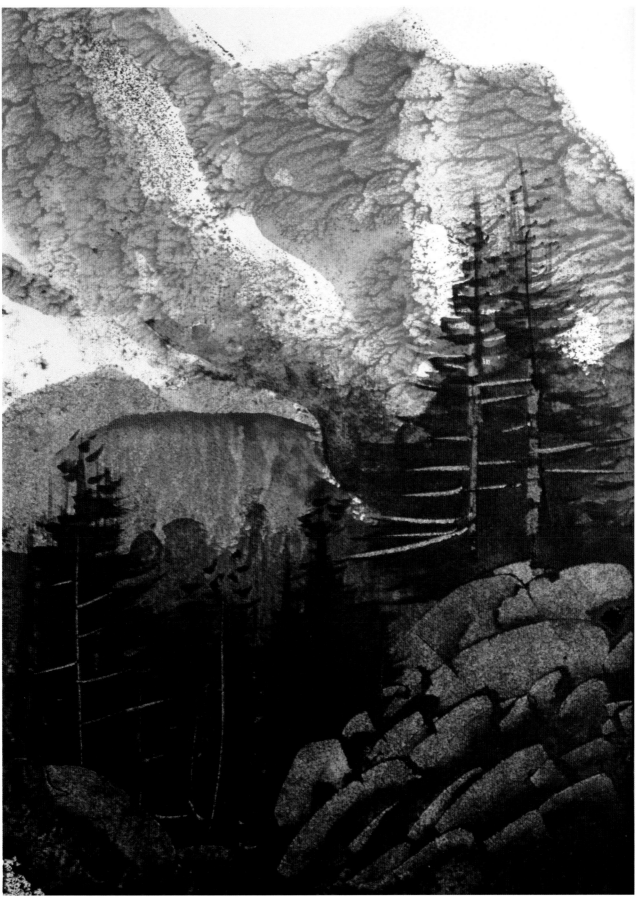

BEAR PASS, 14″ × 16″ (35.6 cm × 40.6 cm), collection of the artist

Other Interpretations

"When I saw the sun rising over the fogbound marshes," the artist says of this image, "I knew I had to record the scene's quiet beauty, its appealing softness of form and simplicity of detail. I began by applying a transparent wash of neutral gray over my painting surface. When the wash was dry, I sketched in the major shapes of sky, sun, marsh grasses, and water. Over this I layered washes of color, lifting shapes out of the wet pigment each time and adding texture with crumpled paper towels and water spray. I continued this process until I had a rich, dark surface. Using the still-visible drawing as my guide, I began to indicate light areas by adding small amounts of titanium white to each color as I mixed them on my palette. I roughed in the sky and water, softening the outer portions of these shapes with dry brushstrokes and blurring them with a paper towel. Once these areas were loosely defined, I intuitively altered the tree and grass silhouettes with a transparent dark color. When I had achieved the effect I wanted, I placed a mat around the painting and looked at it from a distance. The arrangement of light and dark areas was pleasing and exciting to me, but the light areas were a little dull, so I glazed color over them. The layering took time because I wanted the transitions to be gradual. I completed the painting by laying in transparent glazes."

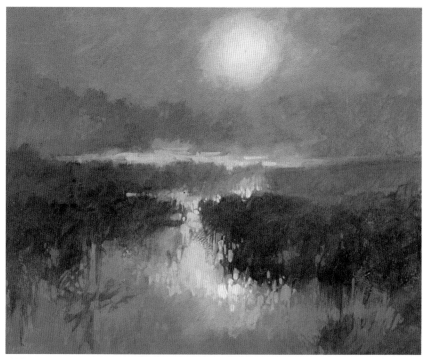

Al Brouillette, BURNING OFF, 14¼″ × 18″ (36.2 cm × 45.7 cm), courtesy of the artist

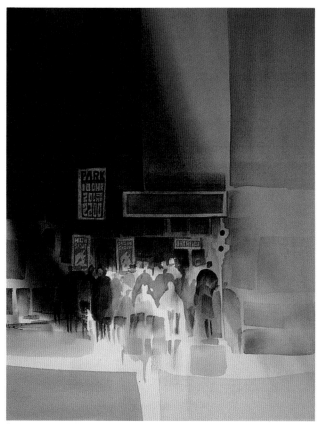

FIRST NIGHTER, 16″ × 20″ (40.6 cm × 50.8 cm), collection of the artist

In this painting I kept all glazes in a very high key to accentuate the intense street lighting. The cross-shaped composition is simple, as are all the forms and figures.

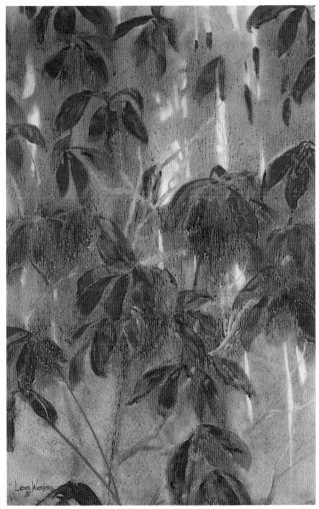

This painting shows just how exciting a monoprint can become. Lee Weiss's approach in this case is slightly different from mine in that she wet the paper and applied pigment directly onto it. "While the paper was still wet," she says, "I turned it face down on a plastic table surface. Then, using a brush, I liberally wet the back of it and painted on colors to enhance and modify what I remembered having applied to the front. At this point I flipped the paper over again, allowing the reverse side to pick up colors deposited on the table's surface by the first side. I then added more color to the first side, flipping again to add texture and color to the reverse. Essentially I was using the table to monoprint with each turning. I continued this process until I achieved an interesting overlay of color and texture that would become the basic background for direct painting. Next I lifted highlights; I squeezed a 1″ flat brush nearly dry and used first the edge, then the flat side to suck up the pigment and reveal the white of the paper again. Finally I added accents, applying some delicate touches of color and some heavier ones to create a representational image from what was an essentially abstract takeoff point."

Lee Weiss, **VIRGINIA CREEPER**, 40″ × 26″ (101.6 cm × 66.0 cm), courtesy of the artist

Practice Exercises

1. Practice the basic glazing technique in two or three small paintings at a time, allowing each color application to dry before you add the next.
2. See how you can add dark shapes to a painting by using a transparent glaze, as in the sailboat demonstration on page 66.
3. Try painting flowers using glazes and the masking technique.
4. Practice the bucket stroke. See how many forms you can define with it.
5. Make practice squares of color with pastels, crayons, and ink. Notice how the different mediums respond when dampened.
6. Try a few monoprints, creating shapes and patterns with the pigment when it is wet and when it is dry. Use a razor blade or other found materials to develop details.

7

THE HUMAN ELEMENT

I once had a student in my class who would ask, "What is he doing?" every time I put a figure in a painting. The only answer I could give was, "It is needed." Figures are an important part of painting. They give you an opportunity to let your imagination run free, and you can make them do whatever you want them to do, as long as you remember that it matters where and how you place them in the composition.

Seeing figures as integral parts of a whole painting is as important as noting who or what any particular one represents. The application of overlapping glazes is a good method for establishing figures convincingly in a painting because you can build them into the interplay of dark and light, as in *The Sandpiper Pub*, opposite.

I like the human element in a painting. Figures are reference points we all can easily identify with; they make a human connection that pulls the viewer into a picture and gives it life. Their scale in a composition is important in establishing depth and drama. For instance, in Charles Woodbury's *Seventh Wave*, on the facing page, the figure is small, emphasizing the immensity of the ocean. Here, as in *Snow Skiers*, page 15, the landscape dominates in a dramatic way. Note how Woodbury creates depth: The man in the boat in the foreground brings us into the scene and pulls us toward the rocks in the middle ground, and from there our gaze is drawn toward the crashing wave.

Not only can figures add dimension to a painting; they also can reveal the artist's vantage point. In a picture done from life, the placement of figures indicates where I sat when I composed the scene.

When adding figures to your work, always consider how they will fit into the composition, paying particular attention to how they relate to one another in terms of size and how they relate to the overall action.

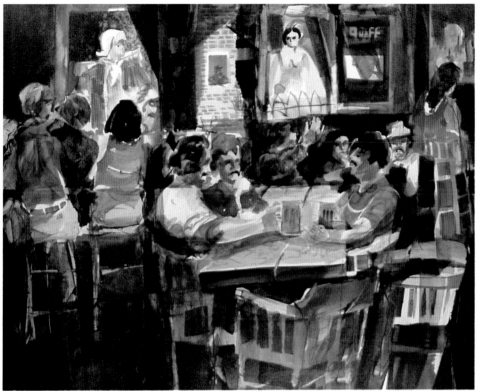

The Sandpiper in Ogunquit, Maine, was once a favorite hangout for local artists, poets, musicians, and actors, and I consider this large image of figures sitting around its massive, initial-carved wooden table one of my best barroom paintings. Based on a number of sketches I had drawn on location, I made this painting in my studio using the glazing technique.

THE SANDPIPER PUB, 44″ × 60″ (111.8 cm × 152.4 cm), collection of the artist

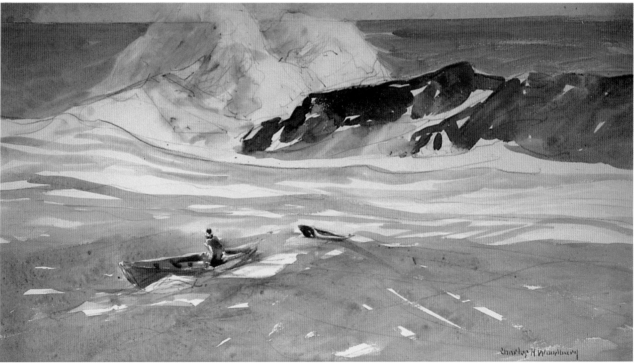

Charles Woodbury, **THE SEVENTH WAVE**, 16″ × 24″ (40.6 cm × 61.0 cm), courtesy of the David O. Woodbury Estate

Charles Woodbury was a master at painting the ocean. By placing the small figure in its midst, he established scale and perspective in the composition.

Getting the Essentials Down

You don't have to be a master draftsman to paint figures successfully. Developing an exact replica of the human figure is not important; indicating human movement and its patterns is what is essential. I have known a lot of very good artists who avoid using the figure in any major way but will place small ones in the background of a painting to add interest. This is what we hope to achieve here.

Begin to familiarize yourself with figures by sketching their shapes, sizes, and movement. Some of the best places to sketch are airports, beaches, markets, or your own home. When I was in school, we used to go to the railway station to draw people waiting for trains. Thousands of passengers, each in a different position and mode of dress, supplied as many ideas and subjects. Don't ask anyone to pose; try instead to catch them as they go about their activities. If there is a life-drawing class near you, join it and practice, and don't worry what your contemporaries are doing.

Anytime you sketch a figure, avoid trying to get down every last eyelash or hair on your subject's head. All you should seek are the general shapes of hair, clothes, per-haps glasses, the slope of the shoulders and quickness of the person's step. With just these essentials you can capture the reality of the figure.

As you begin working with figures, you will discover how their proportions work; for instance, on the average, figures are seven heads tall. I make mine eight heads tall just by way of interpretation, so they have small heads on big bodies. Strange as it may seem, you will find that the figures you develop look a lot like you, perhaps because your own body is the one with which you are most familiar.

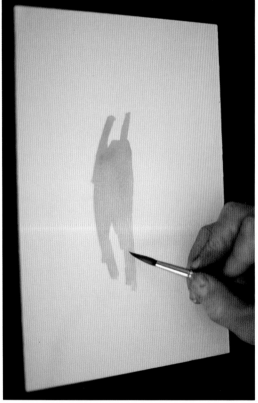

Down in the harbor area of Ogunquit, I make a lot of little drawings of figures that I might be able to use in a painting. One of my favorites is the lobsterman. I painted the yellow rubber protective trousers first, allowing space for the red shirt to be added. Last, I painted the details that gave the figure character: beard, sunglasses, and bait.

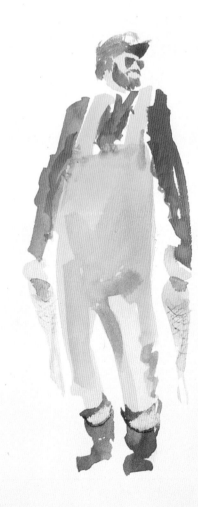

THE LOBSTERMAN, 8″ × 10″ (20.3 cm × 25.4 cm), collection of the artist

WANT-AD FIGURES, 16″ × 20″ (40.6 cm × 50.8 cm), collection of the artist

Use the classified columns of a news-paper as a surface on which to practice constructing realistic figures. The small spaces will force you to put the figures together proportionally, and you can depict them in a series of different positions, making them stand up and sit down in a row that allows for comparison. Paint all the torsos first, then the legs, and finally the charac-teristic attributes—a hat, a golf club, a fishing pole, and so on. If you use two colors, one for the torso and one for the legs, you will easily see what is happen-ing. You can feel free to do as many of these as you wish, as the paper is cheap stock to be used and thrown away.

I created these figures using the same approach as in *The Lobsterman*, opposite.

Handling Groups

Painting people in groups means recognizing the story they tell as a whole and being aware of the rhythms of their gestures as they interact. Study not only the shapes of people in a group but also where they are positioned. Who dominates whom? Pay attention, too, to how one figure in a group relates to another in terms of size and proportion. Sometimes these elements are determined not so much by a person's actual physical size as by how aggressive he is in the group, which you can express by the color of his clothing—red, for instance, suggests boldness; green, calm scrutiny.

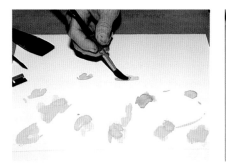

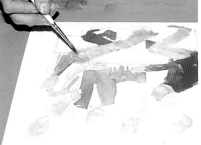

I am fascinated with chess and checker players and with the crowd that gathers to question the next move. I like to work directly with a brush, but you may find it beneficial to draw lightly with a pencil first. To begin, I mixed together Winsor red and cadmium orange and painted in the figures' heads, hands, and feet.

Next I added the two opponents seated at the table, then placed figures around them, creating negative and positive shapes and carefully choosing my color complements—red against green and yellow against purple.

I stroked in the major shapes of the figures with a 1½" flat brush, then went in with a smaller brush to add details, allowing each stroke to create the action—the tipped-back chair, the entangled legs, the involvement of the audience—all important parts of the story. This brought the painting to completion.

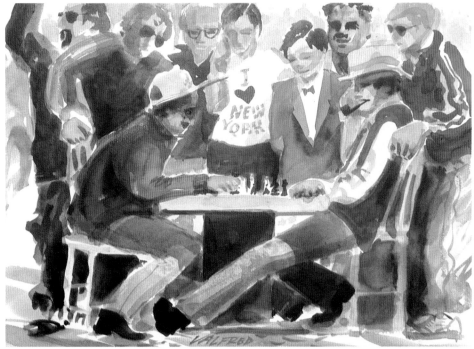

THE CHESS PLAYERS, 16″ × 20″ (40.6 cm × 50.8 cm), collection of the artist

Here the glazing technique worked to catch the color and action of a Saturday market in Guatemala. First I put down the yellows and allowed them to dry.

Then I added oranges.

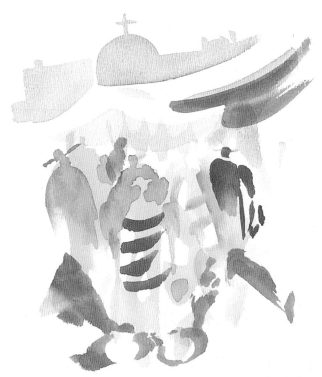

I followed these two glazes with alizarin crimson and cobalt blue, working back and forth with positive and negative, large and small forms, to bring out the figures and create a sense of their movement. This is the same technique I used for the painting that appears on the title page.

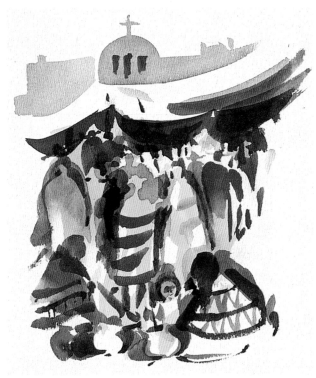

CHICHICASTENANGO sketch, 8″ × 10″ (20.3 cm × 25.4 cm), collection of the artist

Sketching with a Razor Blade

I enjoy sketching figures with a single-edge razor blade. The feel of this tool is very similar to that of a 1½" flat brush and offers the artist as much dexterity. In turn, using a razor blade also helps you develop a freedom of movement that will carry over to your brushstrokes.

To master the technique of sketching with a razor blade, pour a little India ink into a container—an ashtray is perfect for this—and dip the blade into it. When I'm in the field I take my own ashtray, but when I'm in a nightclub or similar surroundings, I borrow any ashtray sitting around. First I pick up some ink on my razor blade, then I begin drawing, using full, sweeping motions to get the action down. I can suggest smaller shapes with a twist of the wrist. It takes a little practice, but it's worth the effort.

The razor-blade sketches shown here were all done on location. Instead of a blade you can also use swizzle sticks, matchsticks, or twigs; however, when I'm sketching in a place like a tough barroom, where the characters are interesting but I may not be welcome, I always use my razor blade. I find that people never bother anybody who's holding a dirty razor blade.

While sitting to one side of the action, I did this sketch rapidly to capture an impression of the audience, which was scattered over a fifty-yard area. For freedom of movement I worked on a 24" × 30" (61.0 cm × 76.2 cm) Strathmore layout pad.

NEIL AND THE NIGHT LIFE, 18" × 24" (45.7 cm × 61.0 cm), collection of the artist

I have done many sketches like this one on location and have used many of the figures in paintings.

THE LIBBY ESTATE AUCTION, 18" × 24" (45.7 cm × 61.0 cm), collection of the artist

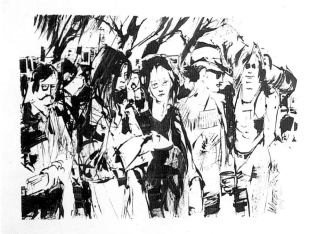

WINTERPARK FESTIVAL, 18″ × 24″ (45.7 cm × 61.0 cm), collection of the artist

While sitting at my booth during the Winterpark Festival art fair, I did this gallery of people passing by. At no time were all these figures at the booth; I added them in one at a time as the sketch progressed.

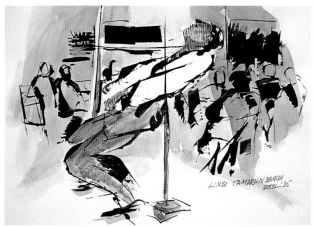

LIMBO DANCER, 24″ × 30″ (61.0 cm × 76.2 cm), collection of the artist

Again I used a razor blade to catch the action of the limbo dancer sliding down beneath the poles. I like to use India ink because it dries rapidly and is permanent, so you can put a light watercolor wash over it without disturbing it. This allows you to make color notations while you're sketching.

BULL RIDER, 24″ × 30″ (61.0 cm × 76.2 cm), private collection, Atlanta

This razor-blade sketch was done in Montana at a rodeo, where I aimed to catch the rapid action.

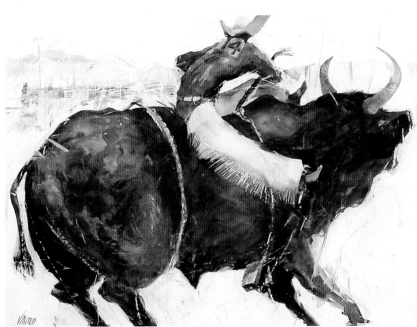

BULL RIDER, 30″ × 40″ (76.2 cm × 101.6 cm), private collection, Atlanta

I began this interpretation of the bull rider with a razor-blade underpainting to capture the same action depicted in my sketch. I then went in with my watercolor to create the texture of the large bull and the animation of the cowboy ready to slide off into the foreground. The background was only lightly suggested, because when you ride a bull or are watching a rodeo, the background seems to disappear.

Varying Your Approach

For abstract figure representations I use a flat brush with the bucket stroke, as the step-by-step example shows. When working more realistically, a round brush works better. In the series of practice figures, note the difference between those rendered with a round brush and those done with a flat. Also note: To make an upright figure balance, keep one of its feet aligned beneath its head.

If you want more pronounced figures, first draw them in lightly, then proceed by using the glazing approach, as in the nude studies opposite. For the more loosely defined figure in *Turquoise Necklace*, I used plastic wrap and watercolor crayon, which you might want to try in your own work.

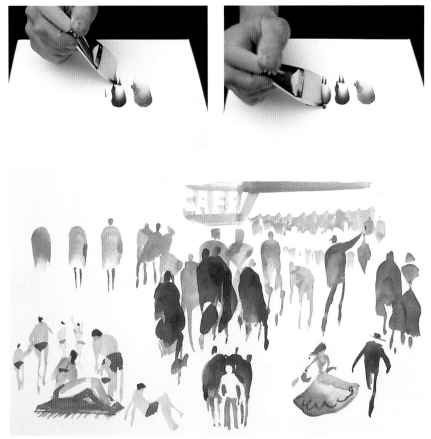

When you use the bucket stroke to paint a figure, the shoulders and head will be dark and will fade down into the legs in a semiabstract shape. Although this is not necessarily how the figure appears in nature, it seems to work in a painting.

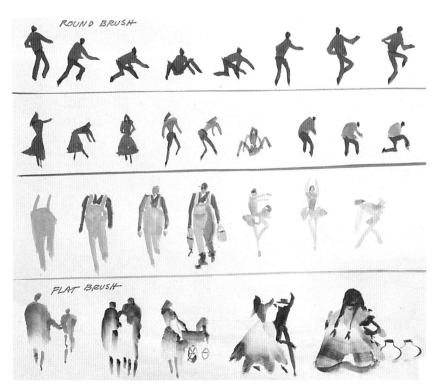

To paint the top three rows of figures, I used a round brush, which allowed me the dexterity I needed to get their patterns down.

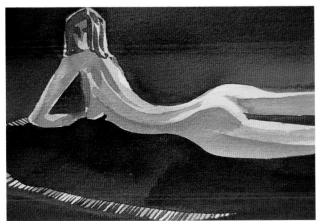

NUDE WITH SUNLAMP, 8″ × 10″ (20.3 cm × 25.4 cm),
collection of the artist

This painting is one of about twenty-five I did one day in my
studio. I began with the glazing technique, quickly putting
down a series of pale flesh tones using Winsor red and
cadmium orange to catch the mood and pose of the model. I
let her take one quick pose after another so as to establish a
relaxed atmosphere, which wouldn't be possible with longer
poses. As the day progressed, she returned to earlier poses to
allow me time for additional work. Slowly I built each glaze,
sometimes adding a touch of cobalt blue to give a cool quality
or a little ochre to emphasize the red tones, leaving a little of
the undertone from the previous layer every time, and ending
at last with alizarin crimson.

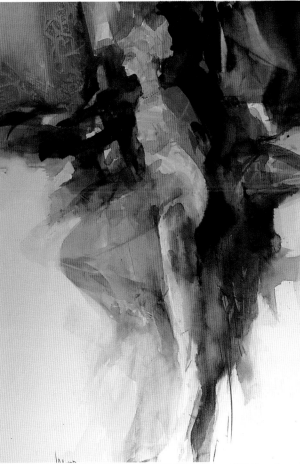

THE TURQUOISE NECKLACE, 30″ × 40″ (76.2 cm × 101.6 cm),
private collection

For this seated nude I tried a new technique. First I laid in
cadmium yellow deep, orange, and flesh tones, then I added
alizarin crimson to the outer areas and placed brilliant green
in the upper right-hand corner. While the painting was still
damp, I put plastic wrap over it and let it dry, then removed
it. Next I used the bucket stroke to pull the figure out of the
background. I finished by adding the turquoise necklace with
a watercolor crayon.

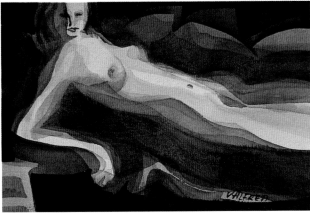

NUDE ON SOFA, 8″ × 10″ (20.3 cm × 25.4 cm),
collection of the artist

Another figure from the same series of nudes. I find the
glazing technique is an excellent way to catch a model's
movement.

Other Interpretations

Sports artist Wayland Moore describes his speedy technique for getting the action down. "First I coated a piece of illustration board with one layer of gesso. Then I sketched in the figure, using a bamboo pen and India ink to capture the looseness of movement. Next I added a thin coat of acrylic paint to get a watercolor effect that would give me a finished sketch fast, since acrylic dries within minutes. When painting action sports on location I need to have dry sketches in a hurry."

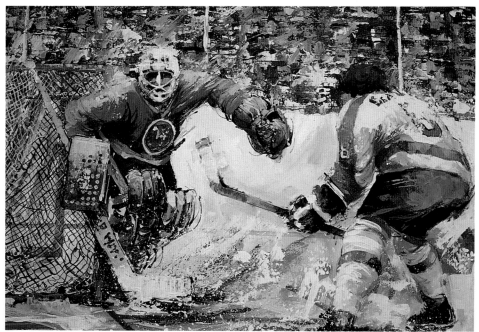

Wayland Moore, HOCKEY SKETCH OF PLAYER/GOALIE, 20″ × 30″ (50.8 cm × 76.2 cm), courtesy of the artist

This nude, painted in early-morning light, is typical of Henry Strater's limited brushwork, which gives fullness to the form. Here he used gouache, an opaque watercolor. Originally a landscape artist, Strater evolved into a figure painter and did a remarkable number of studies of friends, family, and models.

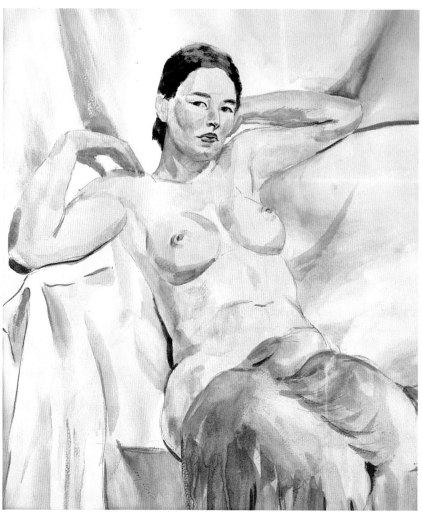

Henry Strater, SEATED NUDE IN REPOSE, 18″ × 24″ (45.7 cm × 61.0 cm), Permanent Collection, The Museum of Art of Ogunquit, Maine

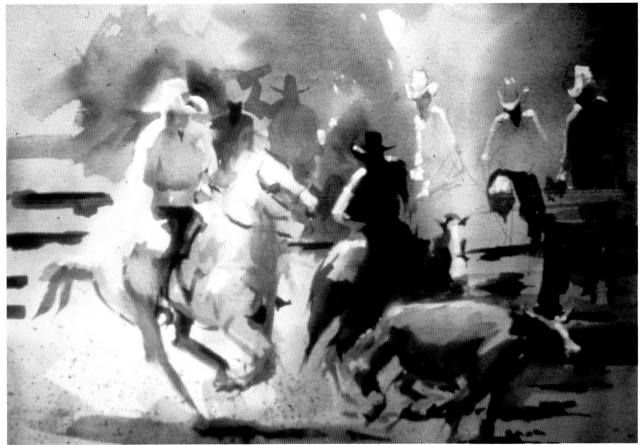

Robert Hiram Meltzer, **THE BULLDOGGERS**, 22″ × 30″ (55.9 cm × 76.2 cm), courtesy of the artist

"I first sketched this cowboy scene on a California ranch," Meltzer says. "For the painting, I made a line drawing in 6B pencil, placed a wet bath towel on my drawing board, then put my paper on top of it and wet the front generously with a 4″ brush. Next I sloshed turquoise, alizarin crimson, cobalt violet, cadmium orange, raw umber, and raw sienna on this surface. With an elephant-ear sponge, I then wiped out the area where the rider would be, dried it with towels, and removed the bath towel from underneath the work. This system encouraged the luminosity I was after by dispersing colors on the reverse side of the painting. Next I built up dark areas such as the horse, steer, dogger, and corral fence, and then lightly penciled in the figures on the fence. To capture more light in the painting, I touched opaque white on the fence-sitters' hats, the bulldogger's shoulder, the horse's rump, and elsewhere. Cadmium orange and cobalt violet throughout added a radiant quality as well."

Practice Exercises

1. Try sketching at least one person per day, at home, in the park, the mall, or wherever you are. If you can do more, so much the better. Take photographs if possible.
2. Sketch people you watch on television as a fun way to practice "quickies."
3. Use sketches you've already made as guidelines for practicing razor-blade figures and bucket-stroke figures. Notice how the figures change with each technique.
4. Collect pictures of people in action from newspapers and magazines, and use them as guidelines for practicing "want ad" figures.
5. Work with your sketches and photographs to construct a series of figures like the ones shown on pages 78 and 79.
6. Do a landscape painting and add some figures for interest.

8
CITYSCAPES

I love the excitement of the city, the noise and the movement, the constantly changing scenes that make it seem alive. Action takes place twenty-four hours a day. The signs, the streetlights, the bold forms of buildings, and the ceaseless commotion all work to make up a city's many shapes, patterns, and values.

The colors of the bright lights at night vibrate in multiple reflections on the streets, especially after a fresh rainfall; in the dust of day, all are quietly dimmed. On sunny days, pulsating crowds cross streets, and shadows dance over figures and buildings. But on gray days, the city settles down into tonal values.

Take time to observe your city or town during different seasons and times of day. Make sketches and photographs. Look at the city from a distance, from a bridge or a high building. Then stand on a street corner and watch people and how they react; venture down a street or a little alley; visit the markets, the parks, the restaurants outside and inside, and the nightclubs. What I am saying is, get involved with the city, with its smell, its feel, its mood. Once you have done this, you will be inspired by the radical changes of color and value that take place there, changes that are not nature's, but are man-made phenomena.

I lived in the city for a while, and most of my original concepts developed at that time, including the techniques I use to create impressions of urban life. In particular, glazing is perfect for capturing both the dramatic and the subtle in urban light and shadow; you can express the complex multiple layers of city life in as many layers of glazes. I soon discovered that you can apply the same techniques to depict most major cities around the world. The buildings may change, as will the calligraphy and the dress of the people, but the general energy and appearance will be similar, with the same busy quality. To re-create an urban scene, pick a subject that identifies the city and then elaborate on it, as in these paintings of New York and Hong Kong.

This painting captures the frenzied activity of Hong Kong in the signs, the laundry hanging out to dry, the rickshaws, and the movement of people in the street. First I put down cadmium orange and yellow, then moved up to the reds, and last added dark purples with alizarin crimson and Winsor blue. With a palette knife I suggested the wires and lines across the top of the street, thinking of them as a network of spiderwebs holding the city together. The rickshaws moving up the street animate the painting and give it depth.

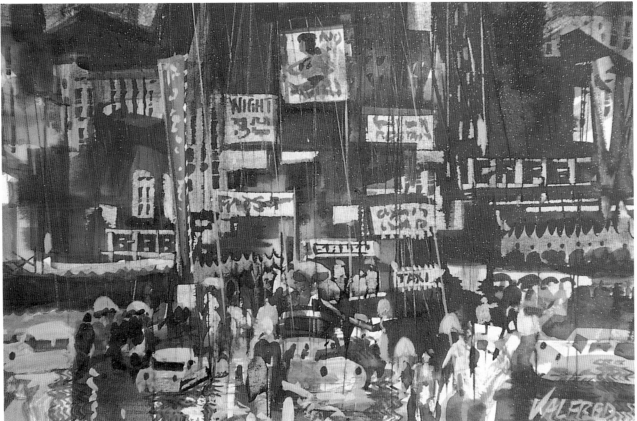

ALWAYS AFTER EIGHT, 16″ × 20″ (40.6 cm × 50.8 cm), collection of the artist

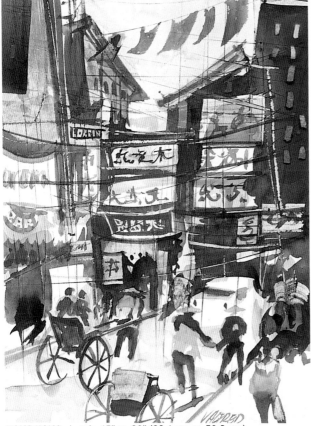

HONG KONG sketch, 15″ × 20″ (38.1 cm × 50.8 cm),
private collection, Florida

Here is an impression of New York City's Broadway just before the show crowds move in. To make this painting I wet the entire surface and began with Holbein's opera, Winsor red, and cadmium orange, letting them bleed and move around. When the board was slightly damp, I came in with a palette knife, scratching back and forth to establish the signs and patterns of the Times Square area. After this had dried I put alizarin crimson in the background to establish the shapes of the buildings. Then cars and people began to appear. I finished by adding Winsor blue over the top. Then, deciding it was much too dark, I squeegeed away color, allowing the buildings to reflect light from the nearby street, as in the upper right-hand corner. When the painting was semidry I used my palette knife to briskly stroke down through the board, bringing up color from underneath. Umbrellas started to pop out all over the place, and the underpainted color in the foreground worked to reflect lights in the wet street.

Glazing Procedures

I approach both day and night scenes, indoors and out, with the glazing technique. I begin by laying down shapes of cadmium yellow and orange, then build up my color to create the positive and negative forms of lights and street signs, adding suggestions of figures and buildings where the composition demands them, designing as I go.

As the color builds, I use the razor-blade technique to squeegee out color and let the no longer quite white paper show through to create light areas. This is similar to the approach I used in painting trees and rocks.

This works well for daytime scenes, but for night scenes I over-paint about eighty percent of the completely dry bright underglaze with a dark color, usually a mixture of Winsor blue and alizarin crimson. While the color is still damp, I scrape out passages for lights, reflections, lighted windows, signs, and brighter buildings, allowing the underpainting to show through. This can result in a very dramatic image that has the appearance of a woodblock print, as in *Boothbay Harbor*, page 92.

This painting was begun with a glaze of cadmium yellow, which I let dry before adding a second glaze of the same color. The overlapping layers created new shapes.

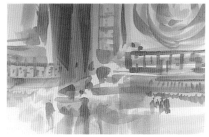

Using the same process, I added cadmium orange, then scraped out light areas with a razor blade, creating even more new shapes. Negative painting was used to snap out the signs and the figures that began to evolve.

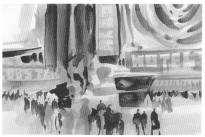

I then glazed on alizarin crimson, using the darker color to further define people and areas of interest.

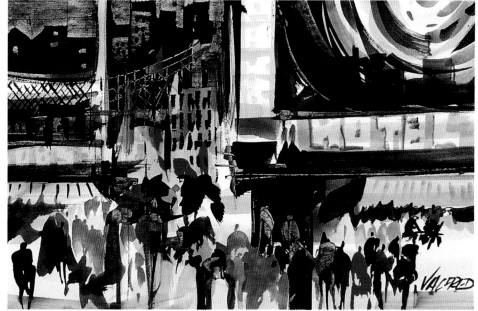

SHOWTIME, 16″ × 20″ (40.6 cm × 50.8 cm), private collection

I finished the painting with a Winsor blue glaze. Throughout the painting process I kept finding forms that said "city" to me. As I saw them I used a darker tone to bring them out and make them visible.

Special Techniques

When painting a cityscape, there are some special strokes you will want to adapt.

To pull out stop signs and posts, paint negatively, using the bucket stroke behind these objects. Also use the bucket stroke to create figures, as shown in the preceding chapter.

For depicting the repeating patterns of tile roofs, windows, and brick facings, use a split brush. Another way to get patterns is to cut notches in a piece of cardboard and use this tool as you would a razor blade.

The split brush is a very useful technique. First, load a flat brush with color. Then, using the handle of another brush or a credit card, divide the bristles evenly, as the illustration shows. Do *not* use a palette knife or a razor blade to split your brush, as they will damage the bristles. Hold the brush flat and draw patterns as demonstrated—tile roofs, brick walls, windows.

You can use a notched piece of cardboard to get the same effect.

Try using cardboard to draw buildings, figures, and backgrounds the same way we have used the razor blade. This is very effective for creating patterns; you can dip the cardboard into different colors and use various types of cards to get a range of textures.

Focusing the Composition

In working out the composition for a cityscape I usually choose a cross format, which I prefer for man-made subjects like buildings, I suppose because all such structures are vertical to the horizon line. Sometimes I use a double cross, meaning simply that more than one cross appears within the composition. Double or single, the cross can have a horizontal or a vertical axis, and you can place it wherever you want (I usually call it the "movable cross" for this reason), even in the center of the picture, but wherever the lines meet is where the action should take place. That's where you should place a landmark identifying the particular city you're depicting. This landmark could be a monument, a specific building, a sign, or even figures in their native dress.

The compositions shown here illustrate how adaptable the format is. You can easily develop positive and negative shapes within this type of scheme; just remember that activity should occur where the arms of the cross intersect. To liven up a scene, I sometimes focus on a central area within a picture and keep the movement around it circular, creating a series of overlapping triangles or rectangles, as in *Monument Square*, opposite.

CROSS POSITIVE

MOVABLE CROSS

DOUBLE CROSS

These diagrams illustrate the highly adaptable cross format, which I find particularly useful for cityscapes. Whether its axis is horizontal, vertical, or even diagonal, the cross can appear anywhere within the picture plane; the main action in your composition should be focused where the arms of the cross intersect.

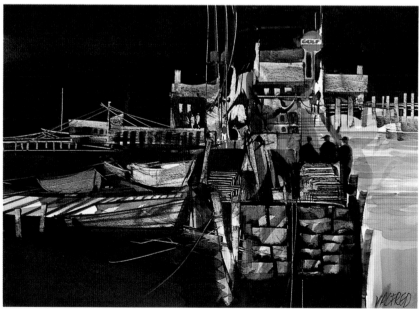

BOOTHBAY HARBOR, 30″ × 40″ (76.2 cm × 101.6 cm), private collection, California

The cross composition is quite obvious in this painting, the angle of the pier leading the viewer's eye right into the scene. I used cadmium yellows and oranges underneath the dark tone. Then I scraped out areas with a razor blade to develop the boats along the harbor line.

To create a special spot, I pick out one subject that will identify the city I'm depicting. All the other things are abstract forms that may or may not actually be there. In this picture I wanted to show the city encroaching on the park in the right foreground, where people are out enjoying the spring sun. As in other paintings, I began with cadmium orange and yellow. After wetting the surface, I put down alizarin crimson and Hooker's green dark, then ran a palette knife through it to develop design lines. (This type of action seems to work best with cities and man-made structures.)

I added the figures using the bucket stroke. The dark alizarin crimson shadows were added to the background to bring the monument forward.

The kiosk that began to appear gave shape to the foreground, while the sun bouncing off the ground and the high-key lighting on the monument reflect back onto some of the buildings, providing contrast. To complete the composition I added street signs and other objects, details that were not specific to any city but gave an impression of the place.

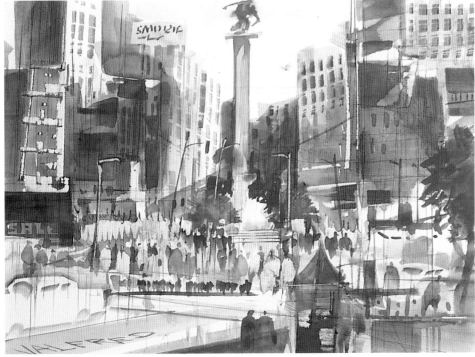

MONUMENT SQUARE, 16″ × 20″ (40.6 cm × 50.8 cm), collection of the artist

Other Interpretations

"For this painting," says Messersmith, "I taped a piece of Bockingford paper to a piece of ¼″ panel board, then dampened the entire surface with a 4″ housepainter's brush. Using a reference sketch, I took a 3″ Japanese brush and applied a heavy amount of watercolor pigment in the general area of the horizon and sky, then lifted up the board and let the medium flow on the flooded surface of the paper. I prepared several pieces of heavy mat board ranging from ¼″ to 3″ wide to use as implements for creating the building forms; I dragged each piece sharply downward, applying enough pressure to remove color until the white paper showed through. The fenestration of the buildings was achieved by dipping ¼″ pieces of mat board into various colors and more or less printing in the window shapes. I also used my trusty trowel-shaped painting knife to add grasses, reflection lines in the water, and bird formations in the sky. I used a rigger brush freely in the foreground to stipple and splash some of the linear shapes you see there."

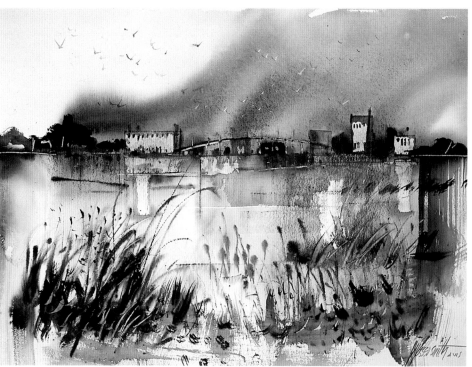

Fred Messersmith, **CITY REMEMBERED**, 22″ × 30″ (55.9 cm × 76.2 cm), courtesy of the artist

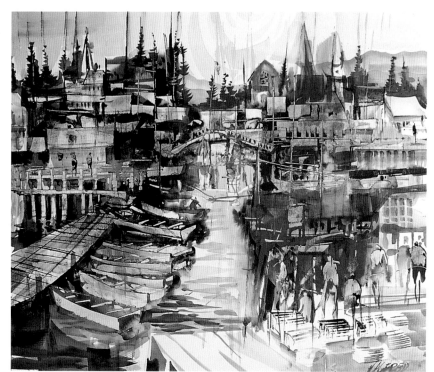

PERKINS COVE, 20″ × 30″ (50.8 cm × 76.2 cm), collection of the artist

This is an impression of Perkins Cove, a favorite spot of summertime visitors to Ogunquit. At that time of year it is filled with activity characteristic of many urban areas, but in winter it is lazy and laid back. Here it is viewed from the "Finest Kind" Pier looking directly out toward the sea, where the late afternoon sunlight bounces back and forth off the boats. My studio sits in the distance at the back of the cove.

SIXTH STREET MARKET, 5′ × 7′ (152.4 cm × 213.4 cm), private collection, New York

Cities after dark are abstractions. Your color palette will change rapidly under any artificial light; at night the spectrum is reduced, and some colors—blues, reds, flesh tones—become saturated with reflected light and gain intensity. The inspiration for this painting came after I had made many nighttime sketches in New York City, sketches that caught the light reflecting down onto hands and arms of figures as they seemed to disappear into the background. I did the painting in watercolor on a Masonite panel coated with gesso, which I applied with a roller to get texture. After the gesso dried, I painted in my initial patterns with watercolor, capturing the ghostly impression of the figures' heads, leaving the skin tones rather pallid in contrast with the bold reds, purples, and oranges.

Practice Exercises

1. Collect pictures of cities and towns.
2. Visit a city and make your own sketches. Observe identifying landmarks that set it off from other towns.
3. Paint buildings using the bucket stroke.
4. Cut out pieces of cardboard and try sketching a city with them, defining tile roofs, windows, and other architectural details. Experiment with the split brush as well.
5. Try doing a night scene using a series of glazes, scraping out lights and signs with a razor blade, as in *Always After Eight*, page 89.
6. Try developing a city or town using the cross or double-cross composition. Use *Showtime*, page 90, as a guideline.

9

THOUGHTS ON SKETCHING

We began this book with the simplest way of using watercolor, the controlled drip. From there we experimented with other techniques and looked at different ways of painting skies, trees, rocks, figures, and cityscapes, always thinking, *Let the medium do it.* But there's an important "first step" that deserves special mention here—before you take all you've learned and put it together in your own painting. To capture the mood, the color, the temperature, and the activity of a scene in paint, you must visit it and sketch it.

Sketching allows you to collect a variety of information and reveals a lot about the things that will fit into your interpretation of a scene. A sketchbook enables you to grasp the flavor of an area, its music, the character of its people, the smells and sounds of the marketplace. My sketch pad is my "security blanket"; I carry one at all times wherever I go, for I never know when I am going to see something that appeals to me. You will often find that a sketchbook is welcome where a camera is not, such as in some foreign countries, in bars, and at private parties. I have been invited into many homes and made many new friends because of my sketchbook.

Even with all my sketching, I still find it necessary to take a camera along for collecting resource material; it's a useful tool for recording some of the details I might otherwise miss. I often use a half-frame camera—a 35mm camera that exposes only half a film frame with each shot—so I can get twice as many pictures on one roll of film and thus don't have to reload so often. I do not, however, rely solely on photographs as reference sources. Quite often they just can't capture something you've seen with the power your imagination brings into play. Making a sketch on location engages all your senses and involves you more deeply in an image.

With your sketch pad as well as your camera, you need to move around your subject, recording shapes, textures, spaces, colors, and the intimate details that interest you. All this information is vital for the store of knowledge you will need as you work on more complete paintings later on. Whether you work realistically or abstractly, you need an underlying foundation of form, composition, and balance, which you can obtain only from observing your surroundings. This is one of the most important aspects of sketching. My grandfather used to say, "You cannot distort what you have not actually experienced; being there is the key." It is crucial that you understand your subject matter if you wish to interpret what you see honestly and personally.

Sketches are a form of short-hand. Look at van Gogh's drawing and note its simplicity. He would do pencil sketches on location, then go to the studio and draw over them with pen to break down the shapes.

Vincent van Gogh, **THE HARVEST**, 12½″ × 9½″ (31.8 cm × 24.1 cm),
National Gallery of Art, Washington, D.C., Collection of Mr. and Mrs. Paul Mellon

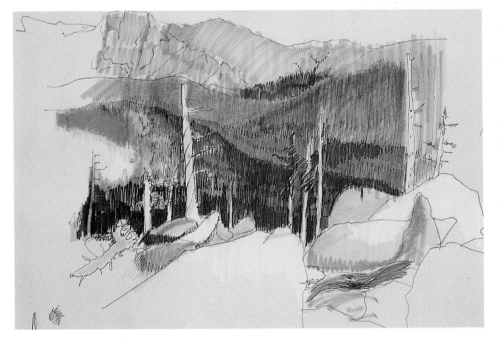

This sketch of the Grand Tetons was done on location at a rest stop on a narrow, winding mountain road. The view was magnificent but my time was limited, so I quickly drew in fine, linear forms with a permanent felt-tip pen. Then I used a series of colored pens, blending the hues with an overlay method. After five or ten minutes I was back on the bus, where I used cross-hatching to bring out the values of the scene. That night, while I still remembered the scene, I refined the drawing.

Sketching Techniques

I do my initial sketches on translucent layout paper, using a marking pen or a razor blade with India ink. That way I can either refine the drawing later by putting another translucent sheet over it or transfer it to watercolor paper. I carry along a small watercolor paint box so I can develop color relations in my drawings. I also use Magic Markers, watercolor crayons, and felt-tip pens. All this equipment fits easily in two or three pockets or a small bag; it's important to keep materials to a minimum so that they're portable, because you never know where you're going to be or when it's going to rain.

When it seems appropriate, I sometimes carry my compact French easel, which I can open up if I want to finish an entire painting on location. Even when I do this, I still begin with two or three sketches of the area before deciding what my composition will be. Perhaps the most difficult thing about painting outdoors is choosing what to focus on, because there are always so many possibilities.

The best advice I can offer you in this regard is to find a scene that appeals to you and make an overall sketch of it. Your sketch can be of an entire landscape, a room, or only the setting of some main point of interest. Next, zero in on the subject of most interest to you, moving about it and making two or three sketches from various angles. Then determine small details that characterize the area, and record them.

When I get back to the studio, I use sketches like these as reference material, as well as any photographs I've taken. Before I begin to create a painting, I sit back, listen to music, and project my slides. Little by little I recall the thrill and excitement of the place, yes, even the smell of it that caught my attention. As I start to feel that I am back at that location, I turn off the slide projector and let my impressions flow onto paper, working in the realm of free association of color, form, and space. When responding to an image this way, drawing is not necessarily the first step. What is necessary, though, is that shapes be recognizable. Sometimes a light pencil underdrawing can be an asset to your painting, especially if you are worried about perspective or specific outlines of buildings, boats, or similar subjects.

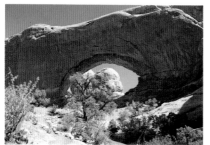

When I am on location I use the most convenient table available—a rock or even my lap. Drawing right at the site is important.

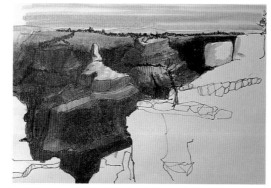

I made this Magic Marker sketch at the Grand Canyon and elaborated on it with watercolor crayon and a black marking pen. In this particular painting I sketched only the canyon in the background and left the foreground vague to emphasize my center of interest.

An arch in Arches National Park, Utah. I take reference photos *after* I do my drawings.

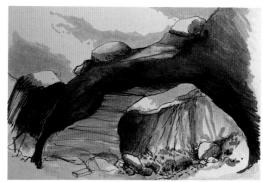

I made some sketches and took photographs of this arch. My photos did not reflect the red-gold of the light that fell on the rock, but as you can see in my sketch, I shifted some of the details to the left and moved the arch to make a better composition, positioning it at an angle that is almost impossible to find with the camera.

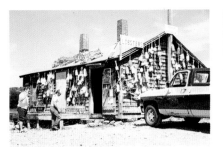

I took several photos of this lobster shack, a good subject for a painting, capturing enough detail that I could use to make my image authentic, though not an exact replica of the site. A medium close-up shot catches some of the character of the building and how it relates to the surrounding space.

This India ink sketch gives an overall impression of what the building looks like, its location, and its relationship to the other buildings and the water around it.

This razor-blade drawing of boats in the water is simply an indication of the surrounding area and serves as a reference for my composition.

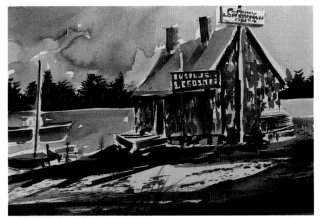

I prefer to do my final painting in the studio, where the solitary act of creation allows me a more impressionistic approach to what I have seen. In this case, I began with a light pencil drawing.

I let the nearly completed painting dry before progressing to the next stage. This is the time to look carefully at your work.

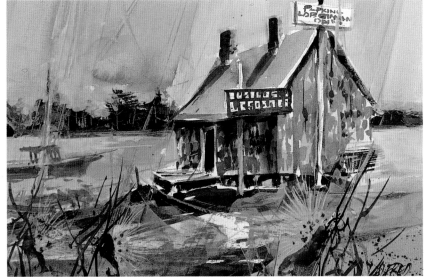

LOBSTER SHACK, 16″ × 20″ (40.6 cm × 50.8 cm), collection of the artist

I felt the shack needed some highlights that would give it more character, so I used gesso overpainting to achieve the effects you see here in the final painting.

Keeping It Free

One way to keep yourself from doing a full, detailed drawing is to make your sketches on paper no larger than 8″ × 10″ (20.3 cm × 25.4 cm). This forces you to work out the forms, values, and composition very quickly—to do the thinking behind a painting immediately. Using a viewfinder—some type of frame, perhaps a small mat or, better yet, the cardboard border of a 35mm slide—will help you determine the scale of your overall impression and find a specific composition. As you look through your viewfinder, move it about and consider the various compositional possibilities. It makes it easy to zero in on a particular subject in a large landscape. I like the 35mm size because it fits easily into a wallet and can be carried with you at all times.

By now you will have practiced with a razor blade and know how handy it can be for sketching. With an implement like this, it's impossible to "noodle," that is, to put in a lot of unnecessary lines. Using a tool as wide as a razor blade is like using a broad brush; you can lay in general shapes and patterns very quickly. Another wide tool that's excellent for sketching is a 4B sketching or carpenter's pencil, which allows you to move rapidly to give value and texture to your subject simultaneously, much as you would when making strokes with a brush. When you work in pen or regular pencil, it's easy to become too concerned with defining one particular area rather than move around the whole drawing. I've found that wider tools keep my sketches much looser, and when using them, I like to also use a large pad, because it gives me the extra freedom of movement I need to catch the action at a scene.

I want you to remember that when you're sketching, it's important to relax and enjoy what you're doing.

These lighthouse drawings are typical reference sketches made quickly on location. Notice how I try to establish a composition as I work.

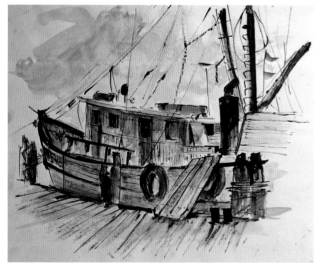

FORT MYERS, 18″ × 24″ (45.7 cm × 61.0 cm), collection of the artist

For this Florida shrimp boat, I used a razor blade and India ink to do the initial drawing, then I found a sliver of wood on the pier and used it to get some of the halftone tints. When the drawing was done I used my small watercolor set to tint it. India ink won't lift or blur when you wash over it.

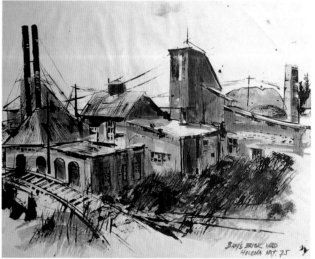

BRAY'S BRICKYARD, 18″ × 24″ (45.7 cm × 61.0 cm), collection of the artist

On location in Helena, Montana, I made this sketch of a brickyard using a razor blade and ink. Because of Montana's dry climate, the ink set quickly and I could use a watercolor tint over it almost immediately. I sealed the completed sketch with polymer medium and mounted it for display as a finished painting.

Another Interpretation

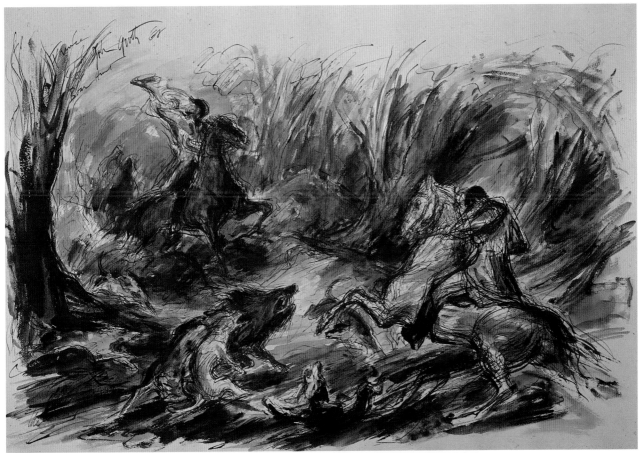

John Groth, **BOAR HUNT NEAR MOULIN ROUGE**, 29″ × 38″ (73.7 cm × 96.5 cm), courtesy of the artist

Groth says of this sketch, "This piece reflects some of my experience as an artist-correspondent during World War II. I would record scenes I had witnessed in endless rough sketches that I could refer to later for details of uniforms and background. In this piece, using Pelikan sepia ink and working loosely, first I drew lightly, leaving all the lines, then I increased the pressure of the pen to accent and move figures, creating the action and composition I wanted. When the pen drawing was completed I added color, also loosely. If at any point a picture goes sour, I immediately begin it all over again. The first attempt serves as a rehearsal for the final picture, in which I try to maintain the excitement of my original sketches, aiming for immediacy in my finished work."

Practice Exercises

1. Do some pencil sketches around your studio or home. Quickly put down the overall appearance of your surroundings, establish the compositional format, and record as many of the smaller details of the scene as you can. When sketching a particular location, you should aim to capture its entirety, not just the specific setting that interests you.
2. Take photographs in conjunction with these sketches.
3. Use a razor blade to capture shapes and forms. Let the tool work for you.
4. Bring your photos and sketches back to the studio and use them together, elaborating on the information they provide to develop a composition for your painting. Try to come up with a complete design of the location, striving not to re-create what is truly there but to capture what you remember.

10
GESSO

Some of my favorite techniques involve gesso, a medium I have used off and on in my work for the last twenty years. Gesso is a water-soluble acrylic paint that can be used for a wide range of effects such as adding a few sparkling whites at the end of a piece or overpainting with it to create a pastel effect.

You can coat a whole painting with gesso or just a part of it to accent a specific area; you can use it watered down for transparent effects, or apply it heavily as an opaque medium and build up patterns with it. You can also use gesso as an overglaze on a dry painting to pull passages together.

Before you try gesso, I want to caution you: Do *not* use good brushes with it. Gesso can build up in a brush and will eventually ruin it.

The various techniques I use are simply the means to an end. I can't stress this strongly enough: Don't let any single technique become obvious in your work; use one in conjunction with several others to obtain an overall effect.

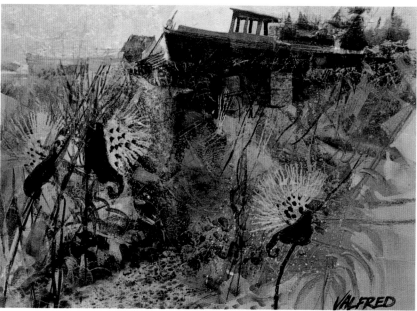

GONE TO SEED, 20″ × 30″ (50.8 cm × 76.2 cm), collection of the artist

In this painting I used the technique explained in the demonstration on page 104. Here, however, I allowed more of the basic composition to show through the gesso overpainting to achieve that gossamer look of fall. Over the dry gessoed area I used sepia umber to create the milkweed plants. When this was completely dry, I applied acrylic spray to set the paint, then glazed the surface with polymer medium tinted yellow to warm everything up.

This large composition represents fall along the Maine shoreline after the first frost, when the sumac turns multiple shades of red, orange, and yellow and the geese make their exodus as the season changes. The painting process included the use of watercolor spatter, plain water spatter, and watered gesso spatter, in that order; then I added a transparent gesso glaze—a thin mixture of water with gesso—over the entire painting to tie it all together. I finished the painting by sealing it with polymer medium.

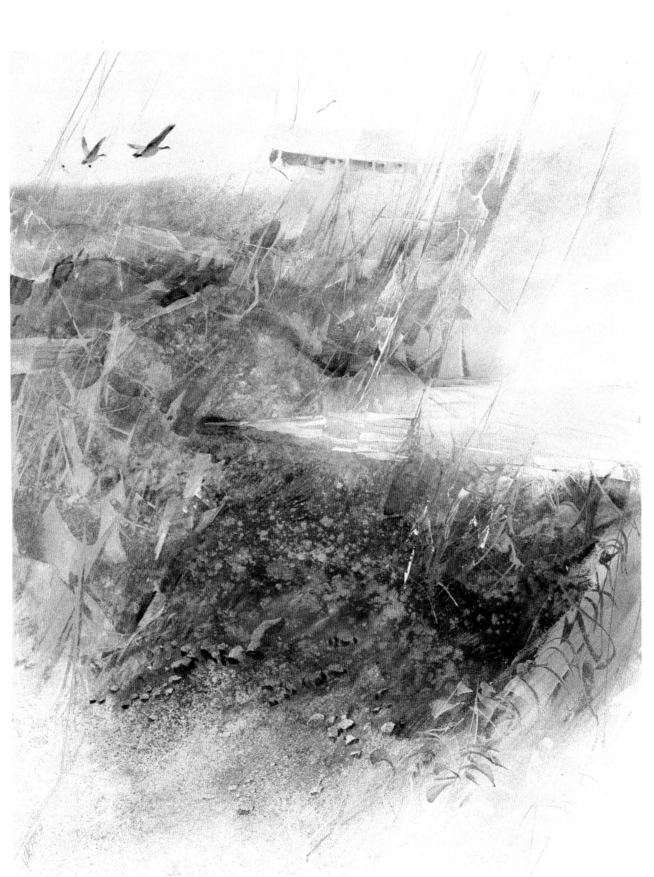

WINTER EXODUS, 30″ × 40″ (76.2 cm × 101.6 cm), collection of the artist

Overpainting with Gesso

Everyone from time to time ends up with a ruined piece of work. By overpainting it with gesso you can create an entirely new surface. Overpainting can be deliberately planned, or it can be a means for saving the better portions of a composition on the verge of getting lost. With this technique, the pigment bleeds through the gesso painted over it, causing a gossamer effect that adds a whole new dimension to your work.

This technique can be used only on a watercolor painting that is completely dry. Since gesso dries quickly, I lay out all the necessary tools before I start to work. Those I need immediately include a 1½″ flat sabeline brush, a palette knife, and a razor blade. I begin by using my large brush to lay in gesso patterns over nonfunctional areas, leaving intact selected passages of the original painting that do work, where I wish to attract the viewer's attention. Then with a palette knife (or a cookie spatula if the painting is large), I quickly squeegee the surface to move the gesso, much as a sculptor cuts away at a block of marble or wood to find the form inside. I also draw in design lines, over which I paint in details.

The first paintings of this kind that I took to a gallery were met with resistance and were shown only reluctantly. However, within a few weeks I was asked for more of my "gossamer" paintings, as the first ones had sold quite well. Now I call gesso overpainting my "gossamer technique."

I decided this painting needed more pizzazz.

With my brush loaded with a lot of water and a small amount of gesso, I coated the painting, dissolving much of the watercolor pigment underneath while saving sections of the original image that I found most interesting. It is vitally important to work quickly when using gesso, and you must constantly keep your composition in mind.

Next, I made design lines in the surface with my palette knife. Then, using my palette knife and a razor blade, I pushed gesso out of the way and brought back some of the underlying color and white of the paper. With a small brush I laid in darks around the design lines, bringing out some patterns and toning down others.

Once the painting was dry I put in my final details, then sealed it with acrylic spray. Next I covered the painting surface with two coats of polymer medium. Even on top of these protective layers I can add a few details or make minor changes with a mixture of polymer medium and watercolor. For example, if I want the fields to be browner or greener, I can tint them at this stage.

CAPE NEDDICK RIVER, 16″ × 20″ (40.6 cm × 50.8 cm), private collection, Florida

Compare this image with its counterpart, *Duplicate Trees*, page 107, to see how varied the same subject can appear when it is rendered by means of two different techniques. Here I painted the basic composition with watercolor, first establishing the tree forms and the background, then I applied gesso across the surface and scratched it out while it was still wet. I finished by putting milkweed pods in the foreground here and there.

LOOKING TOWARD CHASE'S POND, 20″ × 30″ (50.8 cm × 76.2 cm), private collection

This striking painting shows yet another way to use gesso successfully with watercolor. As Vickrey explains, "I covered a piece of hot-pressed Whatman board with gesso and all the watercolor hues on my palette, using broad, broken strokes and leaving quite a bit of white paper showing through. Over this I scrubbed in cerulean blue, then I loaded pure gesso into the slightly wet paint to create small whorls of light. I roughly sketched in the nun and her headdress in a monochrome, then began to work out the light, using stubby old watercolor brushes. With a paper mask I covered the figure, then spattered cerulean and cobalt blue liberally over the wall area. Next I glazed and clarified the shadowed areas of the face with a thin wash of Hooker's green, burnt sienna, and yellow ochre. To introduce the trapped bird motif, I laid pieces of tracing paper around the painting until I was satisfied with their position. Carefully masking off the figure once more, I spattered a very light coat of cerulean blue over the whole background. Finally I glazed the darkest shadows on the wall, then lit the figure's face with a light opaque flesh tone."

Robert Vickrey, WINGS, 22″ × 30″ (55.9 cm × 76.2 cm), courtesy of the artist

Working on a Gesso Surface

Playing with watercolor on gessoed paper, board, canvas, or wood panel is an entirely new experience and a fun exercise. Try applying gesso to your surface with a roller instead of a brush or varying the thickness of the paint application to create an interesting texture. You might even try putting gesso on with a palette knife or a piece of cardboard. You can add even more texture by cutting into the surface while the gesso is still wet. Conversely, if you want a slick finish, smooth your gesso-coated surface down with sandpaper. It usually takes several layers of gesso to establish a good working surface; just make certain you let each layer dry completely before adding the next.

When you apply watercolor over a textured surface, allow the pigment to seek the texture lines on its own and create interesting patterns. You can pull out whites anytime you wish using a clean, damp flat or round brush that is "thirsty" enough to lift color and create new designs and lighten specific areas. A spray of water on a gessoed surface glazed with watercolor can create some very unusual effects too. Since the gesso seals the surface so the watercolor cannot be absorbed into it, the water spray moves the pigment to develop wonderfully exciting shapes and patterns. All you need to do is look for them.

When working on a gessoed surface, I first lay in my light shapes. While the pigment is drying, I take a palette knife and scrape out color to create white areas. The texture lines of the underpainting begin to emerge and add interesting patterns to the composition.

When your finished painting is dry you need to apply acrylic spray (I use Krylon #1303) and then seal the surface permanently with polymer medium.

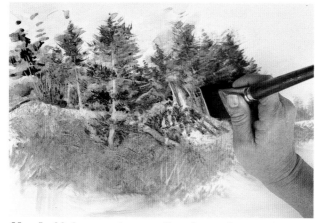

This gesso underpainting was applied with a palette knife to create a rough texture that suggests tree forms. I let it dry before proceeding.

I put various greens over the dry gesso, allowing the pigment to seek the textured lines of the underpainting. Then I picked out forms with a thirsty brush.

Here I added more color, as well as the two figures.

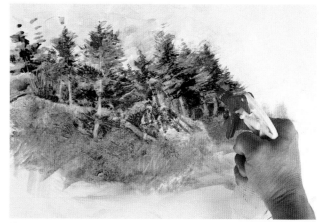

When the figures were dry, I sprayed the painting with water to get an overall textural wash. Because the gesso prevents it from being absorbed into the paper, the pigment sits on the surface and is easily moved with water.

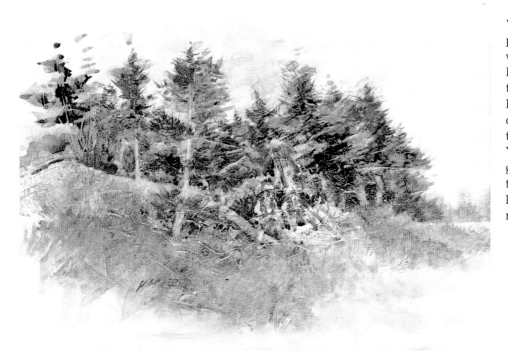

When the painting was completely dry, I reached back in with my thirsty brush and lifted out highlights on the trunks of the birch trees. Finally, I washed light blues over the foreground and over the trees in the background. You can see the texture of the gesso underpainting coming through, building the tree limbs and the patterns of rocks around the hunters.

TWO IN THE WOODS, 16″ × 20″ (40.6 cm × 50.8cm), collection of Vincent Thëlin

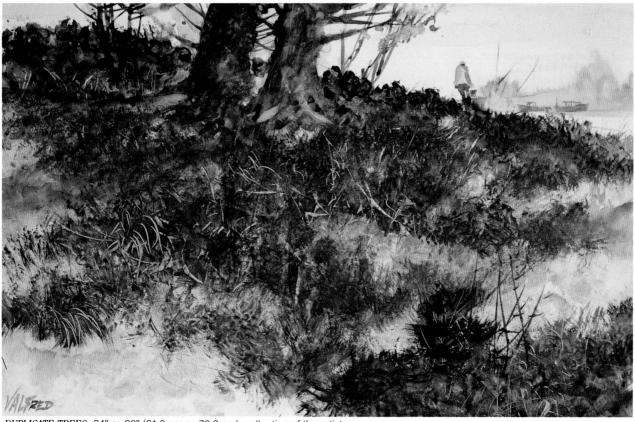

DUPLICATE TREES, 24″ × 30″ (61.0 cm × 76.2 cm), collection of the artist

This picture was completely underpainted with gesso, then overpainted with watercolor, from which I pulled out the grass forms with a thirsty brush. For the background details I used sepia umber and Winsor blue, then wiped out the pigment, leaving a stain in the gesso base.

Correcting with Gesso

When paintings seem to get out of hand, there are ways to correct them. To that end, I have developed some techniques involving radical changes that can make a picture succeed. You will find specific examples of these techniques in the chapter that follows on how to save a painting, in which I demonstrate how I've corrected some of my students' work. But here, let me just mention how handy gesso is for repairing paintings that have gone a little awry.

One way to save a painting is to put gesso over it in the same process I demonstrated on page 104. Another approach is to apply a thick, heavy coat of gesso and form shapes with it, much the way you would apply oil colors in an impasto technique. When you cover a painting this way, the tint of the original watercolor will show through. While the gesso is still wet, you can apply watercolor directly onto it to establish a middle tone over the entire surface; then as the gesso dries, you can continue to apply watercolor to build detail in the foreground, as the demonstration shows. My tools in this case consisted of gesso, a 1½" flat sabeline brush and a #5 round brush, a razor blade, and various watercolors. Look at a painting you feel needs more pizzazz and decide whether you would like to remake it this way.

The beauty of trying to reclaim a painting is that you don't have to be afraid to jump right in and really splash the pigment around. By adding more pigment, you add more power to your work. Remember, every painting, good or bad, is a lesson. A successful work is judged by what you have learned from it, not by the accolades it may earn you. If you think about it from this point of view, no painting can ever really be called "lost." It's the challenge of new experiences that counts.

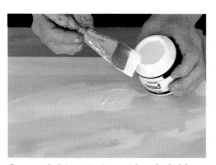

I started this painting with cobalt blue and cadmium orange, then wiped the paint with a damp terry towel to create fog. The image didn't work, so I coated the tinted surface with gesso.

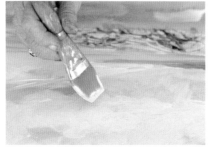

I then moved the paint around on the surface to develop the clouds in the sky, adding Winsor blue to the gesso to increase the intensity of color.

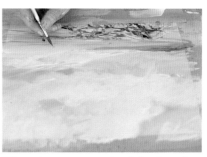

When this stage was dry, I developed the texture lines and beach forms with Winsor blue and sepia umber. Finally, I washed over the foreground and scraped out details with a razor blade.

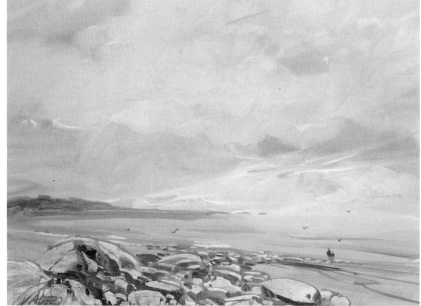

LONG SANDS BEACH, 16″ × 20″ (40.6 cm × 50.8 cm), collection of the artist

The important thing to remember when using this technique is that at any given time you can change the entire texture by going back with gesso, adding whites and getting lighter. The areas over-painted with watercolor can be wiped back to white one more time. This is very effective on damaged boards or old paintings that you want to wash out entirely so you can develop a brand-new composition.

Using Tissue

Laying tissue or rice paper over problem areas in a painting can bring success to passages that weren't working out and is effective for many subjects. To create very softly blended passages, try tissue overlays on a dry gessoed surface. Of course, this material isn't only for making corrections; you may plan to use it in a painting from the start, especially once you find out what it can do.

For experimental purposes, the tissue you find in department-store packages or between shirts back from the cleaners will work well, but do *not* use colored tissue paper for any reason, as it fades quickly. Instead, paint your tissue paper with watercolor, either before you apply it to your working surface or afterward, depending on how you plan to use it in the painting. Tissue paper allows you to create collage effects; you can also use it to push back areas you want to make recede in a composition. As you become more proficient, I suggest you try various kinds of rice paper, which comes in a wide range of interesting textures and can be purchased from art supply dealers.

For landscapes, I tend to tear the tissue into irregular and thus more natural shapes. When I am doing a cityscape, though, I look for hard edges typical of man-made forms, so I cut the tissue paper with a razor blade directly on the painting, not worrying about the line going through and scoring the surface. This helps me get my compositional elements in the right proportion to one another.

When you use tissue paper in a painting, it's important to follow these three steps. First, to prevent watercolor pigment from moving around and dissolving beneath the tissue, apply acrylic spray to your painting. Next, apply the tissue where you want it. Finally, seal the entire painting with polymer medium. If you want the tissue paper to be exceedingly transparent, allowing the background to show through, coat it with clear water first, then cover it with polymer medium to hold it in place. If you want to diffuse the impression to make the background a little less visible, paint the polymer medium directly over the tissue paper without wetting it. This allows some air bubbles and white spots to form, causing a haze to develop. You can also apply tissue paper in the same manner to a surface that has been either underpainted or overpainted with gesso, as long as the gesso is dry; the tissue can be tinted with watercolor mixed with polymer medium.

Once the polymer seal dries, you can come back into the painting with watercolor pigment mixed with polymer medium to add shapes and glazes in the areas you want to strengthen and give more depth to. Paintings made with this technique can be exhibited as collage or mixed media work, but not as watercolor.

Heed this important warning: When you use acrylic spray, always work in a well-ventilated room or take the paintings outdoors, and don't spray too many at one time. I know from personal experience that too much spray can poison your system.

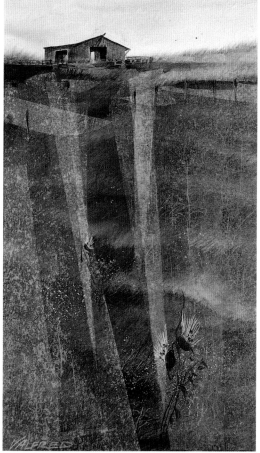

FIRST FROST, 20″ × 30″ (50.8 cm × 76.2 cm), Rahr Public-West Museum, Manitowoc, Wisconsin

The inspiration for this painting came from an overcast day in a Wisconsin valley. In the low level of the hills, the sky is almost completely white. The strength of the foreground as you look up toward the barn brings out the aloneness of the location. But as I worked on the painting, the foreground became too dominant, so I pushed it back by using layers of tissue paper and polymer medium.

Other Interpretations

Edward Betts says that this painting resulted more from technical experimentation—here, combining watercolor and acrylic—than from an intention to create a work of art. As he describes it, "I thinned some acrylic medium with lots of water and applied it randomly with a large flat brush in wide, gestural strokes, leaving plenty of the paper untouched. I let this stage dry; then, knowing that the areas of paper coated with acrylic medium would repel color while the uncoated areas would absorb it, I laid in washes of transparent watercolor all over the surface. When the painting was about half done, I sprayed it with two layers of the same diluted medium to prevent color from bleeding through the thin acrylic whites I used to further develop the image. I applied more watercolor and acrylic glazes to complete the painting."

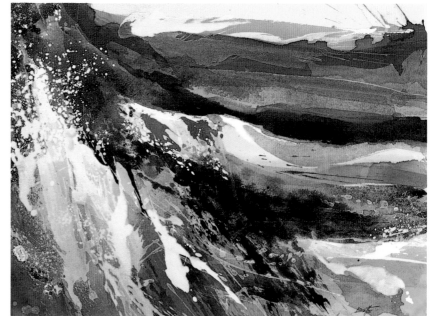

Edward Betts, **SEA MOVEMENT #7**, 22″ × 30″ (55.9 cm × 76.2 cm), courtesy of Midtown Galleries, New York City

This artist worked on a coat of gray acrylic-based paint similar to gesso, which he sprayed on to achieve a flat surface, then smoothed with a fine-grain sandpaper and coated with a sizing made from water and gelatin. He describes how he proceeded: "I mixed each of my colors in a separate container with water to a thin, creamy texture; then I wet my surface with a wide brush and poured the paints onto it all at the same time, moving them around to blend here and there by tipping the surface in different positions. When the paint was dry I was able to visualize figures, at which point I decided to remove areas of color to get back to the gray ground. The forms emerged this way."

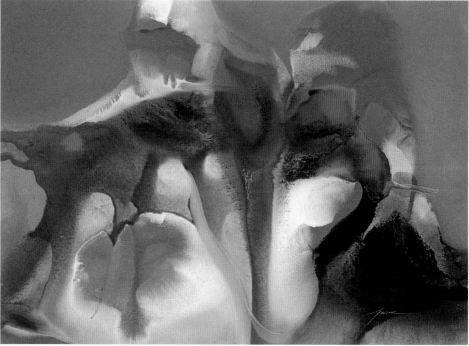

Jason Williamson, **DESERT RIBBONS**, 22″ × 30″ (55.9 cm × 76.2 cm), courtesy of the artist

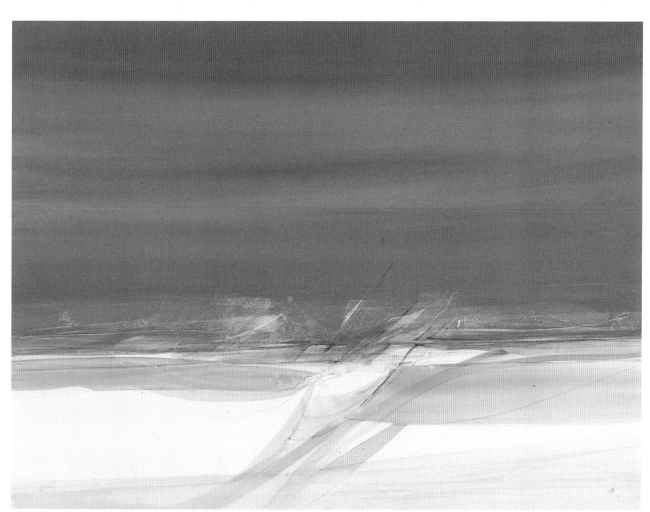

Cher Thompson, **WIND SAILS**, 30″ × 40″ (76.2 cm × 101.6 cm), courtesy of the artist

This is a perfect example of overpainting with an opaque water-based medium such as gouache or gesso. Thompson kept the opaque area at the top of the painting separate from the transparent foreground. She painted the sky by squeezing various transparent watercolor hues straight from the tube onto the board and blending them with white acrylic paint, using a very wet brush. Next, the artist dropped plastic wrap onto the wet surface and lifted it before the paint dried, leaving interesting white forms that appeared to be sails. These she accented with tissue paper cut into similar shapes, gluing them to the surface with acrylic medium. To further enhance the effect of wind-filled sails, Thompson then scraped with a razor blade, drew with a pencil, and added transparent color glazes, echoing their shapes in the foreground.

Practice Exercises

1. Work yourself out of a compositional problem by employing the gesso overpainting technique.
2. Execute a gesso overpainting, leaving some original passages showing.
3. Apply gesso to different surfaces as underpainting, making some smooth and some richly textured; then try watercolor over them. It might be fun to do the same subject on each surface and compare the results.
4. Use the tissue technique to soften a foreground or background passage in a painting.

11
SAVE IT!

There are no mistakes, only corrections. This point was driven home to me day after day by my father and grandfather. Everything I did as a child was critiqued. My father, with his commercial art training, would show me how to correct the faults in my paintings without redoing the entire work.

This approach instilled in me the habit of critiquing my own students' work at the end of a week's workshop. At that time I show them how to improve their paintings, using many of the same techniques discussed earlier in this book. That is how this chapter came into being.

Imagine that you have tried all the techniques you wanted to use, have put in all the patterns you like, along with your heart and soul, but your painting still doesn't work. What went wrong? Perhaps you were so busy trying techniques, you forgot other important points needed to develop a painting, such as composition, negative and positive space, interesting and varied shapes and patterns, or values. But just because what you assembled doesn't work as a whole doesn't mean all your efforts are lost. Even a painting that seems doomed has potential; sometimes you learn the most from it when you let go of your original idea and rework your picture into something entirely different. Try out some of the techniques mentioned earlier— adding tissue paper, using gesso, or overpainting with a darker color. Make the medium your partner; work with each other.

Here's a practice that's sometimes helpful. When you get stuck in a painting, lay a piece of acetate over it and try out new colors, values, and designs on this clear surface before you make further changes on the original one. Pick up some pigment on your brush, then soap it so the paint will adhere to the acetate.

This was originally a landscape dominated by orange reflections of morning sunlight. It wasn't quite working, so I turned it on its side and struck into it with alizarin crimson, Indian red, and warm umber. After I had almost completely overpainted the picture, leaving just highlights of orange, I used a razor blade and palette knife to scrape out and develop the abstract structure of an Oriental floral design, which eventually became the finished painting.

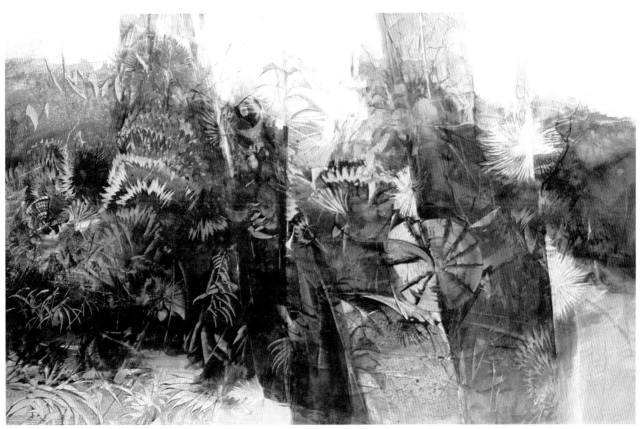

EARTH'S OMEN, 48″ × 68″ (121.9 cm × 172.7 cm), private collection, Boston

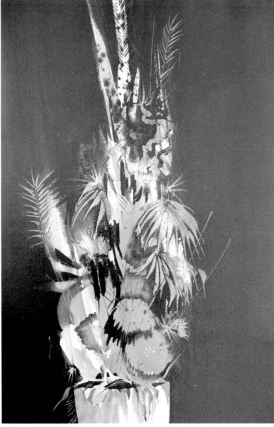

STANDING STRAIGHT, 30″ × 20″ (76.2 cm × 50.8 cm),
collection of the artist

This large painting originally depicted the rocks and beach of Maine. I never liked the composition, so I started working it over and continued to do so for more than two years, leaving it and coming back to it time and again. I tried adding dark browns and oranges, overpainting, underpainting, and sometimes spattering in anger and frustration. I turned the picture all four ways and tried to make the composition work in every direction. I never knew which side was up or down until the plant forms evolved. The patterns and shapes of these Maine plants were constructed with several of the tools we have discussed in the book. Eventually I grew to love this painting, and consider it a major work. One of the joys of being an artist is that you have a place to vent negative feelings, and can use them to help turn out a successful painting.

Student Makeovers

I believe that a student who is willing to let me correct his or her painting with a hands-on approach will gain more than I can give in a verbal critique. Some paintings can be saved just by adding a few shadows to pull things together, while others require what I call "major surgery"—a drastic change, in which only a few forms from the original composition remain.

When a painting needs major surgery, it is time to turn it upside down, look at it from different angles, and apply different colors. Forget about the expression you were trying to create; instead, consider it a fresh surface on which you are starting a new painting. It can be exciting and challenging to rework a picture in this way. I like to think of a remark Picasso once made about painting: "I work on it until I entirely destroy it, then I begin to create." Remember: If all else fails, you can always gesso over a painting and begin a new one on a fresh white surface.

It must be said that relative to content, technique is unimportant, but technique is what can be taught. People who teach art risk making imitators out of their students; to me, though, the best art teachers are those who try to avoid this by offering their students the widest possible variety of approaches, the broadest technical vocabulary that will help each develop his or her own artistic voice.

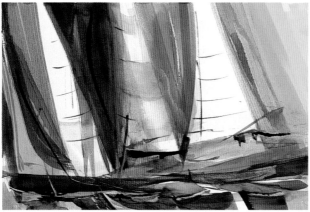

This painting of sailboats was not bad, but it needed strengthening.

What I did was restructure the foreground of the painting by adding sail-shaped pieces of tissue paper to it and placing other scraps over the sky area.

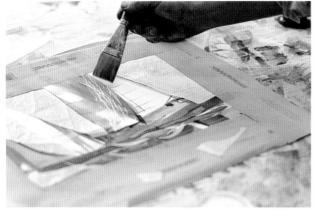

I applied the tissue with polymer medium following the steps discussed in Chapter 10. In this case I wanted to haze out the background, so I put polymer medium over the entire piece and added some more tissue. Then I added watercolor to polymer medium to use as a final glaze over the surface.

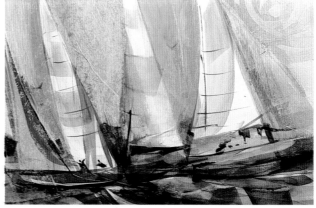

In the end, the difference between this version and the original is not that dramatic, except that the tissue paper softens up the painting's foreground and suggests sunlight pouring through and animating the scene.

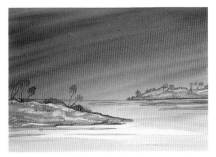

The sunset sky worked out very well and had a nice blending, but the faded islands seemed to add nothing to this painting.

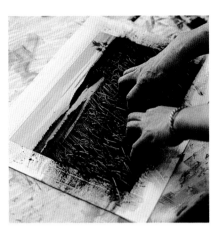

I turned the composition upside down and added Hooker's green dark and Winsor blue over the foreground, leaving intact from the original certain areas of light reflecting on the water at the center. Then I scratched back into the dark pigments with my fingernails to create grass and put in a few palm trees at the top, followed by a light spatter in the foreground.

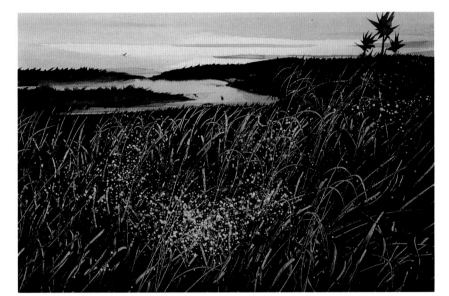

This made for an entirely new painting, now a view back across a field toward a distant sunset reflected in a quiet stream.

The original painting captured the feeling of the flowers, but needed more contour work and design.

I accented the design with alizarin crimson and Winsor blue to give the picture a nice purple tone, then used a white crayon to bring out the stems, line work, and highlights.

The finished composition is the same as the original, except the added lights and darks bring it all together.

More Makeovers

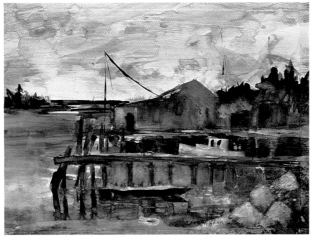

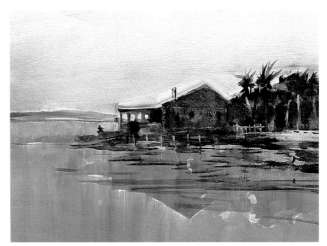

There were no large patterns and shadows to pull this work together; it was too busy all over.

I put gesso over most of the painting, letting parts of the watercolor bleed through to maintain some of the student's original design while deleting many of the more complicated areas to suggest a simple fishing village.

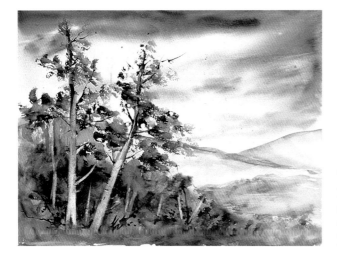

The sky in this painting was working fairly well, as it had been painted during a "sky" class, but the foreground and subject matter did not have enough power; the trees were weak and the whole right-hand side of the painting had to be built up.

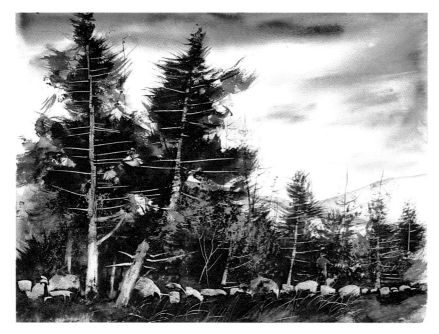

By simply overpainting with Hooker's green dark and striking in all the foreground tree patterns, plus building up a stone wall with a razor blade across the bottom, I was able to connect the painting from left to right. I sponged in some fall foliage with cadmium orange and added the figure to liven things up.

Another Interpretation

Marc Moon, **THE TILLER**, 22″ × 30″ (55.9 cm × 76.2 cm), courtesy of the artist

Some paintings force the artist's hand. "This painting," says Marc Moon, "started out to be a transparent watercolor on hot-pressed paper, which I soon found too slick for my liking. After several hours of work, I was in all kinds of trouble and came to the point of having to make a decision about the painting: a) forget it; b) start over; c) try to save it. Since I had invested so much time and effort in it, I chose to save the picture. I tore some very thin rice paper into small, irregular pieces and covered the entire surface of the painting with them, using a matte acrylic medium to make them adhere. By applying the rice paper, I saved the design and created a new and interesting surface. To finish the painting I used acrylic paints and a drybrush drawing technique, which enabled me to be very expressive but still in complete control of focusing in on the subject."

Practice Exercises

1. Look over your paintings to find passages that you like.
2. Choose a work that needs help and overpaint poorly rendered passages with dark colors, leaving better areas untouched.
3. In the same painting, use tissue-paper overlays, allowing the successful passages to show through.
4. Find a painting that didn't work and bring it back to life with the gesso overpainting technique.

12
ABSTRACTIONS

Abstract painting, in my opinion, is the most difficult, because it is such a personal, emotional way of relating to what is around you. Abstraction is the starting point for much misunderstanding of the kind reflected in comments like "Nature doesn't look like that" or "My six-year-old could have done that," and so on. But we all glean different things from our surroundings, each of us taking a visual census and cataloguing images to be used in our own special way.

When talking on this topic, I like to relate a story that has been attributed to Picasso. One time when he was painting a picture of his daughter, he was visited by a friend who remarked, "Your daughter is so beautiful, yet you are painting her profile with an ear lower than her eye." Picasso turned and asked his friend, "Do you have a photograph of your daughter?" When his friend showed him the photograph, Picasso commented, "I never saw anyone so little." Then he said, "The only reality in art is art itself, real or nonreal." In other words, any interpretation of reality is an abstraction.

Everywhere I go, my eye is constantly responding to visual stimuli and gathering information from all quarters. I look at the negative shapes as well as the positive shapes, always considering the light and dark forms, the points of interest themselves as well as the spaces that surround them. It is these shapes and patterns that make up an abstract painting. Basically we have been working abstractly since the first chapter when we dropped color on a wet surface and let it run, controlling it but allowing it to move freely at the same time. In this chapter I want to open your eyes to further possibilities, to the limitlessness of abstract painting.

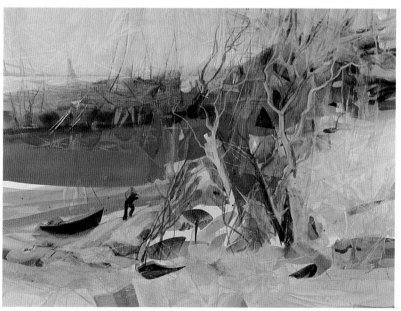

Winter Cove records a remembered spot when dawn's light crossed the waterline, placing bright oranges and reds against the white snow. The painting was done with cadmiums—yellow, orange, and red—plus alizarin crimson. I then broke back into it with gesso, making design lines with my palette knife.

WINTER COVE, 24″ × 30″ (61.0 cm × 76.2 cm), private collection, Connecticut

CRUCIFIXION, 30″ × 40″ (76.2 cm × 101.6 cm), private collection, Wisconsin

In this painting multiple mixed media came together, all of them basically water-color. I first developed the cross composition as I might have for a cityscape. As I moved my palette knife up and down through the painting, the cross form be-came stronger and the figure of Christ began to develop. When this painting was first exhibited, it was said that the figure's head seemed to move when viewed from certain angles, an optical illusion caused by the different shapes surrounding it. The lacy patterns were achieved by stenciling with lace doilies.

Developing an Abstraction

My composition always begins with the water that initially breaks the surface of the paper and becomes my first major shape. The way you disturb the surface—how much or how little water you apply and over how large an area—greatly influences how the medium is going to work and reflects in the design of the total picture.

When you are creating a painting, make sure your light source hits the entire surface so that you can see by the sheen how wet or dry it is at any given time. This will tell you when you can add more color, when it's the right time to use a razor blade or palette knife, and when to glaze. As a rule, the paper should be wet if you want the color to bleed, damp if you are using a razor blade, and dry for glazing.

As I add color to a painting, I ask myself, How does the white area relate to the color area? When I was a student, Hans Hofmann once drew a line on a piece of paper and asked, "Is this line short or long?" It was neither until another line was added to dictate the length of the first one. That's exactly how you'll find the answer to the question of color versus white areas. The important point is, each line, color, or form you put in a painting must relate to a whole. For example, one color repeated in three different areas but varying in size and shape will unify a painting, carrying a viewer's eye across its entire surface.

When you're painting abstractly, I challenge you to simply throw out some color—I mean this literally, let the paint fly. I often squirt spots of color directly from the paint tube onto a painting surface, a practice reminiscent of my old oil-painting days. Mixing the pigment right in the arena of creation causes problems and effects that awaken the imagination. As the medium begins to flow, your feelings and the sur-rounding atmosphere conjure the spirit that will give the painting its direction. Follow the moving patterns of pigments. After a certain point, you must consider the dry and wet places on your working surface and attend to what is happening there. You must decide, for instance, when to create the basic reality of a foreground, middle ground, and background. To develop a painting properly, patience is important! Take time to let individual passages dry and to consider how each relates to the whole.

Remember, the viewer's eye and mind are quite capable of filling in a lot of information that a painting may simply suggest. One well-conceived form can be worth a thousand words; a mere touch of realism within an abstract pattern can create depth and perspective in the picture plane and establish the scale of all the other components present in the work.

After visiting the Medieval Fair in Sarasota, Florida, I returned to my studio still feeling some of the vibes, and knew that was exactly what I was going to paint. I used a 1½″ flat brush and a #12 round, a palette knife, and cadmium yellow, Winsor red, Winsor green, cobalt blue, sepia umber, and Winsor blue watercolor pigments. I also had on hand tape for the edges and cardboard for scraping out paint. I began by squirting cadmium yellow directly from the tube onto a wet board, followed by Winsor red and Winsor green. I added some more water to the central area and moved the pigment around enough to avoid a heavy buildup yet allow it the freedom to run. The movement of color in the wet areas and the white patterns that remained stimulated my thoughts and suggested a possible direction for my composition.

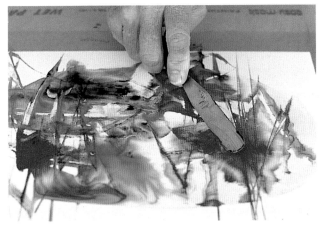 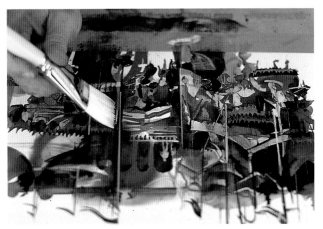

I then took my palette knife and stroked through the colors to establish design lines and patterns in the painting. At this point I could see that the image was moving toward a finished look, that of a medieval fair, as I began to see the forms of shields and armor. By developing relationships with these lines I created recognizable shapes, gradually adding more and more details to complete the painting. I immediately came back with my razor blade and scraped through the surface to accent the shapes that had begun to appear.

After this, I glazed mauve over the picture to tie it all together. Last, I took a brush to add the flags, figure forms, and details of the shields.

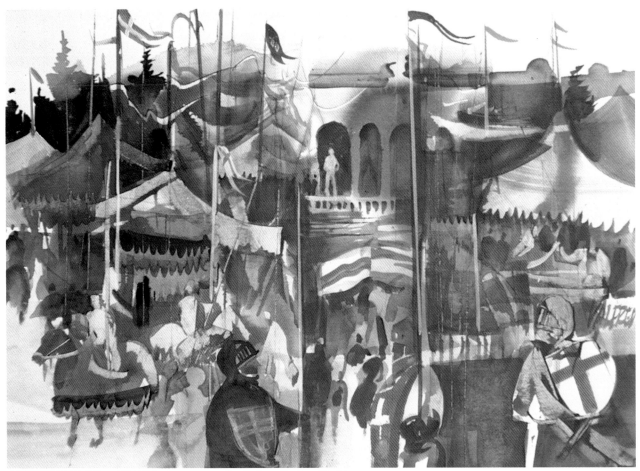

MEDIEVAL FAIR, 16″ × 20″ (40.6 cm × 50.8 cm), private collection, Florida

Taking Off from Photos

When I work abstractly, I am usually inspired by things I've seen and experienced directly. I do use photographs, but only as a means to stimulate my thinking, never as images to be duplicated in a painting. Use photos to suggest ideas, not limit them to what the camera saw. Try turning photos upside down and concentrating on just the shapes in them.

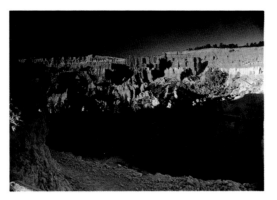

This photograph shows how light casting through Utah's Bryce Canyon creates beautiful negative and positive shapes as the sunset's warm colors play on the rocks.

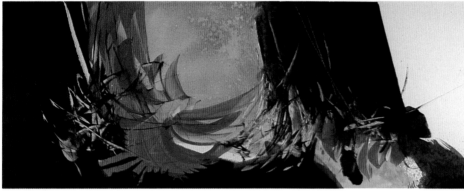

PHOENIX, 20″ × 40″ (50.8 cm × 101.6 cm), private collection, Arizona

Phoenix evolved from a workshop tour to Bryce Canyon, where I made many photographs and developed a number of paintings. I began with bright oranges and reds for the underpainting, over which I brought in accents using Winsor blue, Winsor green, and alizarin crimson. With my palette knife I stroked through the paint to suggest the fluttering feathers of the phoenix rising out of the fire. That was enough to complete the abstraction.

Photographed in late afternoon sun, these lobster buoys strewn along the shores of Maine's Cape Neddick River formed a pattern of bright orange positive shapes and dark shadows.

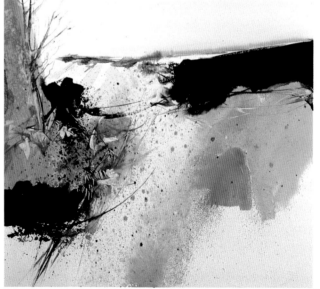

CAPE NEDDICK INLET, 32″ × 32″ (81.3 cm × 81.3 cm), private collection, Massachusetts

I used the photograph of the buoys as an inspiration for the painting of *Cape Neddick Inlet*. I began by squirting color directly onto the surface of my board, then moved it around by adding water to the paint. The arrangement of the pigment suggested the shape of the inlet to me, so I left it in place.

Playing with Color

An abstraction demands the balance of one color with another and a clear relationship of color to the all-important white space.

Here Hans Hofmann's push-and-pull theory comes into play. As he explained it, complementary colors have a way of pushing and pulling each other back and forth in the picture plane, as do small shapes juxtaposed with large ones. In painting, this means that you should counter a large pattern of green with a small square of red, for example, or balance a large area of blue with a small section of yellow; that is to say, play opposites against each other, warm against cool and small against large, always aiming for the variety in these compositional elements that will give your painting some illusion of depth.

Don't dictate to your pigment, don't try to push it too much, but never let it trap you. Always be in mental control, but be willing to yield temporarily to the pigment. I have found that such a mutual arrangement works best! I myself never try to win the battle but reach a compromise and gain what is best for me and the painting. This means working back and forth, turning a painting sideways or upside down and going in and out of it, constantly considering all the various compositional possibilities. Think of the process as a conversation that exists for the exchange of ideas and that neither you nor the painting dominates.

Hans Hofmann, **STUDIO INTERIOR**, 8″ × 10″ (20.3 cm × 25.4 cm), private collection

In Hofmann's *Studio Interior*, the red area right of center moves forward because it is offset by passages of complementary green, a cool color that recedes; likewise, the small, warm yellow area stands out against the cool blues and greens. I find this artist's theory very helpful, especially when working nonobjectively. The push-and-pull principle is a factor in all paintings, but is much more easily recognized in an abstract piece, where only pure form and color make up the composition.

The Role of Imagery

Amid the forms and patterns you see developing in a painting, you may consciously or subconsciously recall images of things you once experienced or abstract sketches you created while working on location. Such images enter the realm of your painting and give it substance. Taking the time to understand, to observe what is happening across the surface of the paper, is what watercolor is all about. Boats, buildings, people, and objects crop up where I least expect them.

When these things pop up in my paintings, I can leave them in and elaborate on them, or I can remove them according to how I feel. But it is just such unexpected subjects, perhaps those that emerge from the memory of someplace I have visited, that give direction to my painting. No doubt similar impulses will strike you during the painting process. I can only recommend that you respond to them, not dismiss them. Allow yourself to gain a sense of oneness with your materials this way.

One of a series I did after a visit to the Rockies, this painting expresses the streaks of first light crashing over snow-covered mountains. I established the circular composition with masking tape. The color ranges from bold, dark blues to crimson, then fades, arching back over what appears to me to be the top of the Earth. I suppose it could be an imaginary view of Earth as seen through the porthole of a departing space capsule. The painting was developed in much the same manner as *Medieval Fair*, page 121. I first wet the surface, then applied cadmium yellow, cadmium orange, Winsor red, alizarin crimson, and Winsor blue, letting the patterns emerge from the color. After allowing the painting to partly dry, I used a razor blade to establish a few lines just off center, suggesting reflected light on some leafless trees on the horizon. This completed the painting; the most important thing to know is that when *you* feel a picture is done, it is.

REFLECTED SUN, 30″ × 30″ (76.2 cm × 76.2 cm), private collection, Montana

I began *Prima Luce* with bright oranges, yellows, and warm sepia, striking back and forth through the paint with my palette knife, then spattering with clear water. While the surface was still damp, I applied gesso to it, bringing the painting to a conclusion of floral patterns inspired by tropical undergrowth.

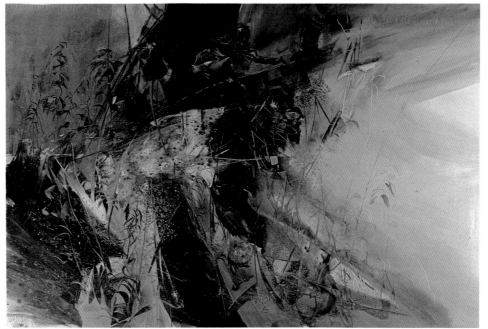

PRIMA LUCE, 48″ × 60″ (121.9 cm × 152.4 cm), private collection, Sarasota, Florida

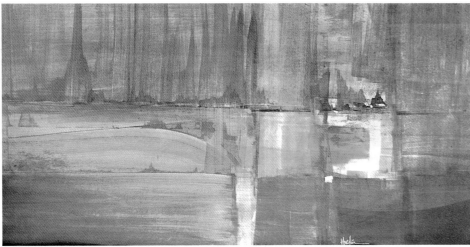

In the beginning I squirted paint across my surface, sprayed it with water, then scraped it with a piece of cardboard. As I added each layer of color, I squeegeed out various areas, creating patterns until forms I liked came to pass.

NIGHT LIGHT, 20″ × 40″ (50.8 cm × 101.6 cm), private collection, Illinois

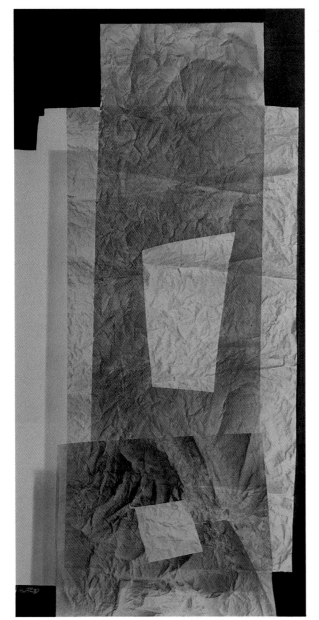

This painting is part of a series I did when I became fascinated by working with tissue and rice paper. To begin, I crumpled up the tissue and sprayed it with a variety of colors from a low angle, touching only the top to get a tie-dyed effect. When it was completely dry, I ironed it on a flat surface. Next, I laid the tissue on my watercolor board and decided what shapes I desired, then cut them out with a razor blade. I painted the board with polymer medium and gently laid the tissue paper on it, proceeding with a coat of polymer medium over this. It is not necessary to let the tissue paper dry completely before adding two, three, or four more overlapping layers; this gives depth to a pattern. I stockpile painted tissue papers so they are ready to use whenever I want them, in single or multiple colors and layers. When using these materials, I find that my subject matter is never determined before the painting is two-thirds to three-quarters finished. At that point, last-minute decisions must be made and the interesting forms need to be accented.

ROCK FORMS, 20″ × 40″ (50.8 cm × 101.6 cm), private collection

What Different People See

Everyone sees an abstract composition in his or her own way, just as any two artists working in the same medium respond to identical shapes and colors by creating entirely unique compositions from them. The beauty of abstract painting is that you are not interpreting an identifiable scene but are reacting to colors, shapes, and patterns.

To emphasize this point, I worked with my coauthor, Pat Burlin, and her husband, Jack, the principal photographer for the book. I asked each of them to look at the early stages of a cross composition I had made and tell me what they saw. All three of us had a different impression, and each had a different idea about the way the painting should go. I proceeded to develop the ideas expressed (including my own) into as many paintings, as this demonstration shows.

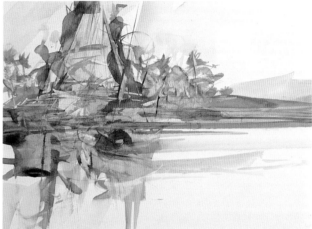

The abstract cross is one of my favorite compositional schemes, and in this case I am using it to show how differently people see things. I asked Pat and Jack Burlin each to look privately at identical paintings I had made of a yellow cross and come to a conclusion about what they saw.

Jack came up with what he thought was obvious: a two- or three-mast brigantine ship. As he studied the cross further, he kept seeing the ship and repeated his observation. As the second part of the demonstration, I brought out the movement of the sails.

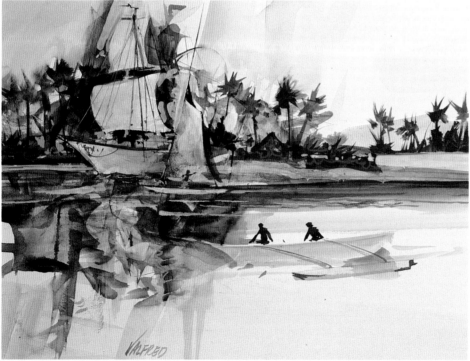

He agreed that this was what he had envisioned, so I completed the painting and called it *Pirate's Cove*.

PIRATE'S COVE, 16″ × 20″ (40.6 cm × 50.8 cm), private collection, Florida

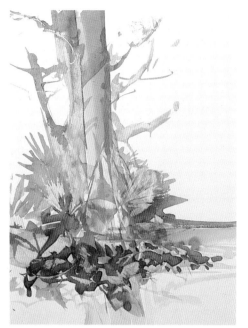

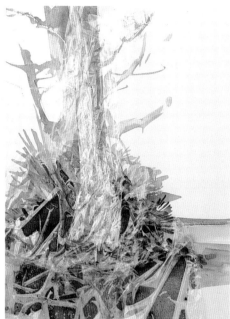

Pat looked at the yellow cross vertically and, in the gyration of lines toward the bottom, saw the intertwined roots of trees, like those you might find in a mangrove swamp.

I accented some areas with cobalt blue and gave the painting a horizon line.

She still agreed it had to be a mangrove swamp.

So I proceeded to develop it this way, placing plastic wrap at the bottom to add texture; after pulling the plastic away, I finished the painting by adding some dark colors, allowing red-orange reflections of sunlight to fall across the cypress.

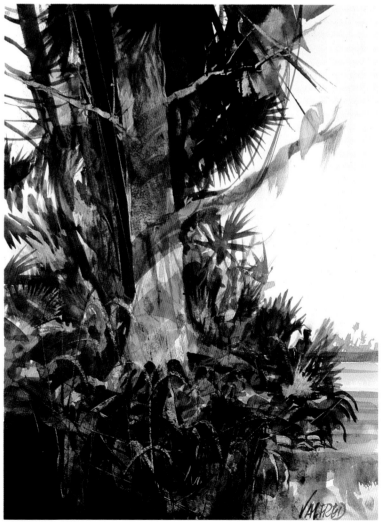

MANGROVE SHORE, 16″ × 20″ (40.6 cm × 50.8 cm), collection of the artist

What Different People See

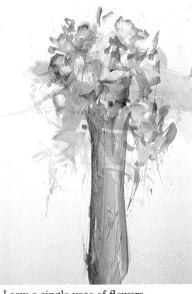

For my own piece . . .

I saw a single vase of flowers.

But as I got into the painting, I turned it around and saw a cityscape developing.

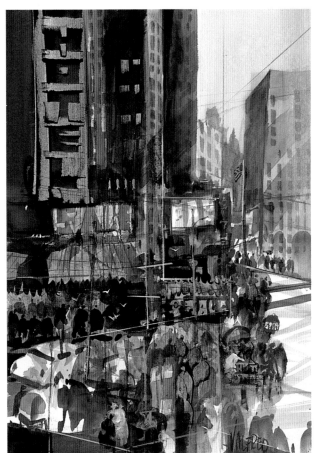

This same basic cross form was used to create two other paintings.

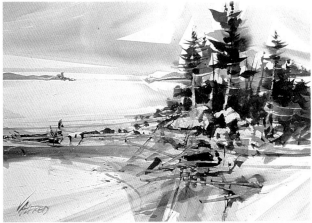

SHADY SIDE OF THE STREET, 16″ × 20″ (40.6 cm × 50.8 cm), collection of the artist

So I continued along that vein. This type of transition takes place often in my work, as I am constantly evaluating the painting from all four sides.

MAINE INLET, 16″ × 20″ (40.6 cm × 50.8 cm), collection of the artist

Placing the cross on a horizontal axis, I added just a few touches of trees and a spur to turn it into a harbor area with a few figures walking along the beach.

The painting I feel was the most successful of all five begun from the same cross is also the most abstract.

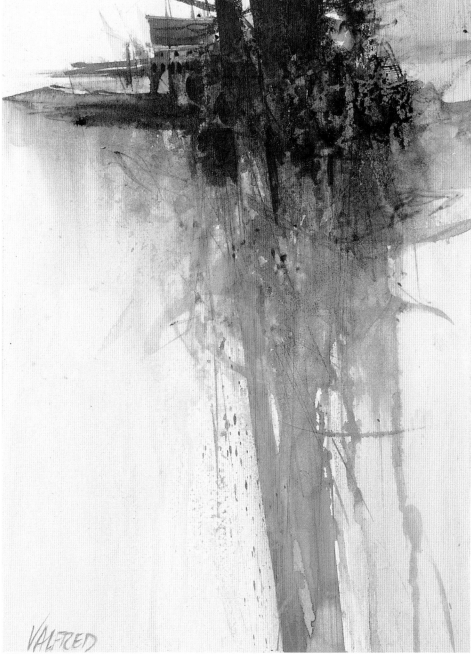

After the oranges were completed I came back and wet the entire surface, putting in some Van Dyke brown and Indian red. I then held the painting in an upright position and squirted it with water, allowing the colors to run. I sprayed it next with acrylic to fix the colors in position. A fishing hut developed in the background and pine trees in the foreground. I added some polymer medium to my watercolor and brought out a few of the lobster buoys to the right of the pine trees and a small red figure in the distance. I then sprayed it again with water. When it was dry, I added a glaze of cobalt blue for the sky and the water by the fishing hut. The rest of the composition was left abstract, the forms in the foreground possibly suggesting the reflected sun.

HIDDEN HARBOR, 16″ × 20″ (40.6 cm × 50.8 cm), collection of the artist

Other Interpretations

"This is one of a series of paintings called 'artifacts' in which the images are created on paper that has been prepared to simulate ancient parchment, leather, or fabric," the artist explains. "In this particular example, I tore the edges of plain white paper to give it a sense of presence, a sense that it is part of the object, not just a surface painted upon. Next I crumpled the paper into a tight ball, then smoothed it out as much as possible by hand. I covered the paper with a mixture of pigment and water, pouring, dripping, and brushing it on and letting the liquid settle into the folds. When it was dry, I ran the paper through a hot dry-mounting press to flatten it and make it manageable. Next I drew the geometric composition lightly on the painted surface and folded the paper on the lines, making both horizontal and diagonal accordion pleats. After doing that, I tinted the planes of the folds with color to reinforce the image. Next I drew a circle, cut the parallel slits, and removed the narrow strips of paper. Behind this circle I placed another image on a separate piece of paper, attaching it to the back of the painting and allowing it to show through the slits. The completed painting was then mounted, by means of linen tape hinges, on a piece of acid-free rag mat board. When I framed it I left about ⅛" between the Plexiglas and the painting to retain its three-dimensional quality."

Larry Webster, **TWENTIETH CENTURY ARTIFACT**, 21" × 29" (53.3 cm × 73.7 cm), courtesy of the artist

Lee Weiss, **WEB OF ICE**, 40" × 27" (101.6 cm × 68.6 cm), courtesy of the artist

"I didn't plan *Web of Ice*," says Lee Weiss. "With a flat sable brush I applied reds with varying degrees of intensity. Then, using a broad flat bristle brush, I wiped out color randomly with water. A geometric pattern emerged, which I enhanced with more wet-in-wet painting, wiping out, and lifting, working in layers. The composition was determined entirely in the painting process."

Glenn Bradshaw, GOD'S EYE: COSMOS II, 26″ × 36″ (66.0 cm × 91.4 cm), courtesy of the artist

To Glenn Bradshaw, there are no barriers in the medium of watercolor. Of this image he says, "Several years ago I assembled nine paintings and showed them as a single work of art. Not a new idea, but I was intrigued by how the units existed independently yet interacted to form an entity. That led me to create a number of paintings using multiple segments. For this painting I applied several layers of diluted casein tempera to both sides of four panels of Japanese Okawara paper. Based on the 'God's eye' symbol of folk art, the composition is one of echoing geometry; the four segments exist in concert. It is my hope that the result is an inviting, gently mysterious visual adventure."

Practice Exercises

1. Seek shapes and forms from nature and use them in your painting without regard for their place in reality.
2. Once you see that a painting is near completion, turn it in every direction and look at it from all angles before proceeding.
3. Wet a painting surface all over and create design lines with a palette knife, then follow these lines to create an abstract painting.
4. Make a painting using techniques you have learned from previous chapters without any objective in mind except the techniques themselves. Evaluate the results. Do you have a painting you can call finished?
5. Prepare four separate pieces of board, and begin to paint identical compositions. Stand back. Do you imagine developing four different paintings from what you see? Ask a member of your family or a friend to describe what he or she sees in the preliminary work.
6. Make a simple realistic painting and evaluate it in terms of negative and positive shapes you can develop into an abstract composition.

13
LEARNING FROM OTHERS

Each of us can strengthen our knowledge of art by studying its tremendous tradition and history, for we stand on the shoulders of giants, artists who started out only as tall as we are now but became great and left us this marvelous legacy. As you learn more about art, you will come to understand legendary artists as human beings whose skills and personal expression can be appreciated on that level. You will also learn what distinguishes the good from the bad—there is nothing in between—no matter what the medium, format, or size. According to the painter and teacher Charles Woodbury (1869–1940), "Great artists teach us that it is better to be definitely wrong and downright bad than to be weak and tentative."

Regardless of which medium you pursue, you must continue to grow in knowledge and capability. To become a good artist yourself, you should become familiar with the work of many artists, past and present. Make an effort to reach out and understand art history, and take up the challenge of becoming

part of visual history yourself. Learn about various mediums other than your own. Study artists who approach the creative process the way you do and a wide range of others who don't.

Every painting you look at can teach you something. When viewing any work of art, study its composition, the artist's use of color, the symbolism, and the mood the image creates, and analyze the technique. Whether the painting is abstract or realistic, it is important that you try to understand what the artist is saying as well as when, how, and why he said it.

As you analyze the work of old masters and of contemporary artists, you will find your own work growing stronger and gaining new confidence. Study not only the paintings, but also the lives of the artists who made them and how their various experiences affected their work. Winslow Homer's extensive travels show in his work, whereas Andrew Wyeth found all his subject matter in his own backyard.

I have developed my own style in

its many variations as the result of such study. Based on what I learned from other artists, certain things became important in my own painting, including the great emphasis I place on negative and positive space, light against dark, warm against cool, and the way I understand how these things interrelate no matter which style my subject matter calls for. All of this is more significant than the subject matter itself and applies equally to working abstractly or realistically. As I suggested earlier, all art is abstract anyway, regardless of how it's labeled; it is a distortion of the reality its creator sees. I have no inhibitions about moving between these two poles; realistic or abstract, whatever image emerges from an idea is what counts for me. The painting seems to create itself during this process. Forms spring into being from memory or the subconscious, and the picture unfolds before me and becomes a world of light and depth that develops its own life. The experience is that of watching a curtain in a theater roll back at the beginning of a play.

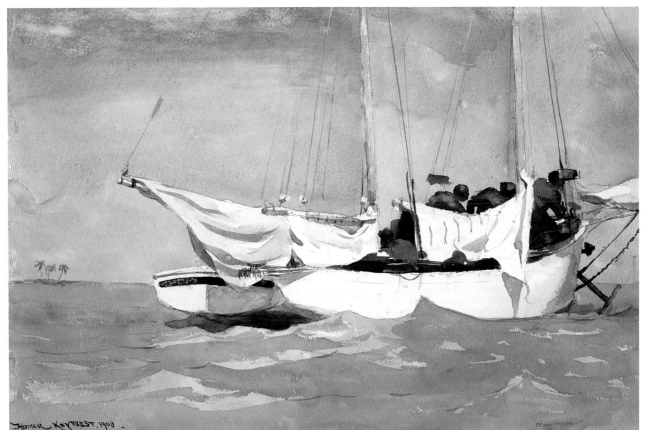

Winslow Homer, **KEY WEST: HAULING ANCHOR,** 14″ × 21⅞″ (35.6 cm × 55.6 cm), National Gallery of Art, Washington, D.C., Gift of Ruth K. Henschel in memory of her husband, Charles R. Henschel

In Homer's work, color flows freely as the painting develops. It is particularly noticeable here in his handling of the water.

Andrew Wyeth, recto: **FIELD HAND,** 21¾″ × 39⅝″ (55.3 cm × 100.7 cm), National Gallery of Art, Washington, D.C., Gift of Leonard E. B. Andrews

I feel Andrew Wyeth has advanced the field of water-color more than any other contemporary artist; he has elevated the medium to such a stature in the art world that it may no longer be looked upon as a second cousin to any other. In *Field Hand*, Wyeth has painted a tree he has used many times in different compositions. This shows how important it is to be familiar enough with your surroundings that you can draw upon your memory or sketches when you need subject matter to complete a painting.

What to Look For

While studying paintings, notice how one color area can dominate another or retreat in the picture according to its size, purpose, hue, and value. Watch how dark and light shapes interrelate. Notice the way the subject breaks down into positive and negative shapes. The duality of positive and negative is the heart of all painting, sculpture, music, writing—of all art forms, for each must have this conflict to be successful. Look for the artist's technique. Try, for instance, to determine what types of brushes were used and how, and try to detect evidence of any unusual tools or techniques. Some artists guard secrets like these well.

I admire Vincent van Gogh's drawings and use of color, as well as his ability to create distance and perspective with line. *The Olive Orchard* shows the marvelous, constant animation one finds throughout his work, which he accomplishes through color and his unmistakable calligraphy, the texture of his heavy brushwork. In a free-flowing manner he moves from foreground to background; the trees seem to grow right out of the ground, just as the women stretching to reach the olives seem to be pulling themselves directly off it.

Vincent van Gogh, **THE OLIVE ORCHARD**, 28¾″ × 36¼″ (73.0 cm × 92.1 cm), National Gallery of Art, Washington, D.C., Chester Dale Collection

Painted in the 1930s, this picture is a good example of calligraphy at work. In his unique and bold style, Burchfield conveys continual motion and animation by making the grass, trees, and clouds perpetuate the storm's action. During this artist's career, large-size watercolor paper was not available, so he painted *Wind Storm* on four separate sheets and mounted them on a single board.

Charles Burchfield, **WIND STORM**, 42″ × 60″ (106.7 cm × 152.4 cm), Permanent Collection, The Museum of Art of Ogunquit, Maine

Discovering Diverse Techniques

As you study various artists, you will discover that very often different people working great distances apart develop similar techniques at the same time. However, these will have evolved along separate courses based on each artist's personal background and unique interpretive vision. A classic example of this is a comparison of Braque and Picasso, contemporaries born within a year of each other who found themselves working so much alike at times that even they had trouble telling their work apart.

This happens often in art. As we develop techniques and methods we believe to be our own, we discover that they have been used before, although perhaps in a different manner or medium. Paying attention to how one technique translates into use in diverse mediums enables the eye to acquire new judgment.

Georges Braque, STILL LIFE: THE TABLE, 32″ × 51½″ (81.3 cm × 130.8 cm), National Gallery of Art, Washington, D.C., Chester Dale Collection

Like many painters, Braque found contentment in working on specific challenges and maintained basically one style for most of his life.

Pablo Picasso, STILL LIFE, 38¼″ × 51¼″ (97.2 cm × 130.2 cm), National Gallery of Art, Washington, D.C., Chester Dale Collection

This painting and Braque's *Table* are so similar, yet each was executed in different quarters. Picasso, a continual innovator, would see a problem, step in, solve it, and move on to the next, always changing his approach right up until his death.

Joseph Mallord William Turner, APPROACH TO VENICE, 24½″ × 37″ (61.6 cm × 94.0 cm), National Gallery of Art, Washington, D.C., Andrew W. Mellon Collection

The English painter J. M. W. Turner used glazes in oil paintings as well as in watercolors to achieve the luminosity for which he is so renowned. A great experimenter in a wide assortment of techniques and tools, he kept his working methods a closely guarded secret. He was known to sandpaper his watercolor paper from the back and paint in pale suns to give an extremely diffuse effect from the front. This technique is very closely allied to the Oriental way of painting on the back of rice paper and then on the front. Turner's paintings are classic examples of camouflaging techniques and making them work.

Other Possibilities

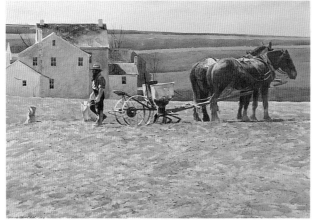

Don Stone, **FIRST PLANTING**, 22″ × 30″ (55.9 cm × 76.2 cm), courtesy of the artist

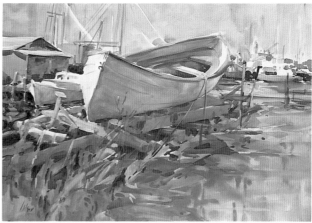

Betty Lou Schlemm, **THE NORTH SHORE**, 22″ × 30″ (55.9 cm × 76.2 cm), courtesy of the artist

"In this painting," Stone says, "I took the unusual approach of working on the main areas of interest—the horses and figure—first, establishing the darks before the lights. My first concern was composition; to keep the painting from being commonplace, I made the peak of the house and one horse's ears just about touch the horizon line and chose to have the man and the horses face opposite directions."

Betty Lou Schlemm explains how she approached this painting. "I began by selecting my subject and placing it where I felt it expressed my thoughts. Then I concentrated on finding the white and the shadow. Next, I worked out my overall color composition, first putting in all the blues—for the boat, sky, water, and so on—and following with the other colors in succession. After completing that stage, I worked up my forms. I finished by detailing objects in the foreground, using their edges to direct the viewer's eye through the scene and create a feeling of depth."

This painting uses a Z-shaped compositional scheme to direct our focus toward the town of Ogunquit at left and in the center background, then toward Wells Beach at top right. The light greens and yellow ochres in the foreground create the illusion of sunlight hitting the grass, while the gray-blues in the background are darker, setting up a contrast that gives depth to the painting.

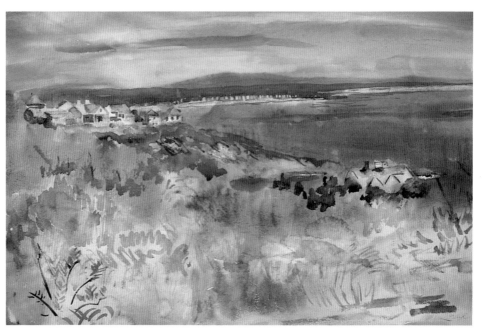

William Zorach, **VIEW OF OGUNQUIT**, 18″ × 20″ (45.7 cm × 50.8 cm), Permanent Collection, The Museum of Art of Ogunquit, Maine

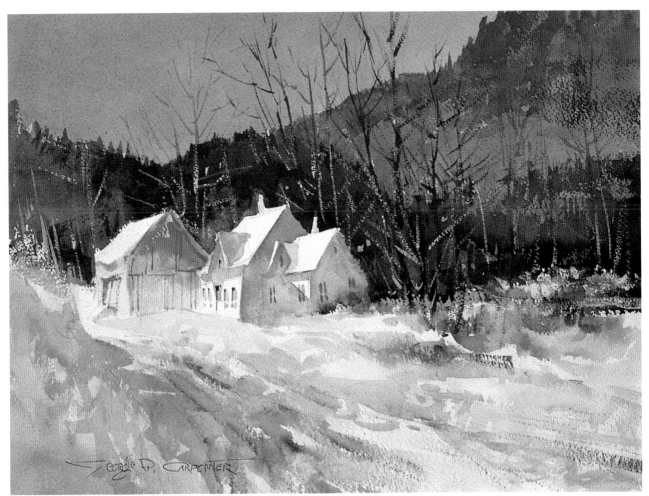

George Carpenter, **VERMONT RURAL SNOW SCENE**, 16″ × 20″ (40.6 cm × 50.8 cm), courtesy of the artist

For George Carpenter, the paper is the most important element in a watercolor painting. "I used Whatman 140-lb. rough paper a while back and it seemed too soft; however," he says, "its pure whiteness was just what I was looking for. By trial and error I discovered that a light wash of new gamboge gave me the foundation I needed. In this painting I wanted to bring out the dramatically sunlit cluster of buildings against the deep purplish hills. I began with the shadows in the foreground and built the painting quickly, spraying it with fixative a few times to dry the paper and make the paint more flexible. The whitest objects—the roofs especially— look almost fluorescent; that's only the new gamboge wash shining through. It does not distort the blues or purples. I used opaque watercolor just on the tree limbs to catch a spark of light."

Practice Exercises

1. Go to museums and art shows. Take time to look carefully at other people's work, paying attention to the mood of a painting, the time of day, the rhythm, the composition, and the use of color, as well as technique.
2. Study many different mediums, materials, and the art forms made from them.
3. Compare the development of art during specific periods in various parts of the world. Copy paintings to learn from them.
4. Heighten your awareness of your surroundings no matter how simple or elaborate they may be. Become more attuned to the leaves and flowers and what blooms together.
5. Take a walk through your house or neighborhood and make mental notes. After you leave a scene, make a sketch of what you remember of it. Do it once more, and you will see things anew. This was Renoir's practice.

14
EVALUATING YOUR OWN WORK

As you pursue the "how" of creating watercolors, it is important to learn the "why." To grow, your goal should be to understand the visual world around you and the immense stimulation it offers.

Together we have worked through many techniques and ideas. Consider each of these steps as a building block that adds to the artistic vocabulary you already have while allowing you to keep your own personality. This increase in your skills, combined with our examination of contemporary and past masters, should help you analyze your own work.

Here I would like to emphasize again that in order to render your subject matter well, you must become familiar and comfortable with it. A painting should capture the feeling, smell, and overall attitude of a subject. Remember, it need not be a specific place you have seen, but

an impression of a place; what you think you saw makes it yours. The late Georgia O'Keeffe would give her students assignments such as painting the temperature of the sand dunes. When she painted flowers, I think she felt she was inside them; her work became her being, as your work should become yours. That is what painting is all about: getting inside of something.

What you create is good art if it is an extension of your emotional being, which is what gives your work its integrity. Your art is a reflection of all that has passed through you, a reflection or perhaps a refraction based on information gained from present and past experiences. What you create may be simple or multidimensional, depending on your outlook.

Because making art is so personal an act, evaluating your own work can be difficult but is essential. You

are the best judge of the particular reality you have created. This is especially true for nonobjective paintings, in which you alone can determine whether the image that appears is the impression you were after. Evaluating the success of the overall effect you've aimed consciously or subconsciously to achieve—your reality—is what's important.

How do you know when a painting reaches completion? When it is finished in your mind, not in someone else's. Basically, the forms and patterns should relate; the color harmonies should be appropriate and well balanced; and the painting as a whole should offer an interesting experience for the viewer. Most importantly, though, it should please you! In it you must see all you need to see.

When you evaluate a painting, look at all the components and techniques to see what makes it work. This painting depicts a rock where I have sat many times to contemplate, and I wanted to emphasize that mood. I used an oval composition, which tends to give a picture a romantic look. The grasses swaying in the foreground lead your eye to the rock, where the lone figure is framed by the tree limb, expressing quiet solitude. The shadows, painted with cobalt blue and warm sepia, are soft, as on an overcast day; I carried their color throughout to unify the painting and maintain the contemplative atmosphere.

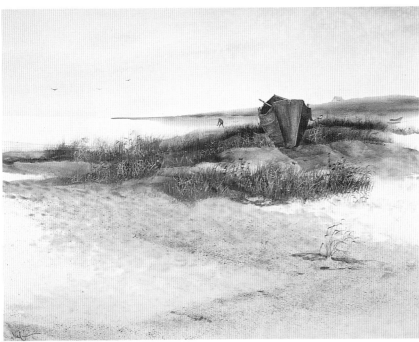

For this painting I used a very wet surface and painted cadmium yellow and new gamboge over the entire background. While it was still damp, I added warm sepia and Van Dyke brown to suggest grass, scratching into it with my fingernails. I spattered the foreground to create sand, then lightly traveled through it with my fingertips to suggest footprints. After painting the dory, I added the figure, the boats in the distance, and finally the red scarf. Then I set the painting aside for a few days. The composition was working, but something was missing. At last, inspired by some gray weather, I added a tonal wash over the sky, and when this was slightly dry, I sprayed it with clear water to suggest a cloud formation. The completed painting gave me a strong sense of place and mood.

RED SCARF, 30″ × 40″ (76.2 cm × 101.6 cm), private collection, Teaneck, New Jersey

PRIVATE PLACE, 28″ × 36″ (71.1 cm × 91.4 cm), collection of Deidre O'Flaherty

Questions to Ask

It is important to take time to evaluate your work as you progress. Examining and understanding the good facets of a painting will be a learning experience. Do you have enough patience to allow passages to dry? Remember, once the surface has been disturbed by water, pigment, or in any other way, you should not push it. Allow time for the natural occurrences. Let the medium do its work. Try to understand how an effect occurred, how much pigment and how much water was used. How did the pigments interact? Did they blend? Or separate? You need to understand all of these questions so that you can replicate the effect at will in the same casual way. With the proper knowledge and control, you will find that "happy accidents" will occur again and again.

Have you studied the shapes and passages in your work every step of the way, comparing how one relates to another and to the whole? Did you let the medium help create those interesting forms and effects? Take time to find out. Did you develop push and pull, negative and positive, light and dark in your work? To gain a better perspective, step back and look at your painting from a distance. It is so easy to miss dominating forms as well as the subtleties in a piece when you're too close to get an overall view of it. Does the painting hold your attention? Is it interesting? Does your eye move through the composition? Does the painting make as distinct an impact from across the room as close up? Will it live for you? Are you part of it?

From the very beginning of a painting you should be concerned with the whole and work toward it constantly, bringing into play all the observations you made and selecting from among them during the creative process. Occasionally a painting will not work as a whole yet has parts that are quite good. Study these passages by placing a small mat over the picture and shifting it across the surface to isolate them. This will show you new directions to pursue. But be wary of making an exact repetition of a painting, as it can lose the emotional response you originally felt and will therefore lack impact.

Your personal response to what you see is always subjective and interpretive, never objective or literal in the way a camera may record it. The camera has one point of view; your painting is your point of view. Take time to investigate a subject. Let information flow into the cornucopia of your mind as if into a funnel, then let the medium work for you.

Using an underpainting of yellows, oranges, and blues, I began this view of Pemaquid Point on location but then had to return to my studio. On a dreary day a week later, I went back to the composition and tried to capture the bright light of that original morning, but instead, the painting got darker and darker. Still intrigued, I set it aside again. Another week or so later, I looked back at it just as the sun was coming up on a bright, crisp morning. Immediately I mixed yellows and oranges into gesso and feverishly struck into the painting with these bright colors. After this rush of inspiration, I examined what I had done and decided the painting was completed. A watercolor may take an hour or years to finish.

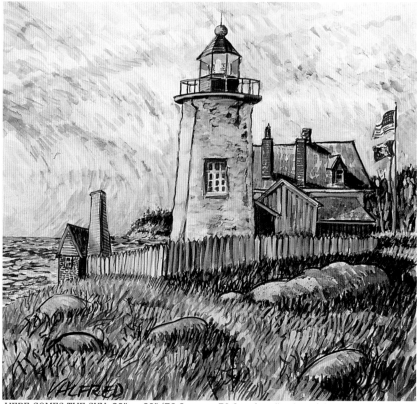

HERE COMES THE SUN, 30″ × 30″ (76.2 cm × 76.2 cm), collection of the artist

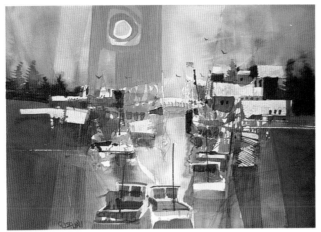

To evaluate a painting, try looking at it in a mirror. When you view your work this way, you can pay more attention to its composition, which becomes more emphatic in reverse and allows you to see any small mistakes you might have made.

You will find that looking at your work through a piece of red or blue acetate helps break down shapes into values. This can also be helpful in analyzing the works of others.

As you examine your own work, you will often find several paintings within a painting. To discover passages that work well on their own, use a cardboard mat and shift it over the surface of the painting to break it down into many small pictures. Interesting areas will indicate further possibilities you may want to explore.

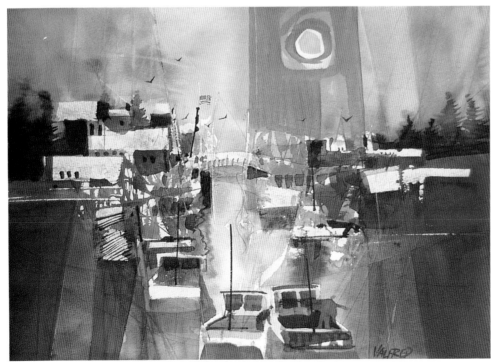

PERKINS COVE, 16″ × 20″ (40.6 cm × 50.8 cm), private collection, Boston

Final Thoughts

To begin this painting, I laid in yellow, cadmium orange, and Winsor red and created design lines with a cookie spatula. In this state it stood on an easel for two weeks while I considered how to proceed. I then covered the surface with alizarin crimson and Winsor blue and worked out the three trees on the ridge; while the surface was still damp, I squeegeed in floral patterns, paying attention as I finished each passage to any positive messages the shapes might dictate. After scratching in grass in the foreground, I put the painting aside again and looked at it through blue acetate to study the values. I also looked at it in the mirror, which revealed that the foreground was too dark. So I scraped it out with a razor blade and lightened things up with a spatter of gesso and cadmium yellow.

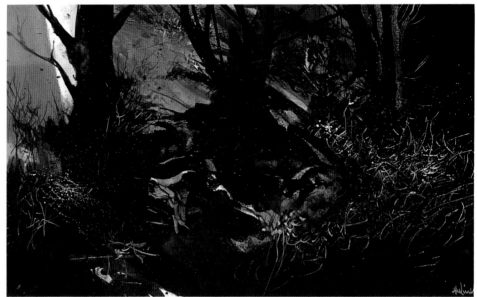

AFTERNOON LIGHT, 20″ × 40″ (50.8 cm × 101.6 cm), private collection, Washington, D.C.

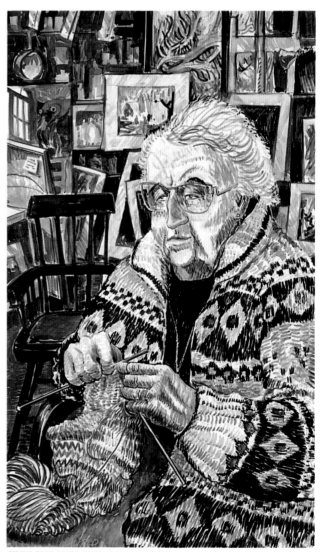

Seated in a classic pose, this is my mother, who has become very involved in my career since my wife's death. I made this picture using what I call my "crosshatch" technique, perfect for capturing her in sporadic sittings, because the paint can dry in between poses. The underdrawing was done in yellow with a #5 round brush; then I washed in the flesh tones and the basic elements of the room. When my mother was again available to model, I worked up the picture in several series of short, overlapping parallel lines, using cadmium orange, alizarin crimson, cobalt blue, and dark purple. For this technique I used an Art Sign lettering brush, a flat-edged brush with a round ferrule. I put in broad patterns and shapes with overlapping glazes, crosshatched over these, and repeated the layers, slowly building pattern upon pattern. This technique is time consuming and requires a degree of draftsmanship, but the completed work has been said to look like Impressionist painting. The approach does capture the light of an image, and has recently brought brilliant colors to my palette.

KNIT ONE PURL TWO, 24″ × 36″ (61.0 cm × 91.4 cm), collection of the artist

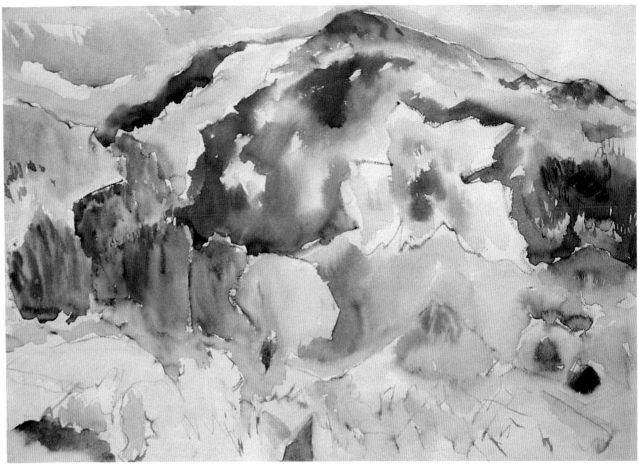

Charles Demuth, **MOUNTAIN LANDSCAPE,** 16″ × 20″ (40.6 cm × 50.8 cm), Permanent Collection, The Museum of Art of Ogunquit, Maine

This is a beautiful watercolor painting of light detailing without outlining. Demuth used cobalt blue behind one hill to bring out the foreground, zeroing in very subtly on the sagebrush. In your own work, avoid outlining when you use darks behind light areas. And do not even think of zeroing in on a detail until you have reached the final stages of the painting and can properly evaluate it; only then will you know what else might be needed.

Practice Exercises

1. Set your paintings around the room. Take a look at them with your "new eye," considering the many techniques and compositions you have learned from this book and tried.
2. Pick works that seem to be particularly "you," the ones you enjoyed doing most and found the most rewarding, and determine why they seem particularly successful.
3. Block off quarters of each painting with a mat to see if individual areas stand alone. Look at the composition as a whole again. Do the quarters work well together?
4. Can you answer the above questions with regard to each work? If not, go back and use some of the corrective techniques you learned in Chapter 11. Remember, every painting is a lesson, and if you learn one thing from each, each is a success.
5. While reviewing your work, seek the strong and the weak points in each painting and reflect on them. Ask yourself: Have I said what I wanted to say? Does my work reveal what is emotionally appealing to me? Try to be quite honest with yourself. There are no excuses, only results!

INDEX